OP TO POP

Furniture of the 1960s

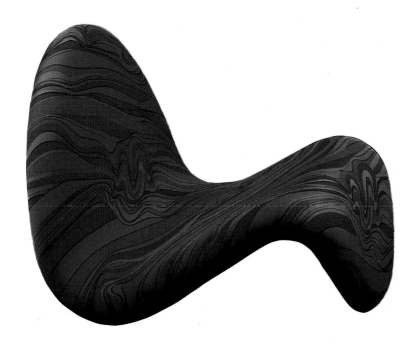

OP TO POP

Furniture of the 1960s

Cara Greenberg

A BULFINCH PRESS BOOK
LITTLE, BROWN AND COMPANY
Boston • New York • London

■ **Page 1: A Pierre Paulin "tongue" chair of 1967, upholstered in vivid psychedelic fabric by American textile designer Jack Lenor Larsen, fetched nearly $5,000 at a public auction in 1998.**

■ **Pages 2–3: French designer Olivier Mourgue's mid-'60s Djinn series, named after the mythical spirit who assumed human form, used the new foam and steel technologies to invest informal seating with the powers of comfort and relaxation.**

Author's note

Quotes from designers not attributed to other sources or publications are from interviews with the author. Dates given for pieces of furniture are generally dates of first manufacture, unless otherwise indicated.

First edition

Library of Congress Cataloging-in-Publication Data
Greenberg, Cara.
 Op to pop : furniture of the 1960s / Cara Greenberg. — 1st ed.
 p. cm.
 "A Bulfinch Press Book."
 Includes index.
 ISBN 0–8212–2516–2 (hardcover)
 1. Furniture—History—20th century. I. Title.
NK2395.G74 1999
749.2'0496—dc21 98–46005

Bulfinch Press is an imprint and trademark of Little, Brown and Company (Inc.)

Designed by Abigail Sturges Graphic Design

PRINTED IN ITALY

ACKNOWLEDGMENTS

I am grateful to those designers who were particularly cooperative in providing material for this book, including Eero Aarnio, Vladimir Kagan, Neal Small, and the offices of Gaetano Pesce and Verner Panton. In addition, a number of people were especially generous with information, photographs, time, or support. These include George Tanier, Charles and Eleanore Stendig, Barbara D'Arcy White, George Beylerian, Charles Gary Solin, Harvey Probber, Derek Ostergard of the Bard Graduate Center for Studies in the Decorative Arts, R. Craig Miller of the Denver Art Museum, David Rago of David Rago Auctions in Lambertville, N.J., Richard Wright of John Toomey Galleries in Oak Park, Ill., Marcus Tremonto of Sotheby's Chicago, Steve Gertz, Robert Wexler, Alexander McLendon, and Scott Reilly.

For his unflagging enthusiasm and encouragement, I owe a special debt of gratitude to my knowledgeable Internet friend, Joe Kunkel.

Others without whose efficient help I could not have managed include Lisa Choi and Messeret Sertse, Knoll; Bob Viol, Herman Miller; Monique Wagemans, Artifort; Anne Margrethe Hauge, Fritz Hansen; Guido Buratto, Artemide; Katie Lovekin, Arconas Corporation; Linda D'Anjou, Montreal Museum of Decorative Arts; Andreas Nutz, Vitra Design Museum; and Alexander Payne, Bonhams.

My warmest thanks to Christopher Lyon, this book's acquiring editor, for his initial interest and guidance, and to Dorothy Williams, who picked up the ball and kept it rolling. My appreciation also to the ever calm Abigail Sturges, the book's designer, and to my agent, Carolyn Krupp, for finding this project a good home.

Finally, my profoundest gratitude and love to my husband, Jeff, whose standards as a writer I can only aspire to, and who really is my biggest fan.

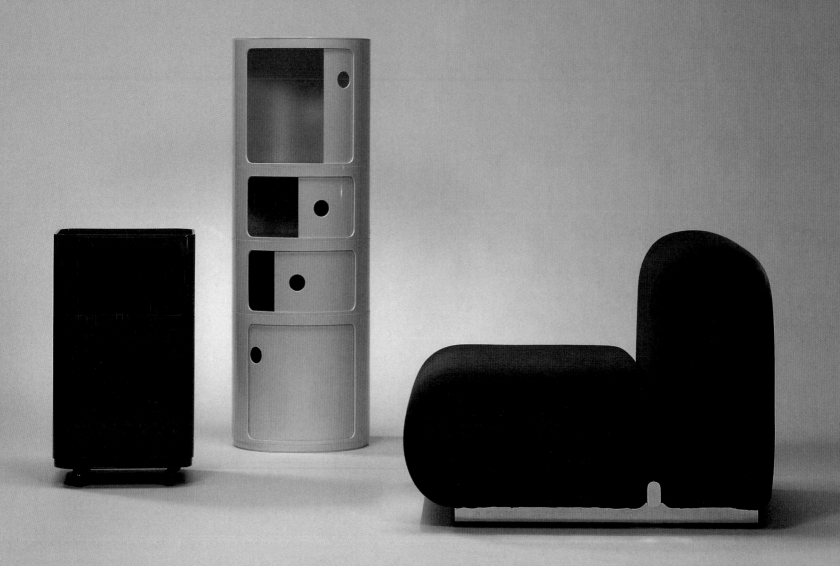

■ Kazuhide Takahama's rounded Suzanne seating unit of 1965 for Gavina seems to float on its recessed base. Anna Castelli Ferrieri's round plastic stacking units for Kartell, designed in 1969, were ubiquitous in dens and dorm rooms.

CONTENTS

■ One of a series of
abstract screen prints
by Verner Panton
hinges, like much of his
furniture, on juxtaposed
geometric shapes.

OP TO POP

Furniture of the 1960s

From Bauhaus to the

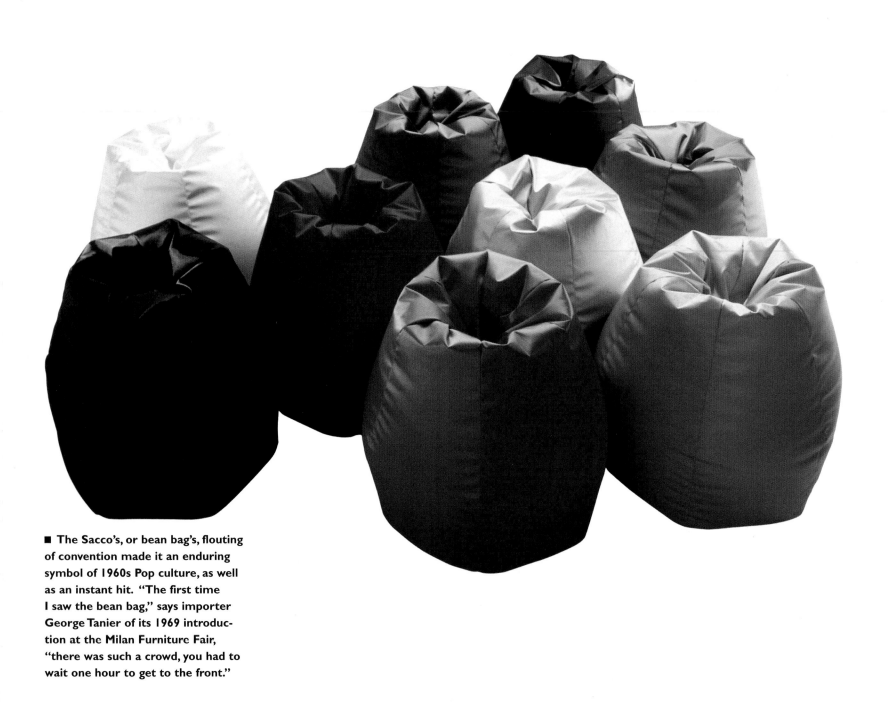

■ The Sacco's, or bean bag's, flouting of convention made it an enduring symbol of 1960s Pop culture, as well as an instant hit. "The first time I saw the bean bag," says importer George Tanier of its 1969 introduction at the Milan Furniture Fair, "there was such a crowd, you had to wait one hour to get to the front."

Fun House

Those smug words, written about the Russian Revolution, are exactly how I feel about the exhilarating 1960s. If you are too young to recall the '60s firsthand, if you missed out on all the excitement—well, at least you have your youth to compensate.

What stands out in this postwar baby's memory is the counterculture we invented, the new freedoms we reveled in. What luck, to come of age just as decorous shirtwaist dresses were giving way to miniskirts, Pat Boone to Little Richard, reproduction four-poster beds to bean bag chairs.

For most of the decade, the country was in an uproar, a national acting-out touched off by the assassination of President Kennedy in 1963. In Europe as well as the United States, students and workers were bent on mounting challenges to every institution and authority. Civil rights marches and anti-war protests were regular weekend activities. Even if you stayed home and listened to Jefferson Airplane, there was still a palpable sense of making history.

In many ways, for all their geopolitical hell, the 1960s were *fun*—and so were the furnishings that came out of them. Design never fails to capture the spirit of an age, and the furniture in this book, arguably the most

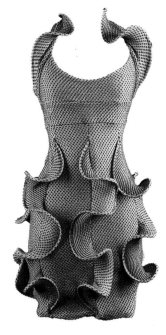

■ Never before had women's skirts risen so high, as in this unknown designer's 1960s minidress of almost architectural construction.

inventive of the twentieth century, expresses perfectly the irreverent, iconoclastic, experimental, tumultuous temper of those times.

Neither America's hippie students nor Europe's rioting workers, however, formed the audience for the advanced furniture designs here. Rather, these suggest another '60s archetype: a mythical consumer who might have been a member of a sexy, witty, lively, chic, sophisticated, jet-set, fast-paced, white-booted, boutique-shopping, discotheque-hopping international crowd, living in a world of unchecked consumerism, enjoying the novelty of credit cards, the Beatles and the swinging London scene, and a futurism fetish launched by the space race.

To that heady brew, add an array of new synthetic materials—clear acrylics; cool, hard ABS plastics; inflatable vinyl; dense polyurethane foam—that allowed designers to create practically anything they could imagine, and you have a decade in home furnishings marked most vividly by the purely outrageous and never-before-tried.

■ Parodying American popular culture, Italian designers Gionatan De Pas, Donato D'Urbino, and Paolo Lomazzi blew up Joe DiMaggio's baseball glove (bottom) to mythic proportions for Poltronova in 1971. Studio 65 did likewise with Marilyn Monroe's kisser in 1972 (top).

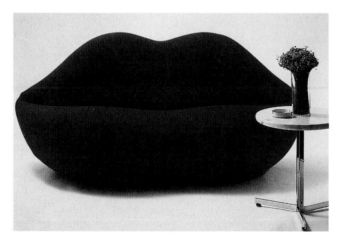

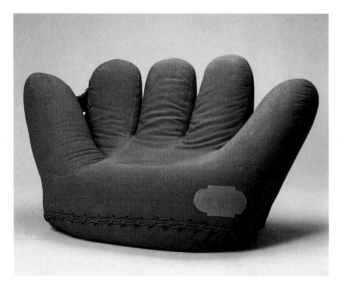

■ A new idiom

Beginning about 1962, '60s designers found a rich lode of inspiration in the Pop Art movement, which translated in furniture into carnival color, robust form, and gargantuan scale—a very different look from the plywood and wrought iron of the previous decade.

In fact, the central current of '60s furniture design—and the heart of this book—is furniture we can loosely refer to as Pop. Defining Pop furniture is

a tricky business, and it's best not to be too rigid. Sometimes it can be identified by a specific pop-cultural reference, as in the Joe chair, evoking DiMaggio's baseball glove, or the lip-shaped Marilyn love seat. More often it is simply bright primary colors, basic geometries, or oversize scale, which are links to Pop impulses. Because of their ephemeral nature (novelty and faddishness being honorable Pop concepts), inflatables and bean bag chairs certainly qualify.

Of course, much '60s furniture was more sober-looking and rational than the word *Pop* implies. The decade also produced a number of masterful designs in a classic modernist vein, like Poul Kjaerholm's wicker and steel chaises, now manufactured by Fritz Hansen of Denmark, and Warren Platner's wire group for Knoll, both so successful they've been in continuous production for more than thirty years.

■ Hail Italia

Curiously, though the Pop Art painting movement arose in England and the United States, the furniture that best expresses its exuberance was mostly Italian—but examples came from Scandinavia (Eero Aarnio, Verner Panton) and the United States (Wendell Castle) as well.

The Italians were unquestionably the most venturesome and successful furniture makers of the decade. Furniture was part of the "Italian design miracle" that bloomed after five grueling decades of Fascism, war, and reconstruction—a creative and economic flowering that gave Italy design hegemony in glass, lighting, and accessories as well as in furniture.

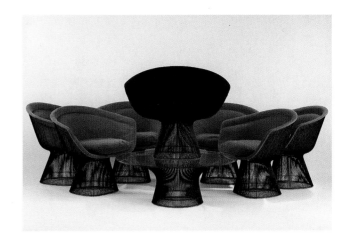

■ Poul Kjaerholm's austerely graceful 1965 chaise (top) of wicker and chromium-plated steel is a direct descendant of Bauhaus. Warren Platner's 1966 wire group for Knoll (bottom) was International Modernism in a shapely new guise.

Italy had an age-old system of *botteghe*—small, family-owned craft shops employing just a few people, which recognized plastics as the coming thing and were able to tool up *presto chango.* Forward-thinking larger manufacturers like Zanotta, Bonacina, and C&B Italia were willing to invest in design on the edge. "The Italians are light-years ahead of America in plastics technology," wrote J. Roger Guilfoyle, editor in chief of *Industrial Design* magazine, in a report from Milan in 1968.

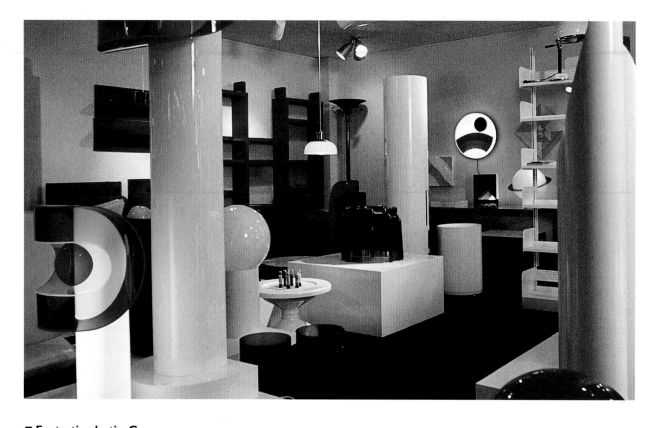

Genius designers like Joe Colombo, Vico Magistretti, and countless others had vision aplenty to go with the emerging technology. Finding few opportunities in building construction, young graduates pouring out of Italian architecture schools in the 1960s trolled small manufacturers for work. They then proceeded to outdo one another designing plastic chairs, lamps, umbrella stands, vases— all manner of bright, lively housewares and furniture.

■ **Fantastic plastic: George Beylerian's showroom in High Point, North Carolina, displayed an assortment of Italian imports in October 1970, plus multicolored acrylic lighting columns by New York designer Victor Lukens.**

Here is how Ettore Sottsass, undisputed leader of Milan's radical avant-garde, addressing a 1987 conference at New York's Metropolitan Museum of Art, remembered the "miracle" days:

Around the sixties, consumerism finally invaded Italy; like after a long-lasting rain, Italy was—and still is—totally flooded. . . . There were no more memories of antique, disastrous social organizations that had not worked for centuries; no more cultural blackmailing by the central power; no more complexes; no more fear; no more depressions: music all over, information all over, fashion all over, art all over, TV all over, sports all over, hospitals all over, psychoanalysts all over, technology all over, and design, too—Jesus Christ—design, too, all over.

The excitement was not in Italy alone. There was also a lively design scene in France, where Pierre Paulin and Olivier Mourgue were twisting foam-upholstered steel frames into sensuous sculptural seating; and it was in France that the "pneumatic," or inflatable, architecture movement took hold against the backdrop of worker/student unrest in 1968.

■ Olivier Mourgue's eerie **Bouloum chaise, of fiber-glass with a gel coating for outdoor use or uphol-stered steel tubing for indoors, is light enough to be carried under one arm.**

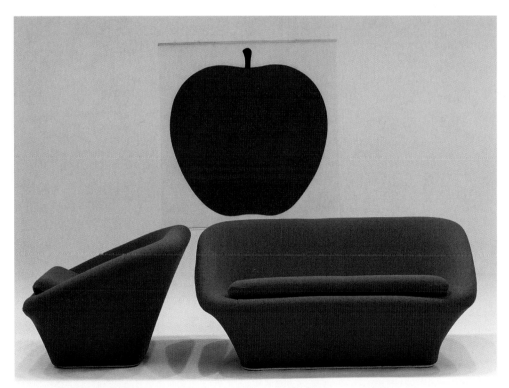

■ The calming visual unity of Pierre Paulin's mid-'60s designs for Artifort invites repose.

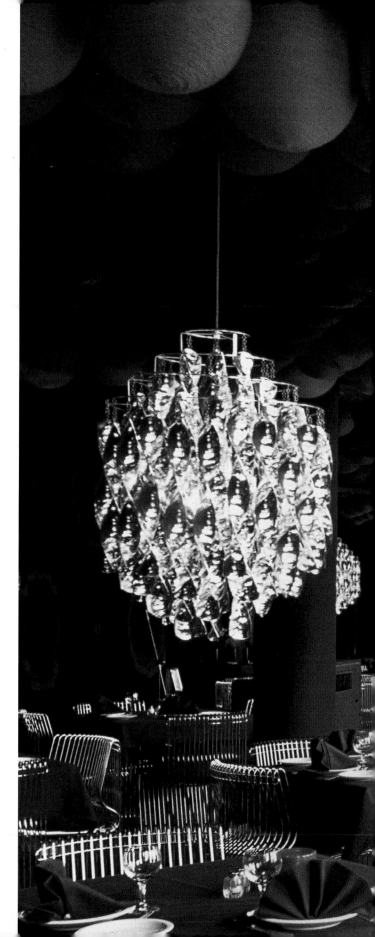

■ Denmark's Varna restaurant (right) in 1970 was a symphony of red and purple. Verner Panton's no-holds-barred approach to interior design included decorative floors and acoustic ceilings as well as furniture and lighting. The wire rod chairs are from the designer's Pantonova line by Fritz Hansen.

Calm Scandinavia seemed creatively unleashed by the events percolating around it, producing dozens of design luminaries in the 1960s. Eero Aarnio's massive elemental work in plastics and Verner Panton's jazzy, color-saturated design schemes were every bit as unconfined as anything Italy had to offer.

■ Its outlandish silhouette made Eero Aarnio's Tomato chair of 1971 (left) one of the exclamation points of the era.

■ 16

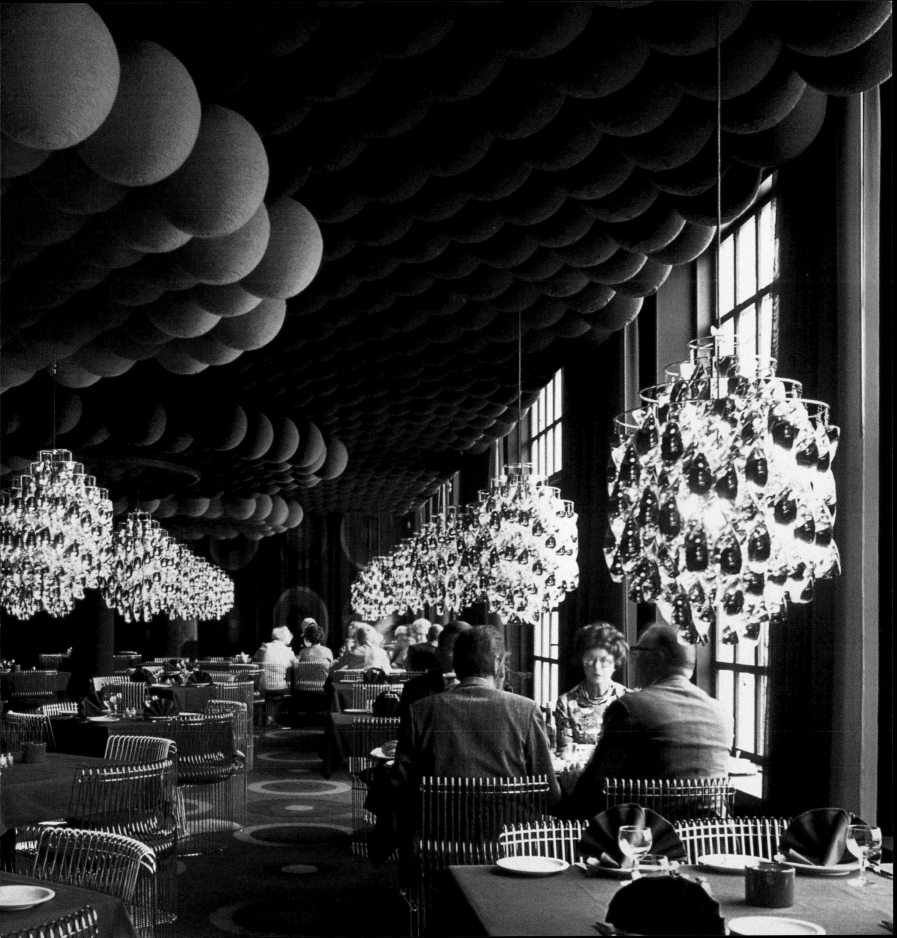

■ On the home front

American design muscle in the 1960s had vanished from the residential furniture market and gone to where the money was—the corporate arena. Many of our indigenous contributions were in the style called International Modernism: coolly geometric metal, glass, and leather furnishings based on Bauhaus (the German design school of 1919–33 that defined modernism for the rest of the century) principles of austerity and restraint. The style's leading American proponents, Knoll and Herman Miller, directed their efforts toward the contract market, furniture intended primarily for commercial and institutional use that inevitably found its way into a few chic homes as well.

The big names that had made America such a design powerhouse in both residential and contract furniture in the 1950s—Eames, Nelson, Bertoia, Noguchi—had moved on to other pursuits, and no new talent of equal influence appeared to replace them. While Italian architects/furniture designers formed collectives, and British designers developed think tanks like Archigram, which put forth extraordinary utopian visions of the built environment, American furniture designers worked away in isolated pockets, far from anything that could be called a movement. Without collective energy and vision, the marketplace ruled. Manufacturers made design decisions, with often mediocre results.

■ Upholstery suspended from steel cables, hanging from the frame in a downward, or catenary, curve, produced a flexible, resilient seat in George Nelson's 1963 Catenary line for Herman Miller.

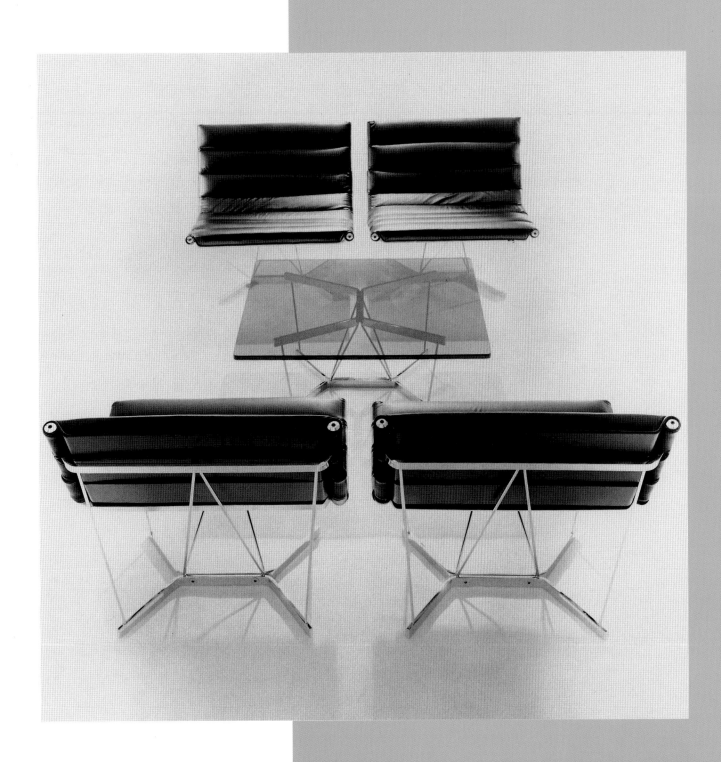

■ The creativity of prolific New York designer Neal Small, shown here around 1967, encompassed lighting, furniture, accessories, and plastic sculpture (opposite).

■ Cheaper by the dozen: the Container Corporation of America made these egg-crate construction cardboard beds (above) in three different sizes.

■ The pace quickens

International Modernism, however, with its steel-based technology and design rooted in 1920s Bauhaus ideas, belonged to the machine age, and the machine age was over. By the 1960s, we had entered the information age, a new age of electronics and miniaturization (though a computer still took up an entire room). The world was much faster paced than it had been even ten years earlier. In furniture as in fashion, the novel, the faddish, the short-lived, ruled.

We were a more mobile society, and we wanted light, portable furnishings for nomadic lives spent in ranch houses and apartments—spaces lacking the dining rooms, libraries, and studies previous generations took for granted. Apartment-house construction was booming in the United States, in suburbs as well as in cities. In his 1964 book, *American Houses: Colonial, Classic, and Contemporary,* author Edwin Hoag asserted that apartments made up about one-third of all dwelling units being constructed, up from one-tenth a decade earlier.

Traditional Depression ideals of thrift were gone, replaced by a belief in the virtues of disposability. Even paper dresses enjoyed a brief run. Furniture no longer had to be forever, and the new furniture certainly didn't *look* forever (transparent acrylic sheeting does not have the solidity of mahogany). As Neal Small, a New York sculptor and designer of clear acrylic furniture and lighting, pointed out in a 1968 *Life* magazine interview, "Furniture doesn't have to be dark and gloomy, like a whale that fell asleep in your living room."

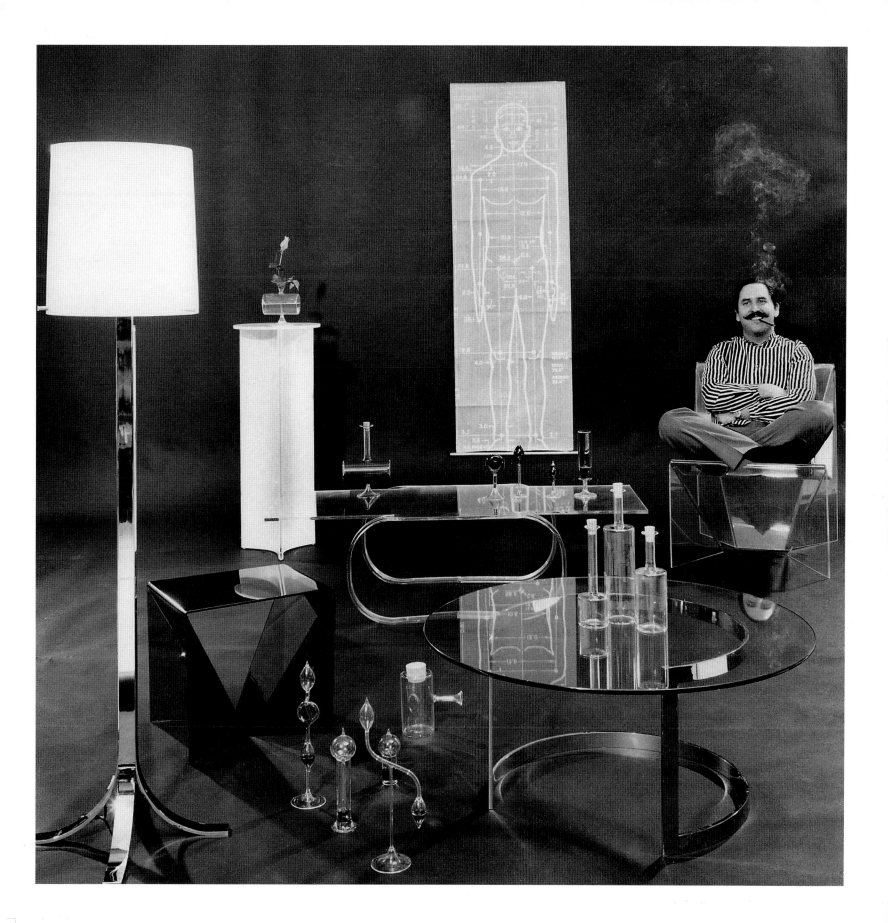

■ Age of orbit

Space travel, just an idea through most of the 1950s, became a reality in the 1960s, and another source of design inspiration. A whole subgenre of visionary furnishings grew out of the interest in the possibilities of space exploration, or came to represent it. Lightweight materials, some developed for the aerospace industry, were usurped for home furnishings, as were the noncolors of space vehicles: silver, chrome, clear, and white.

Included in the futurism frenzy were pieces that crammed as many functions as possible into a single unit, like Joe Colombo's Carrellone, an entire kitchen in a small rolling cart—for soon we would all be living on spaceships, would we not?

From this new awareness of ourselves as a planet afloat in the cosmos arose the single most characteristic shape of the 1960s: the sphere. The sphere was to the 1960s what the streamline was to the 1930s and the boomerang was to the 1950s—an orb for the age of orbit. The Finns didn't send a man into space, but Eero Aarnio gave us the emblematic Ball chair—a personal space capsule, outfitted with stereo speakers, in which to take solitary flight.

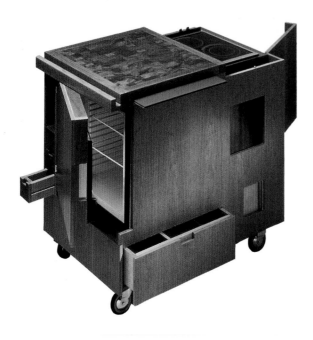

■ Joe Colombo's multi-purpose units, like this 1964 kitchen-in-a-cart—more equipment than furniture—arose from a conviction that people would live the way designers wanted them to.

■ A world within a world, Aarnio's mighty Ball chair has been variously called the Globe, the Thunderball, even the Bomb. Asko Oy, its brave Finnish manufacturer from 1967 to 1979 and 1984 to 1987, called it Pallotuoli. The chair is made today by Adelta of Germany.

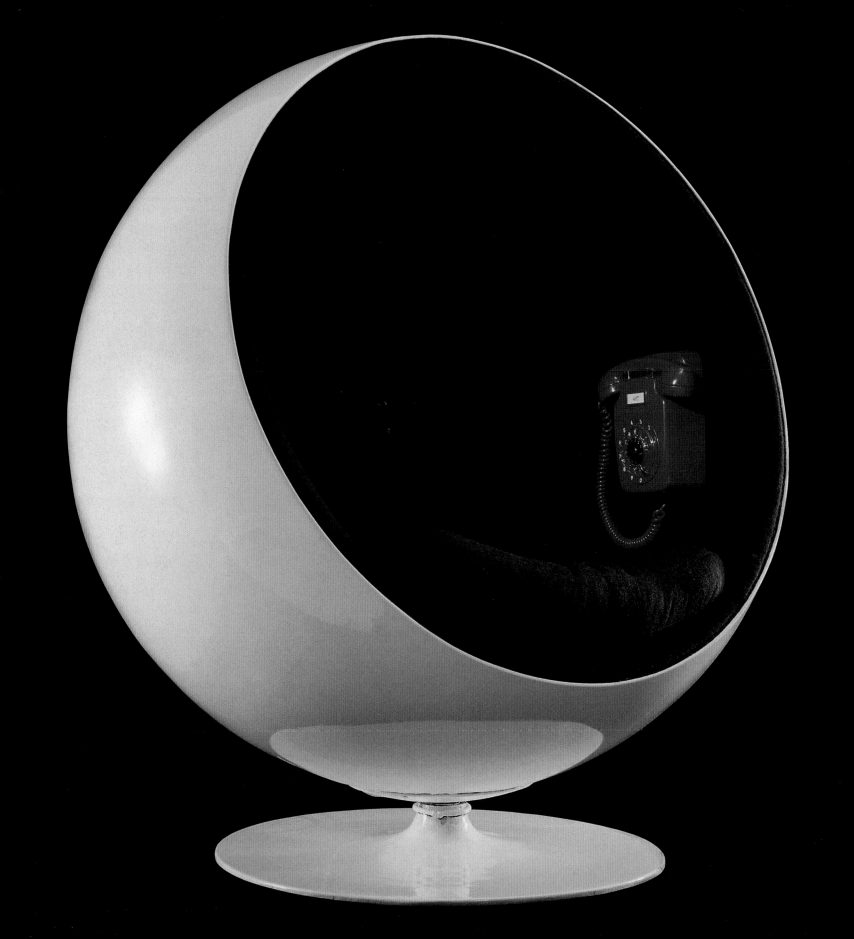

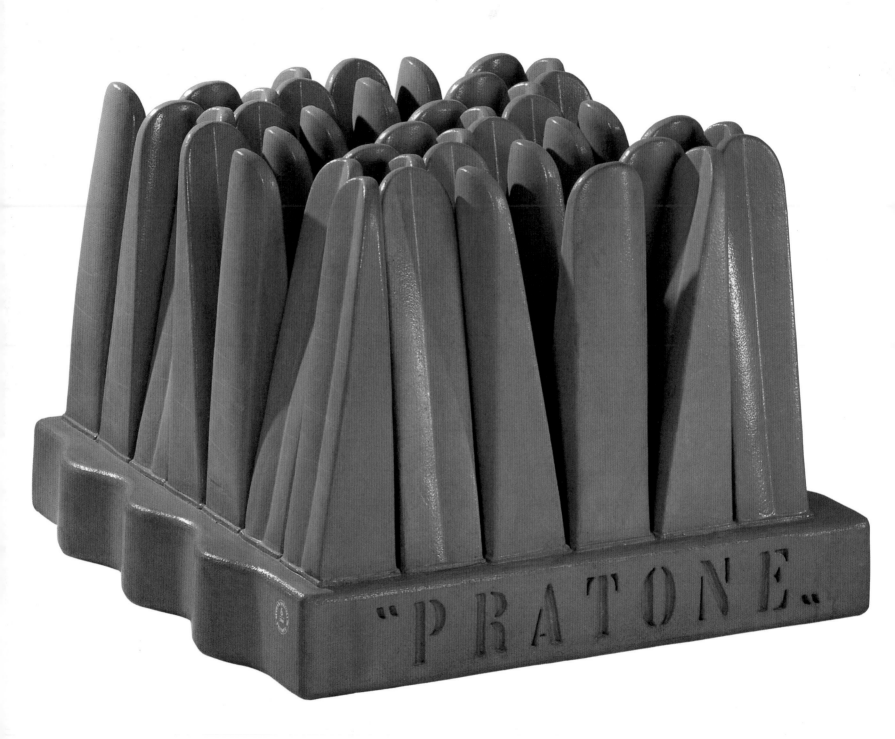

■ Rebels in foam

The feistiness of the 1960s had its fullest expression—the Italian furniture equivalent of *Oh! Calcutta!* and the electric Kool-Aid acid tests—in the so-called Anti-Design movement. Toward the end of the decade, young architects in Turin, Italy, went berserk with polyfoam upholstered shapes, producing surrealist, over-the-top, laugh-provoking pieces that came closer to pure sculpture than functional furniture. Archizoom, a Florentine design group, tried to restore "poetry" to daily life with a series of Dream Beds that had more than a touch of kitsch.

■ **Il Pratone, Gruppo Strum's strange take on nature for Gufram in 1970, was a monstrously magnified swath of grass, produced in four-and-a-half-foot squares that could be linked to form an entire meadow.**

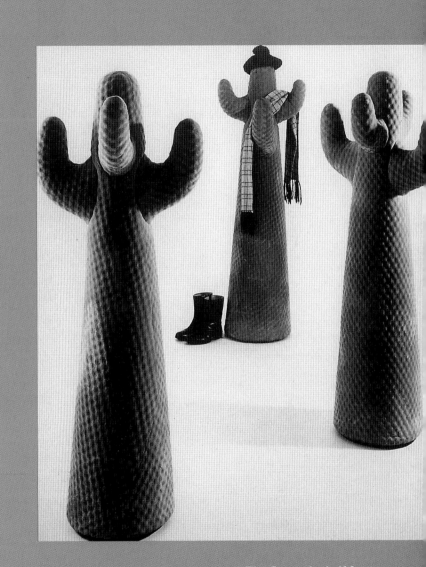

■ **The five-and-a-half-foot-tall Giant Cactus for Gufram, by Guido Drocco and Franco Mello, was made of molded urethane foam with a weighted base. It served incidentally as a hat rack after its primary function as a piece of Pop art.**

■ In the real world

But who remembers any of this zany furniture in real life? The truth is, few Americans in the 1960s came into contact with the more extreme designs. My own '60s memories include being in biology class when Kennedy was shot, seeing the Beatles twice, standing on endless lines at the 1964–65 New York World's Fair, and taking a dip in the reflecting pool of the Washington Monument during an antiwar demonstration. I couldn't tell you what I sat on, however. Growing up in suburbia and, later, living in a student crash pad, I saw very little of the furniture in this book.

Most of it was simply too avant-garde to have found its way into American homes. If available at all on these shores, it was often through architects or designers, and was very expensive. Retail furniture and department stores mostly carried furniture in traditional or contemporary modes that, with few exceptions, is best described as bland.

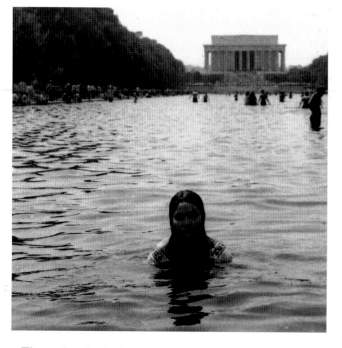

■ The author in the late '60s.

Sad to say, the favored look overall was reproduction early American or "Colonial" furniture, modeled after something the Pilgrim fathers might have built. When Jackie Kennedy redecorated the White House, she did not go to the Merchandise Mart or the D&D Building and order Mies van der Rohe chairs from Knoll. She endorsed traditional tastes, and adoring Americans imitated her.

As the 1960s began, at least 80 percent of the furniture on Bloomingdale's selling floor was traditional, says Barbara D'Arcy White, who from 1957 to 1971 was in charge of decorating the New York store's famous "model rooms," some thirty-two of them a year. "In 1963 or 1964, we were the first department store ever to have a chrome-and-glass cocktail table," she

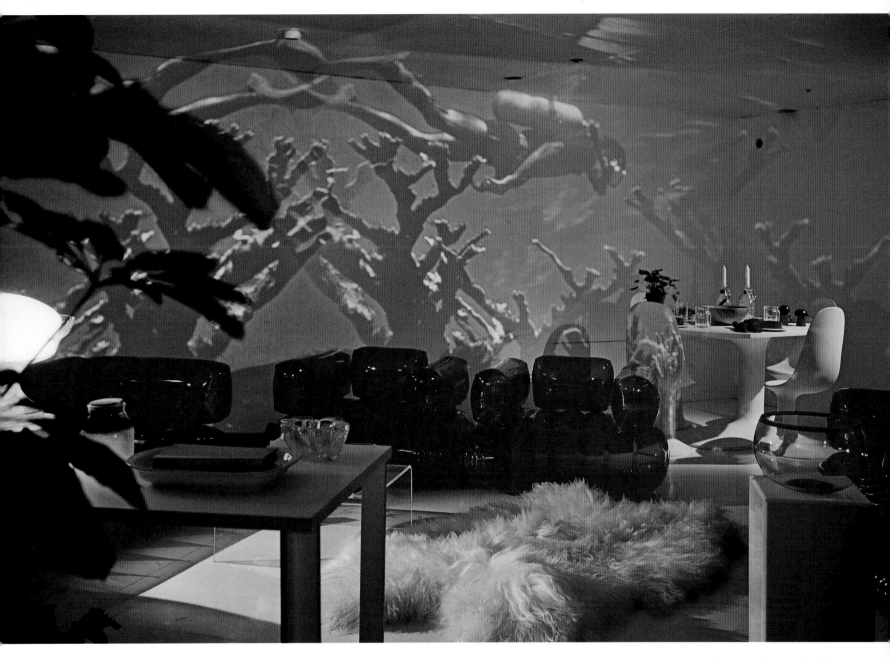

recalled. "That was very radical. People were hungry for that stuff, and
from then on, the percentage of modern to traditional increased each year."

But only slightly, and not in the hinterlands. As with the high style of the
1950s, few people in this country had the sophistication, or the money,
to actually live with Poltronova or Artek or Herman Miller furniture.
Still, its impact on the culture went beyond any one person's living room.

■ Four projectors flashing
thirty-six images kept
things from getting boring
in this ultramodern
Bloomingdale's model
room featuring inflatable
furniture and an over-
grown shag rug.

Recalled Charles Stendig, pioneer importer of Finnish and Italian designs, from utilitarian stacking chairs for the contract market to Pop emblems like the Marilyn love seat and Joe chair: "We kept sending furniture out for photography, it would come back, we'd send it out again. The Joe chair was in magazine after magazine, but we probably sold only about thirty pieces a year, to architects and collectors who wanted to show off."

"If a piece sold well," he sighed, "you can be sure it was boring."

The fact is that avant-garde design was, and always will be, a niche market. Of Il Pratone (The Meadow), Gufram's four-and-a-half-foot square of varnished polyurethane foam intended to represent a swath of nature—essentially an art piece presented only secondarily as something you might be able to sit on—Stendig sold an annual total of two.

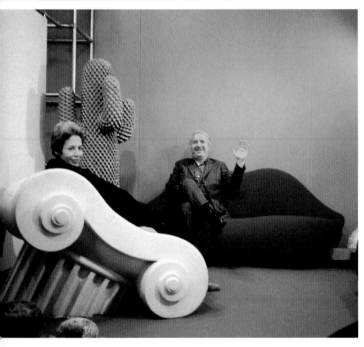

■ Charles and Eleanore Stendig were intrepid importers of the most avant-garde Italian designs to the American market.

■ Only collect

From the point of view of furniture design, the 1960s lasted until about 1972, when New York's Museum of Modern Art enshrined then-current Italian furniture in an exhibition titled *The New Domestic Landscape*. The show turned out to be a summing-up of a genre in which the most important pieces had already been produced. The following year's energy crisis and subsequent worldwide recession drastically reduced furniture production. The 1960s were definitely over. Inflatables had had their day, the moon landing had been achieved, the madness level had fallen, and we entered a period of consolidation and relative conservatism.

By the end of the 1960s, infatuation with plastics was waning. The public had begun to have doubts about unchecked consumption. High school teachers were assigning Vance Packard's *The Waste Makers,* which alerted people to the garbage crisis for the first time, and Rachel Carson's *Silent Spring,* with its predictions of environmental disaster.

"When there's a big upheaval socially," said George Nelson in a 1979 conversation in *Ideas,* a quarterly published by Herman Miller, "people . . . intuitively start going back in time until they find stable ground." Perhaps this explains the turning away from glass orb lighting fixtures, plastic chairs, and Pop colors that by the 1970s (a decade remembered in furnishing for lack of commitment to any color, and sectional seating systems that ate up entire rooms) looked as dated as they had thrilling a few years before.

Perhaps the most interesting development in interior design as the 1960s receded was the awakening interest in vintage furniture and ever-more-recent "antiques."

In the early 1970s, consumers embraced the ornament and curlicues of Art Nouveau that had been long scorned in serious academic circles and forgotten by the masses through decades of less-and-less modernism. Tiffany lamps and Victorian bentwood began showing up at auction, and soon it was retro all the way. While their parents were still living with Ethan Allen, a younger generation leaped back into the comforting arms of overstuffed velvet couches from the Salvation Army store.

Even strenuous efforts to amuse by the radical Italian design groups Studio Alchimia and Memphis in the late 1970s and 1980s never squelched

■ Pieces from Gaetano Pesce's conceptual UP series of 1969 consistently command big prices at auction today. Throughout his career, the multidisciplinary Pesce has mixed performance art, sculpture, ceramics, architecture, furniture, and industrial design.

enthusiasm for vintage material, and mainstream manufacturers have continued to do well with knock-off versions of Mission and Art Deco styles.

From where we stand now, the 1960s look like the last completely original, forward-thinking design era before flea markets replaced political demonstrations as a weekend mania, and we began bending backwards in time and taste.

Rebirth of an era

It seems impossible that the adventurous furniture of the 1960s could ever have been forgotten, but it was indeed consigned to oblivion for two decades or more.

Happily, many '60s designs are back in production. (The Source Guide at the back of this book lists manufacturers and distributors.) Pieces turn up at auction, in shops specializing in vintage twentieth-century furnishings, and on the Internet, though not cheaply. Collectors are paying in five figures for items like the Florentine design group Archizoom's 1968 Safari sofa, an overscaled Pop piece in the shape of a giant daisy—as much as one would pay for furniture made two hundred years ago.

The new popularity of '60s furniture raises the question: is it now at the crest of a nostalgic taste wave, bound to go back out of fashion? Not likely. As I hope this book will show, there's a marvelous repository of material, and we're just beginning to delve into it.

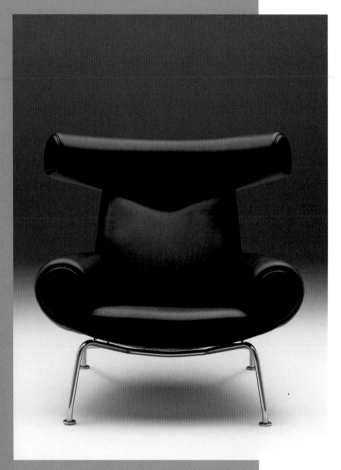

Hans Wegner's powerful Ox chair was ahead of its time when first produced in 1960. Production stopped two years later, until Danish manufacturer Erik Jorgensen brought it out again in 1985.

Here, at the turn of the millennium, more of us have been exposed to design through books, periodicals, museum exhibitions, shops, auctions, lectures, and web sites. We are better equipped to appreciate the consummate mastery of Hans Wegner's Ox chair, the thinking behind Joe Colombo's Rotoliving unit, the tongue-in-cheek gravity of Archizoom's Safari sofa.

Back in the 1960s, designers were not the heroes they are now. People hardly realized that furniture *was* designed. Decorating books and even sales brochures often did not attach names to pieces, even while they depicted the creations of such giants as Joe Colombo and Eero Aarnio. Few '60s consumers could be bothered to remember the names De Pas, D'Urbino, and Lomazzi ... they just wanted a Blow chair. For about $20, complete with patch kit, they were a grand novelty, and at the time, that's what mattered.

In his 1971 book, *Design for the Real World,* Victor Papanek worried about the "tyranny of choice" engendered by an endless list of new materials and processes at the disposal of designers. "When everything becomes possible, when all the limitations are gone, design and art can easily become a never-ending search for novelty... until newness-for-the-sake-of-newness has become the only measure."

It appears Papanek was being overly cranky. The genius of '60s design was inseparable from its very newness. In looking back, we can see that the best design of the 1960s has lost none of its freshness, vitality, or intrinsic humor. Characteristic '60s design still speaks to us of the future, not the past, so advanced were its ideas and techniques. It still carries the overall high spirits of the era in which it was made. Its bold iconography continues to delight, its ingenious engineering to amaze. Indeed, as it turns out, what was new in the 1960s had a lot more staying power than anyone thought.

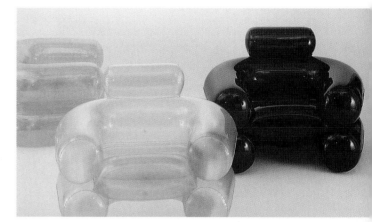

The emblematic Blow chair by Gionatan De Pas, Donato D'Urbino, and Paolo Lomazzi, produced by Zanotta of Milan in 1968–69 and revived by the company in the late 1980s, expressed a generation's urge toward lightness and mobility.

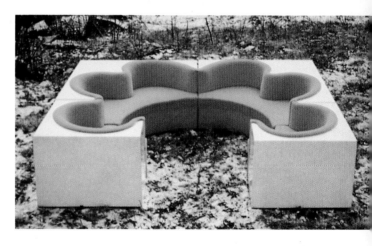

Archizoom Associati's larger-than-life Safari sofa of 1968 was fetching more than $30,000 at auction by the late 1990s.

AMERICAN

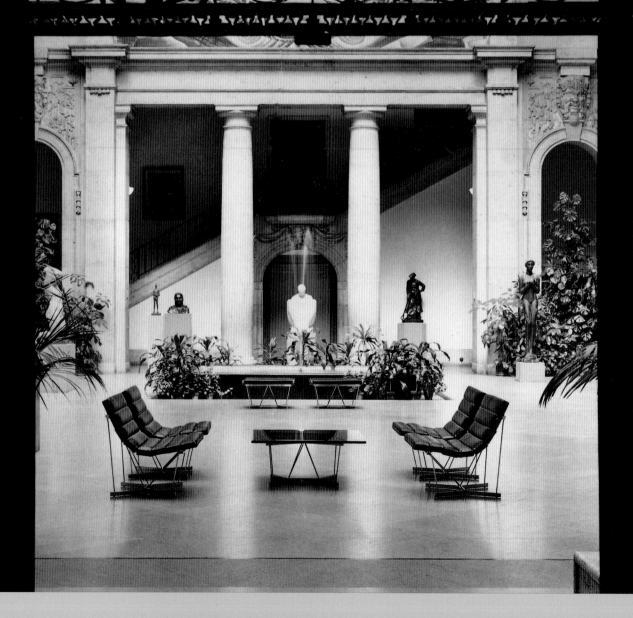

ORIGINALS

America entered the 1960s in a furniture lull. The flamboyance of the 1950s, with its free-form shapes and atomic-age pizzazz, had fizzled. Cheap copies of designs first introduced at a custom level flooded the market. Even Scandinavian imports had become mostly formulaic case goods. The revivifying effects of Pop Art had not yet been felt, and designers of residential furniture didn't have a clue what to do next.

■ **To illustrate their versatility, four ultra-modern chairs and a coffee table from George Nelson's Catenary Group for Herman Miller were photographed in a neo-classical setting at the Detroit Institute of Arts.**

The chief area of vitality in the United States was the contract furniture industry, which supplies sturdy, wear-resistant furniture for use in public spaces. Here the cause of International Style Modernism, an essentially minimalist, rectilinear approach harking back to the work of Bauhaus vision-aries Marcel Breuer and Ludwig Mies van der Rohe, was impressively upheld by two companies: Herman Miller of Zeeland, Michigan, and New York–based Knoll Associates (later Knoll International). George Nelson's exemplary Catenary Group for Herman Miller, its upholstery suspended from steel cables, and Florence Knoll's long, lean sofas and credenzas were not merely functional and built for heavy-duty use but sleek and stylish in the extreme.

Power statements

Such furniture was assured enough to hold its own under a soaring atrium or in a cavernous building lobby. Its masculine look, born of chromed steel, glass, and leather—sober yet technologically advanced—became the dominant style in the corporate halls of power.

International Modernism was most at home in the 1960s in boardrooms and conference rooms, VIP lounges, and skyscraper lobbies. That was ironic for a style which, when it first took root in the Bauhaus, was supposed to be unpretentious enough for the common man.

The now-married ex-GIs who had furnished homes in the 1950s became the executives of the 1960s, more interested in the conference room than in the living room. They were the audience for the open-plan office systems that became the backbone of the contract furniture industry in the 1960s, and in which inventor-designer Robert Propst's Action Office system, introduced in 1964 by Herman Miller, led the way. Intended to provide privacy for the individual within a large open space without creating isolation, Action Office replaced the freestanding desk and chair with a complex of work surfaces, screen panels, and storage units that could be variously configured and used to create partitions.

The 1960s saw new interest in humanizing the workplace. Research at Herman Miller to study the human body and psyche led to ergonomic

chairs to reduce muscular stress, partition panels with inch-wide slots so people could at least sense others passing outside their cubicles, and, under the direction of Herman Miller's textile design director Alexander Girard, bold colors and dramatic patterns never before used in office settings.

Hallowed names

The designers who had made Herman Miller and Knoll the leading lights of modern furniture design in the 1950s had moved on to other things: Charles and Ray Eames to filmmaking, airport seating, and World's Fair architecture; Eero Saarinen to important architectural commissions like Dulles International Airport near Washington, D.C.; Isamu Noguchi and Harry Bertoia to their sculpture studios.

Some iconic '50s pieces, like Saarinen's pedestal group and Bertoia's diamond chair, both for Knoll, remained in production and sold well into the 1960s and beyond, as did many of the Eameses' efforts for Herman Miller.

■ In the 1960s, the office of Charles and Ray Eames largely gave up furniture design, pursuing instead such commissions as the IBM Pavilion for the 1964–65 New York World's Fair, shaped like the ball of a Selectric typewriter.

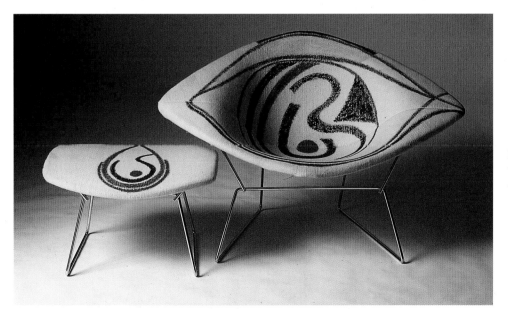

■ Harry Bertoia's 1952 wire diamond chair and footstool was one of Knoll's greatest success stories, here decorated in abstract '60s patterns by fashion designer Clovis Ruffin.

The Eameses did create one landmark piece of furniture for Herman Miller in 1968: a beautifully sculpted leather chaise, just 17½ inches wide. It was suggested by their friend Billy Wilder, the film director, whose all-time favorite spot for a nap was a plank slung between two sawhorses in a Nova Scotia lighthouse, when he was filming *The Spirit of St. Louis.*

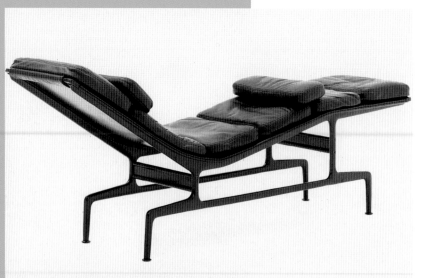

■ The Eameses' most memorable furniture design of the decade was this stunning chaise of 1968—a cast aluminum frame with six leather-covered foam cushions, plus two loose cushions for added support.

George Nelson continued to design for Herman Miller. Besides the very different looking Catenary Group (International Style rarely displayed such curves), his Sling Sofa of 1964, with leather cushions supported by rubber webbing, had a distinctly age-of-big-business appearance.

The unsung genius of Herman Miller in the 1960s was Alexander Girard, who conceived appealing, clean-lined seating for the contract market in 1967, with squarish arms splayed out like wings. A typical Girard sofa fearlessly used yellow-and-red-checked upholstery, or combined orange cushions, black inner upholstery, and pea green outer upholstery, bringing unusual zest to the contract market—perhaps too much, for Girard's line of seating stayed in production for only a year.

Girard's imagination really ran amok with coffee tables, which he topped with everything from pink marble to metal hexagons embossed with triangular wafflelike patterns, and with ottomans, upholstered with concentric circles or pie-shaped slices of unexpected color combinations, like purple and brown.

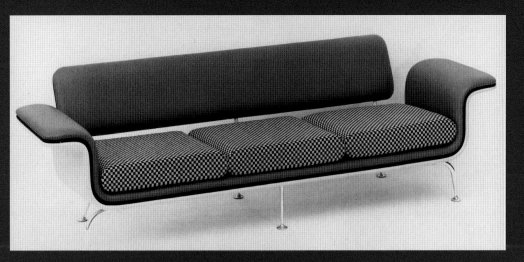

■ The winglike arms
of Alexander Girard's 1967
sofa for Herman Miller
(above) still look fresh and
unique, but his furniture
group sold poorly and
was discontinued after only
a year. Girard's pleasure
in designing ottomans
and coffee tables (right)
is evident in this
lighthearted array.

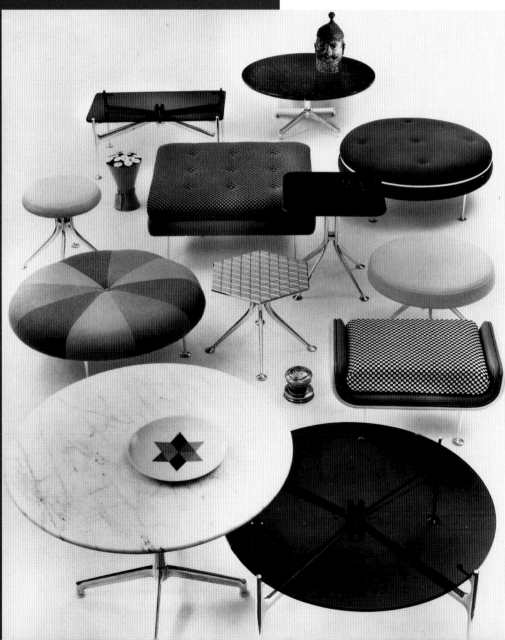

Success at Knoll

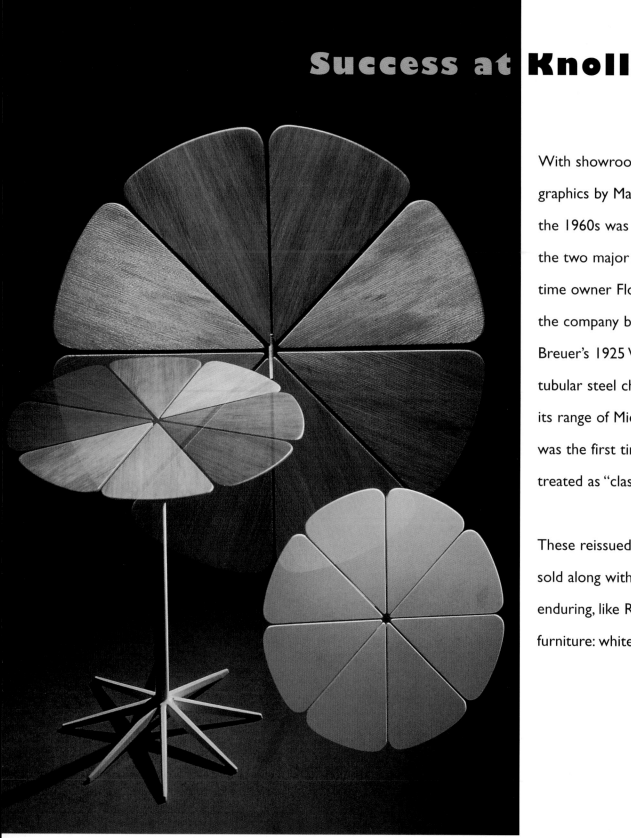

With showrooms designed by Gae Aulenti and graphics by Massimo and Lella Vignelli, Knoll in the 1960s was the more aggressively stylish of the two major American companies. Just as long-time owner Florence Knoll was retiring in 1965, the company bought the rights to reissue Marcel Breuer's 1925 Wassily chair, as well as a 1920s tubular steel chair by Le Corbusier, and expanded its range of Mies van der Rohe furniture. This was the first time early modern furniture was treated as "classic."

These reissued pieces were presented and sold along with new Knoll designs that proved enduring, like Richard Schultz's line of outdoor furniture: white vinyl mesh slings curving over

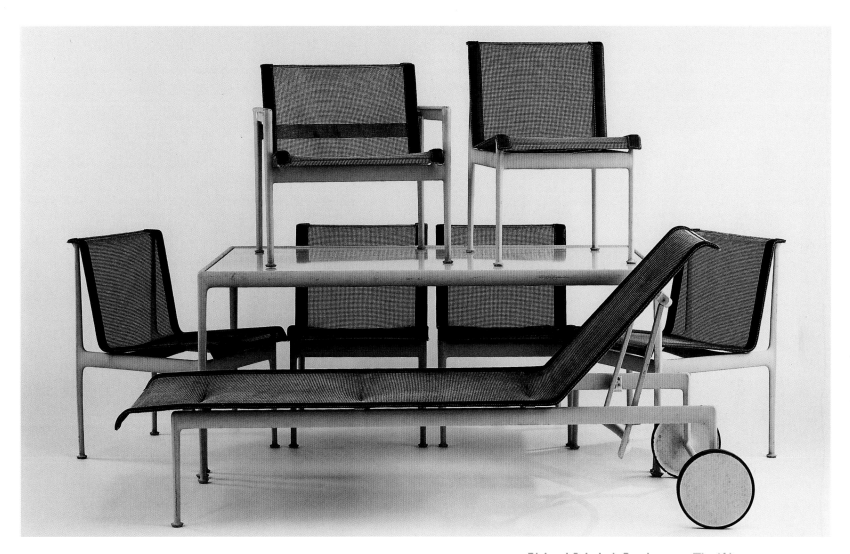

■ Richard Schultz's Petal table (opposite page), of redwood on an eight-pronged cast aluminum base, was made by Knoll from 1960 to 1964 and recently has been reissued by the designer.

■ The '60s were great years for the chaise longue, not least Richard Schultz's lean, freewheeling example, standout of the ten-piece Leisure Collection for Knoll (above).

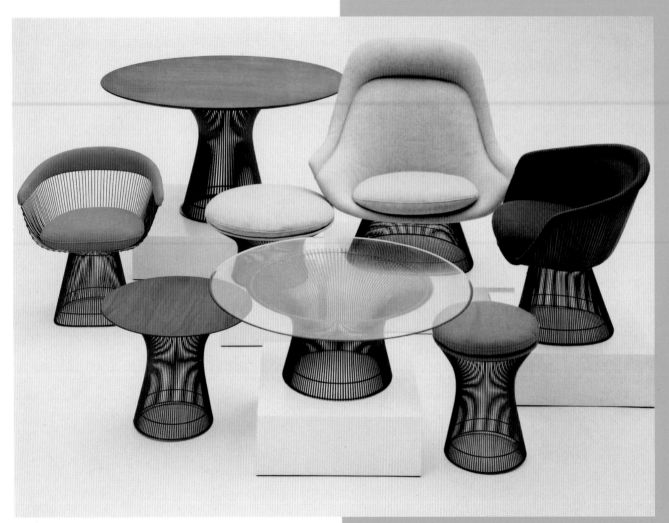

■ Warren Platner's 1966
wire group for Knoll—
steel rods and plastic
shells filled with cushions
of foam and Dacron—
recalls the modernist
dictum to expose the
beauty of structure.

lightweight aluminum frames. The line was created in 1966 at the request of Florence Knoll, who was tired of rusty iron around her pool. Warren Platner's sculptured wire collection was introduced the same year, its steel rod bases creating interesting optical effects, and its chairs recalling the bucket seats of American car culture.

In 1968, Knoll acquired Gavina, one of Italy's most avant-garde furniture makers, picking up designs like Kazuhide Takahama's lozenge-shaped foam lounges, which seem to float on their recessed bases, and Roberto Sebastian Matta's Malitte, a puzzlelike, participatory approach to seating. Described in Knoll literature as "not for the timid," the Malitte and other Italian pieces took the company squarely into the realm of Pop.

■ Innovative, imaginative Cini Boeri, a Milanese architect and industrial designer, created the Bobo sofa for Arflex (below, top) in 1967. It was the first foam seating made without an internal supporting structure.

■ Roberto Sebastian Matta's 1965 Malitte (below, bottom) for Gavina, a jigsaw puzzle of foam, disassembled into a complete living room suite. It was imported into the United States and distributed by Knoll in the late '60s.

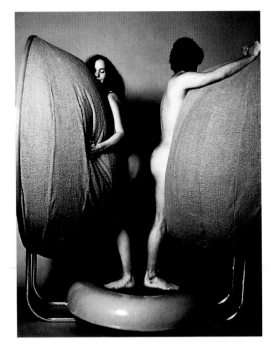

■ Remember "If it feels good, do it"? Marc Lepage's "body drier" inflated with the weight of one or two persons who could then rub dry against warm terry cloth. It deflated automatically when they stepped off. Knoll manufactured the Canadian inventor's inflatable lamps.

Knoll even succumbed to the inflatables craze, manufacturing Canadian inventor Marc Lepage's parachute-cloth lamps, which contained both a light source and a fan, and encouraging his experiments with terry cloth "body driers," though these were never produced.

Knoll became Knoll International in 1969 and worked with a global stable of designers, including Italy's Cini Boeri and Frenchman Marc Held, a former physical therapist who conceived the stress-relieving reinforced fiberglass Culbuto chair, which both rocks and swivels. Increasing emphasis on imports at Knoll occurred because relatively few of the exciting '60s furniture designs seemed to be homegrown.

Market rule

And what was going on in American residential furniture design, whose '50s superstars—Eames, Saarinen, Bertoia, Noguchi—had led the world in innovation and daring? In general, the field was a grab bag, without cohesive integrity, ruled by the marketplace. Unlike in Italy, where designers working closely together stimulated and challenged one another, freelance American designers, selling their work piecemeal to whatever manufacturer they could interest, never produced a national "look" in the 1960s as distinctive as that of the Italians or Scandinavians.

Design decisions made in the United States by manufacturers and marketing people tended to be detrimental to overall design quality. Consider what Letitia Baldridge found when she arrived to begin a job as public relations

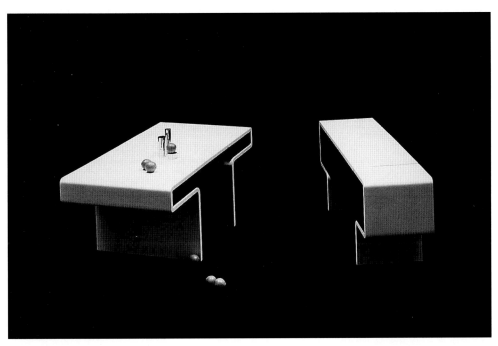

■ William Sklaroff, a Philadelphia designer, created a glossy white desk of gel-coated fiberglass-reinforced plastic with a top that sweeps out to become the legs.

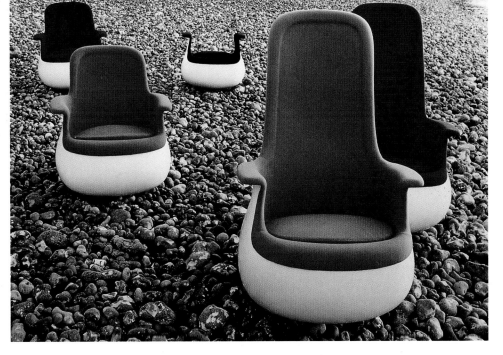

■ Cini Boeri's 1971 snake-like Serpentone sofa (left) for Arflex defined a room with curves of ribbed black foam. Individual units could be joined to form infinite lengths.

■ The Culbuto series by Marc Held (above)—a large chair, lounge chair, and ottoman on convex fiberglass shell bases—rock and swivel, but never tip. They were put into production by Knoll in 1970.

■ Outside of mainstream tastes was the heavily textured "brutal look," achieved with a patchwork of epoxy resins, welded steel, bronze, aluminum, and carved wood. The dining set (below, top), with its sunburst pattern and blue velour upholstery, is an unsigned example. The stool and table (below, bottom) are by Paul Evans, the Pennsylvania-based sculptor who was the leading artisan in this style, notably for Directional.

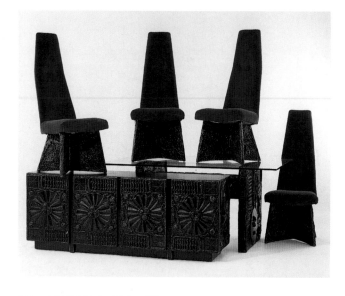

director at Chicago's Merchandise Mart in the mid-1960s, following her stint as social secretary at the Kennedy White House. "I stopped enthusing over objects in the showrooms," she wrote in *Of Diamonds and Diplomats,* "because my rapture would be met with an inevitable frown and the statement 'It doesn't sell.' The only important questions in the minds of buyers and sellers in this industry were 'What will sell, how fast can we get it, in what shape will it arrive, and how quickly can we move it?'" Hardly the climate to encourage risk-taking design.

The 1960s were tough years for the American furniture industry. The "replacement rate" was low. It was between furnishing generations: the parents of the baby boom generation, who set up housekeeping in the late 1940s and the 1950s, had what they needed, and the boomers themselves were years away from shopping for sofas and dining sets. And competition from Scandinavian and Italian imports only grew more fierce as the decade progressed.

The big residential furniture companies in North Carolina and Michigan spewed out Colonial, silver-gray French Provincial, and what was called Mediterranean, furniture with wrought-iron curlicues or carved wood that looked vaguely Spanish, or steered a bland course between traditional and contemporary for the mass market.

There were some interesting exceptions. These included Directional, a forward-thinking company that brought out the heavily carved, brutal-looking designs of Pennsylvania sculptor-designer Paul Evans, as well as

■ The 1963 stainless-steel-and-leather arc chair (above, left) and slim-legged laminated walnut chair and table (above, right), all for Directional, are among the attractive accomplishments of Kipp Stewart, a California designer.

■ Distinguished American designer Milo Baughman has been most closely associated with Thayer Coggin, which introduced his inviting velvet upholstered Baseball chair late in the decade.

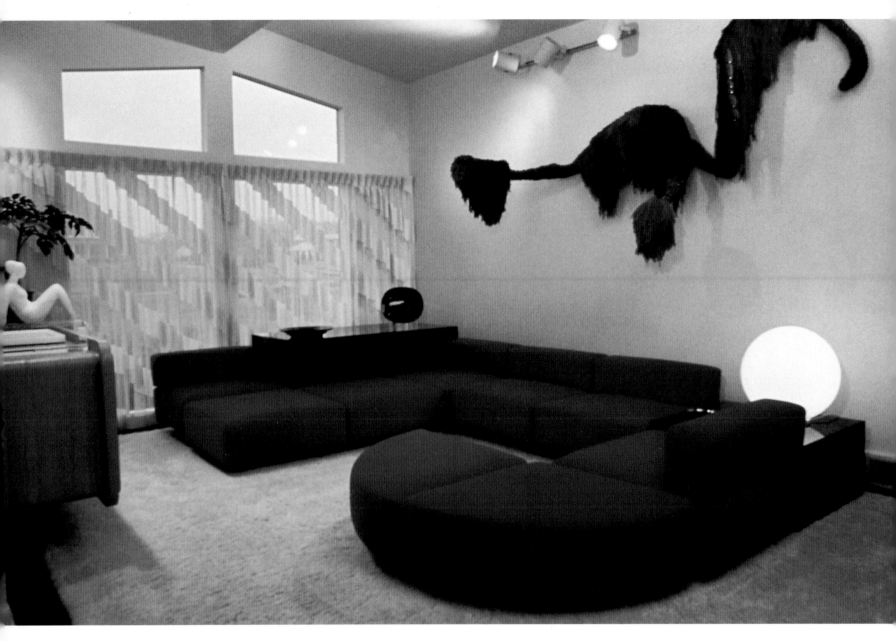

■ Square- and wedge-
shaped pieces of cold-cure
urethane on a steel
supporting structure make
up Harvey Probber's Cubo
system (above), introduced
about 1969 with steel legs
or a hexagonal wood
plinth base. Probber's
omnidirectional Hexabloc
system (right) was
developed for the contract
market in the late 1960s.

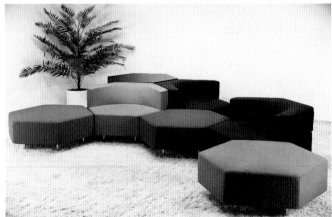

Californian Kipp Stewart's sophisticated machine-look metal-and-leather chairs. Milo Baughman's commercially successful lines for Thayer Coggin brought serious modernist tenets to the popularly priced market. Broyhill introduced a series of plastic-faced case goods called Chapter 1, based on the designs of Raymond Loewy's firm, a rare instance of storage furniture with a space-age look.

The most dramatically modern furniture available directly to the consumer in the better department stores, other than teak from Scandinavia, was the attractive wood and upholstered pieces of American designers T. H. Robsjohn-Gibbings (for Widdicomb) and Edward Wormley (for Dunbar). These gracefully straddled the line between traditional and modern but lacked the verve and blithe spirit of more definitively '60s design.

■ In 1967, thick tubular chrome legs gave this glass-topped coffee table by New York designer John Mascheroni an up-to-the-minute look.

Different strokes

Most of the memorable American pieces of the 1960s were produced outside of the major companies. "Do your own thing" was a '60s credo, and that's what many U.S. designers did. Harvey Probber, the designer-manufacturer who originated the idea of modular seating in the 1940s, did well in the 1960s with infinite stylistic variations on that concept. New Yorker John Mascheroni created an archetypal rounded-edge coffee table, using thick chromed-steel tube legs and a glass top. Neal Small sliced,

■ New York designer Neal Small worked wonders in the late '60s with clear acrylic sheeting, forming furnishings with incredible lightness of being. For a chair (right), two 3/8" pieces were bent and joined with chrome connectors; the table (below) has a glass top.

bent, and folded clear acrylic into furniture and lighting that have found their way into museum collections. In California, Paul Tuttle created delicate-looking yet sturdy chairs for a custom clientele, using structural steel and laminated wood in a fresh way.

■ Californian Paul Tuttle
exploited metal's
structural freedom in
a snail-shaped coffee
table (above, right)
and wood's warmth
in a tub-shaped caned
chair (above, left).
The designer likened
his cantilevered steel-
and-leather Z chair
(right), shown here
in 1964 prototype,
to a rocket launcher.

■ The circa 1960 fiberglass Tulip chair of designer-manufacturers Estelle and Erwine Laverne of Long Island, New York, looked made to order for TV's Jetson family. The rare Laverne settee at right dates from the mid-1950s.

■ The unpretentious wire mesh chair and ottoman designed in 1963 by Darrell Landrum and Louis J. Zerbee (below) are in the permanent collection of the Museum of Modern Art.

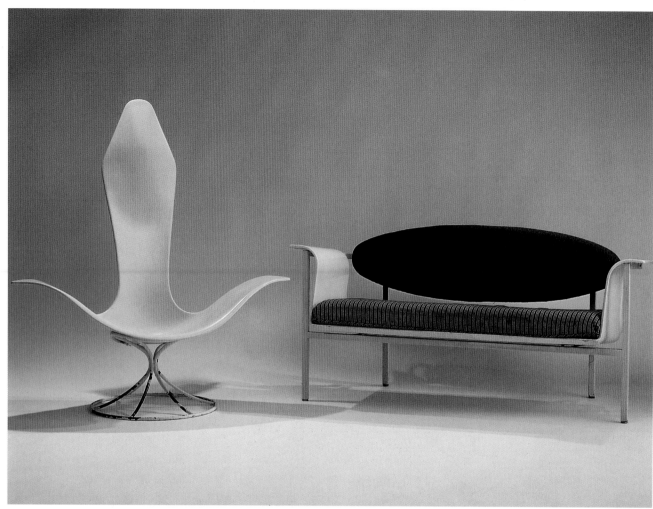

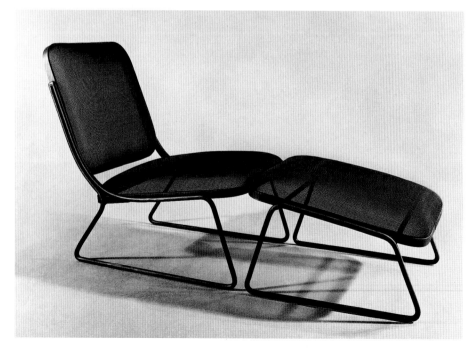

■ John Risley of
Connecticut created
whole villages
of wire chairs full
of Pop whimsy.

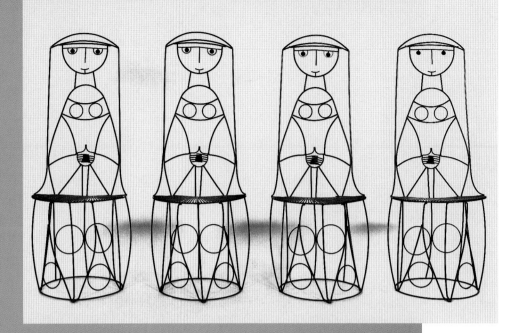

■ The great woodworker
George Nakashima of
New Hope, Pennsylvania,
reworked the most organic
of materials—walnut, in this
case—into completely
modern shapes.

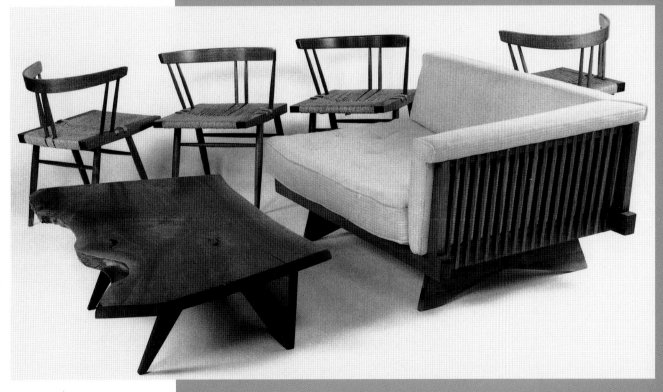

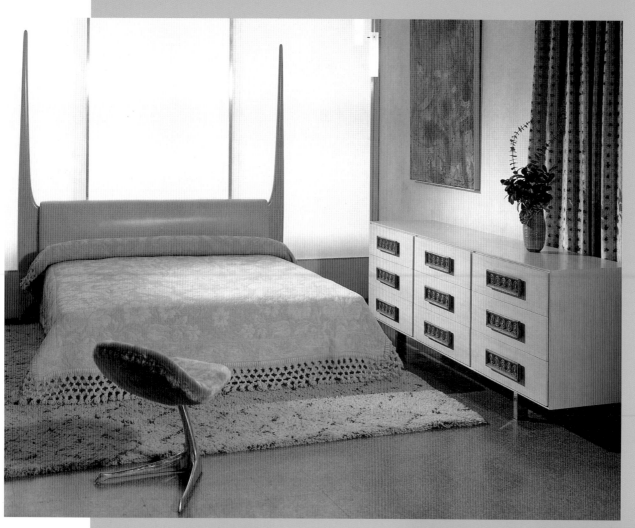

■ A bed with dramatically spiked posts dominates a glamorous bedroom circa 1964 (left), designed entirely by the debonair designer-manufacturer Vladimir Kagan (angled photo). This sleek 1960 chair and ottoman (below) were one-off designs in leather and stainless steel, made for a psychiatrist's office.

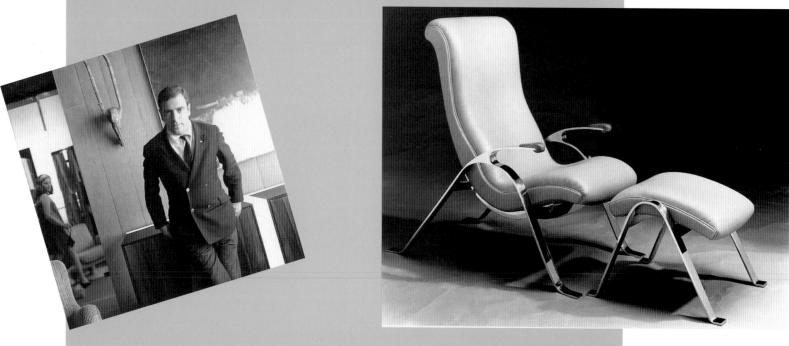

VLADIMIR KAGAN

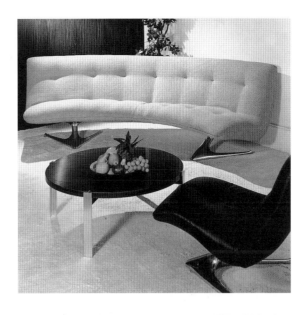

■ In the early '60s, Kagan's chairs and sofas were often curved slings on "unicorn" bases of mirror-finished cast aluminum (left), here shown with a walnut-and-aluminum coffee table, also by Kagan. The blue Plexiglas sofa and coffee table (below) date from 1969.

Vladimir Kagan, known in the 1950s for extravagantly biomorphic upholstered and wood pieces, took a turn for the rectilinear in the 1960s. "I felt I had reached an apex in terms of organic shapes, and could only end up going baroque if I continued," he said. In the 1960s, like other designers weaned on the boomerang and the amoeba, he found himself interested in Mondrian, cubist shapes, minimalism. "I had exhausted an idiom and needed some new expressions. Second, sculptural shapes had become very expensive to make. Third, a lot of people had started to emulate what I was doing—so I changed, in self-defense." His newly squared-off revolving bookcases and dining chairs presaged a return to the right angle that was to become a cult in '70s furniture design.

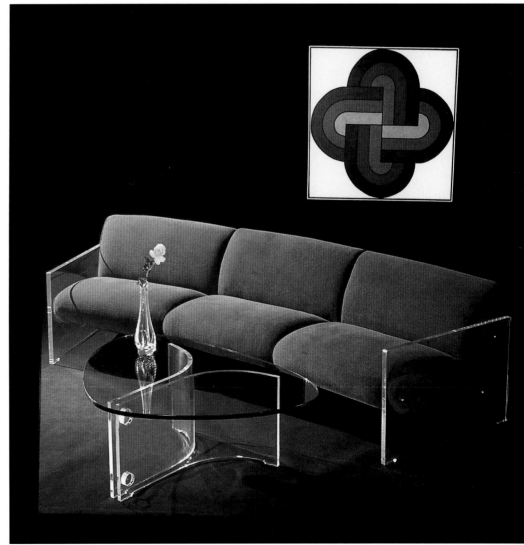

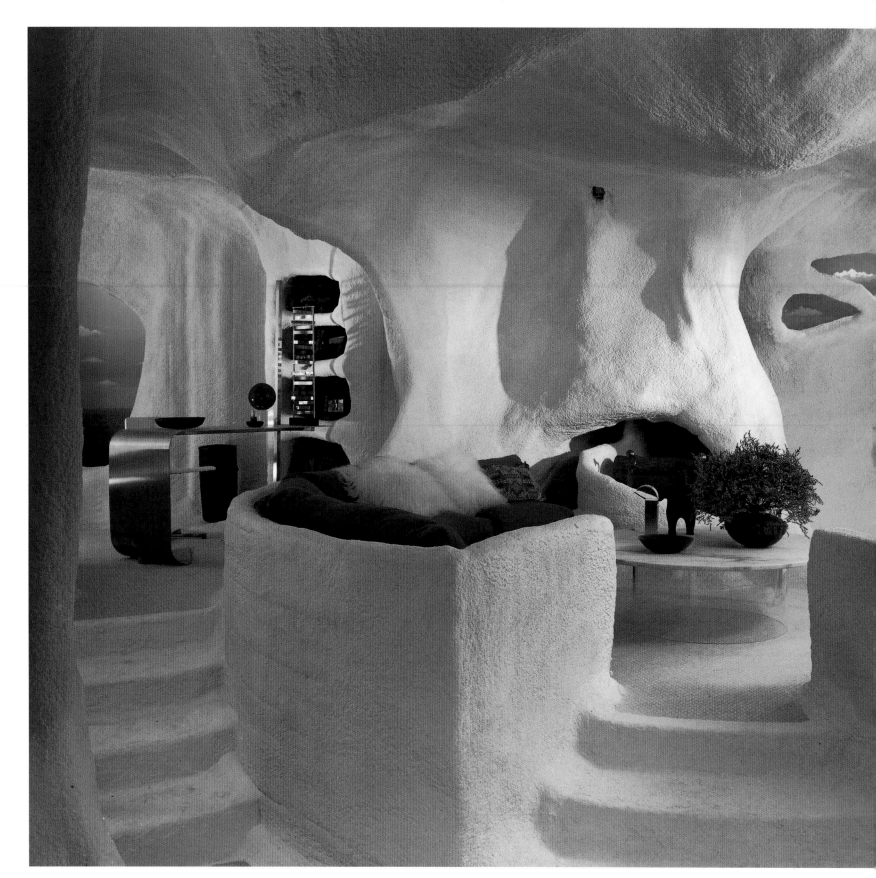

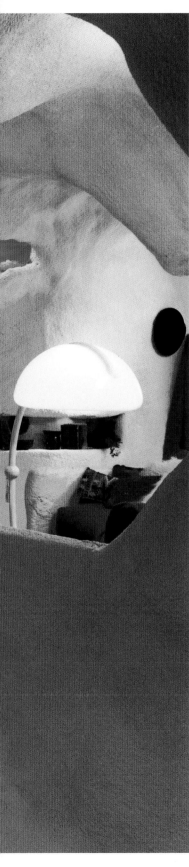

A question of taste

Where was the tastemaking press in promoting modern design in the 1960s? Holding back, for the most part. The 1960s weren't offering the familiar Good Design, based on Bauhaus restraint, that the public had come to accept, but asked for yet another aesthetic leap of faith that neither the essentially conservative furniture-buying public nor the magazine publishers were prepared to make.

Exposure to European tastes revealed our own as provincial and unsophisticated. Compare any American shelter magazine of the 1960s with *Domus* or *Abitare,* two leading Italian interior design magazines of the day: while the Italian magazines still look fresh and exciting, the American ones look fusty and reactionary, with their continued insistence on bringing back our Colonial heritage. Only late in the decade did the mainstream press endorse some of the developments that were taking place, for the most part,

■ Of all American department stores, New York's Bloomingdale's, under the design direction of Barbara D'Arcy, was the boldest. The "cave room," circa 1968, had an armature built of wood and chicken wire, then sprayed with urethane foam.

■ Architect Frank Gehry contributed to the design of this all-cardboard Bloomingdale's model room of the early '70s, which featured his corrugated Easy Edges chairs against cardboard walls and floors.

outside the country, outside the industry. It was 1969 before *Better Homes & Gardens* ran a feature on plastic furniture, but at least it was a splashy pull-out spread.

Macy's, Gimbel's, Burdines, the May Company, Jordan Marsh, and other stores all had big furniture departments, but only New York's Bloomingdale's engaged the most radical '60s interior design ideas: spraying a wooden armature with polyurethane foam to create a "cave room," combining inflatables and plastic furniture with more traditional pieces, projecting slides on a wall to change a room's backdrop on a whim.

The dearth of excitement in mass-market residential design in the 1960s ultimately had a curious, positive upside. As designers and manufacturers felt themselves "being pushed into a crossover," as Harvey Probber put it, from residential furniture design to the more lucrative corporate sphere, the markets themselves began to blur. "People quite naturally saw things in offices and wanted them for their homes, and vice versa," said Probber.

For the rest of the century, exposure to furniture designed for the contract market, often by architects, would raise the general level of design consciousness and widen choices for the American consumer.

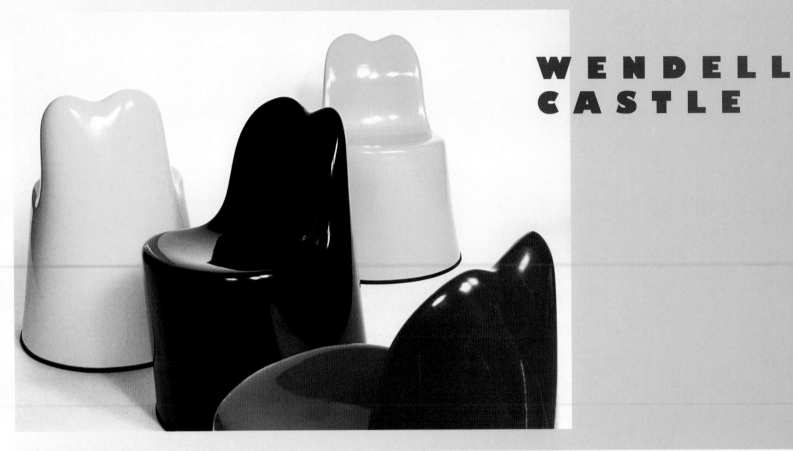

WENDELL CASTLE

■ Wendell Castle's amusingly shaped 1969 Molar dining chairs took inspiration from human dentition. They were manufactured in bright colors, if limited numbers, by George Beylerian. The accompanying dining table came with a round or oval top.

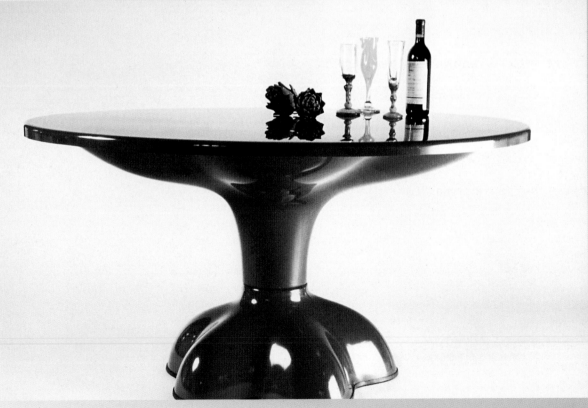

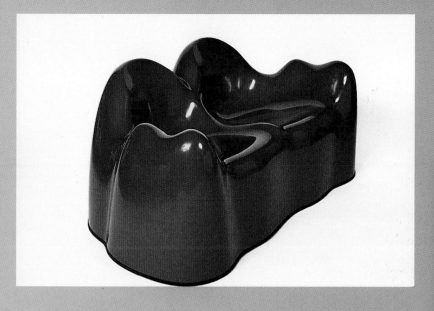

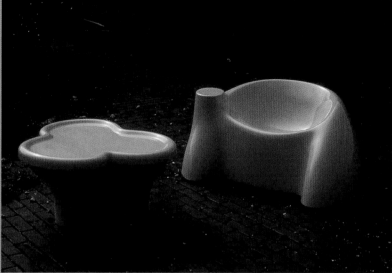

■ Castle's fruitful 1968–69 experiments with plastic produced the well-known Molar series, which included a surreal settee (left); the Castle armchair (below, top); and neon light sculpture (below, bottom).

Wendell Castle of New York State revealed himself in the late '60s as a Pop artist at heart, dabbling for a few short years in fiberglass-reinforced polyester before returning to his renowned career as a woodworker. His forays into plastic furnishings are pure Pop delight, wresting organic shapes out of the most inorganic of materials.

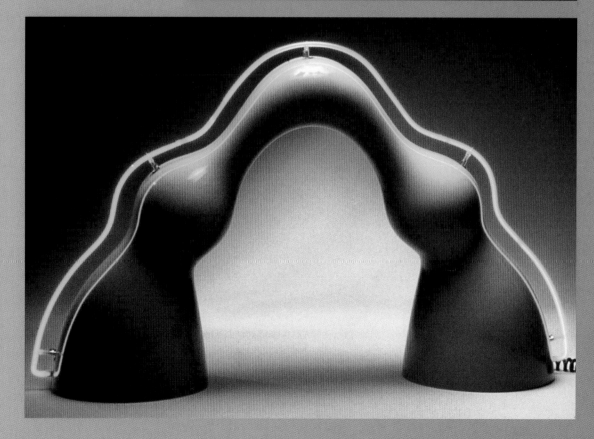

NORTHERN

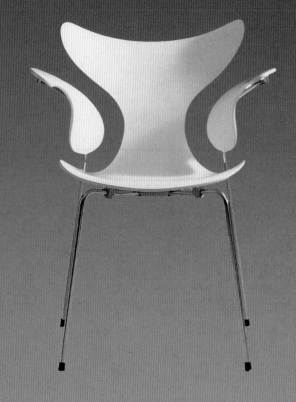

■ The same species as
Arne Jacobsen's popular
'50s ant chair, this 1970
model with arms
(Jacobsen's last chair
design) has pointier
shoulders and a
higher waist.

In Scandinavia—particularly Denmark—International Modernism thrived. Companies like the century-old Fritz Hansen furnished many a corporate suite and some design-forward homes.

Hans Wegner, Arne Jacobsen, Finn Juhl, and lighting designer Poul Henningsen had made Danish design world-famous in the 1950s. The Danes worked chiefly in wood, and gloriously so, with flush joints so smooth you couldn't feel a seam, and a silken planed finish that brought out the glories of the material even in quantity production.

Perfectionist manufacturers E. Kold Christensen, Johannes Hansen, P P Mobler, Fritz Hansen, and others reached a pinnacle of engineering, combining natural materials like wood and wicker with gleaming steel for a seamless blend of hand and machine craft. In no other region did pared-down functionalism attain such elegant execution.

LIGHTS

■ Henning Larsen's 1967 chairs for a Copenhagen café were originally made of aluminum, replaced by chromium-plated tubular steel when reissued by Fritz Hansen from 1985 to 1997.

Star turns

Scandinavian heavyweights of the 1960s included the Danes Poul Kjaerholm and Arne Jacobsen, both working more or less in the International mode; Hans Wegner, also Danish, first and foremost a carpenter who looked to ancient models for inspiration; and Verner Panton of Denmark (later of Switzerland) and Eero Aarnio of Finland, whose work was flamboyant and lighthearted, tending toward Pop.

Jacobsen was Fritz Hansen's resident genius. His lovable Egg and Swan chairs of 1958–60, designed for the Royal SAS Hotel in Copenhagen, have become among the most sought-after of mid-century furniture designs. Jacobsen's primary contribution to furniture in the 1960s was the Oxford chair on a five-star swivel base. Its high-backed version was designed for the professors' dining room at St. Catherine's College in Oxford, England, a project for which Jacobsen designed everything from doorknobs to landscaping.

■ Jacobsen's Egg chair
of 1958–60 was one of
the seminal chair shapes
of the mid-century,
a sensuous precursor
to numerous Pop designs.

■ A sophisticated chair for student use, Jacobsen's 1962 laminated teak, oak, and rosewood chair for St. Catherine's College in Oxford, England, came with a high or low back.

■ Jacobsen labored for four or five years over the design of his Ox chair. Tiltable and with a loose down cushion for comfort, it was finally produced by Fritz Hansen in 1966.

In the 1960s, the rigor of Kjaerholm's earlier chair and chaise designs, whose legs were a minimal splay of metal slung with natural materials like cane, leather, canvas, or rope, took on jet-age springiness and a more curvaceous silhouette. Though associated with the austere functionalist style, Kjaerholm's designs had enough warmth and comfort to make them popular for domestic use.

■ Poul Kjaerholm's furnishings, manufactured by Fritz Hansen and distributed in the U.S. by ICF, brought Bauhaus style into the jet age. The splayed-leg chair in the upper right-hand corner dates from the mid-1950s; cantilevered spring bases came in 1967. The flat tufted bench is in the manner of Mies van der Rohe.

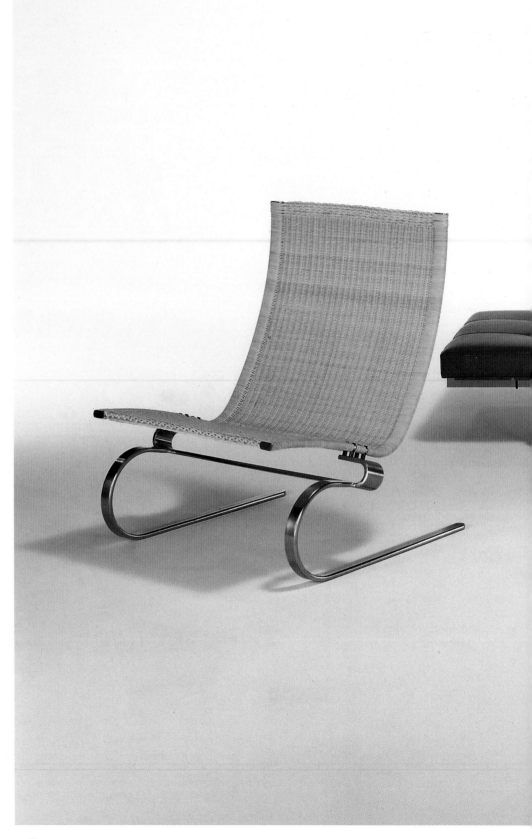

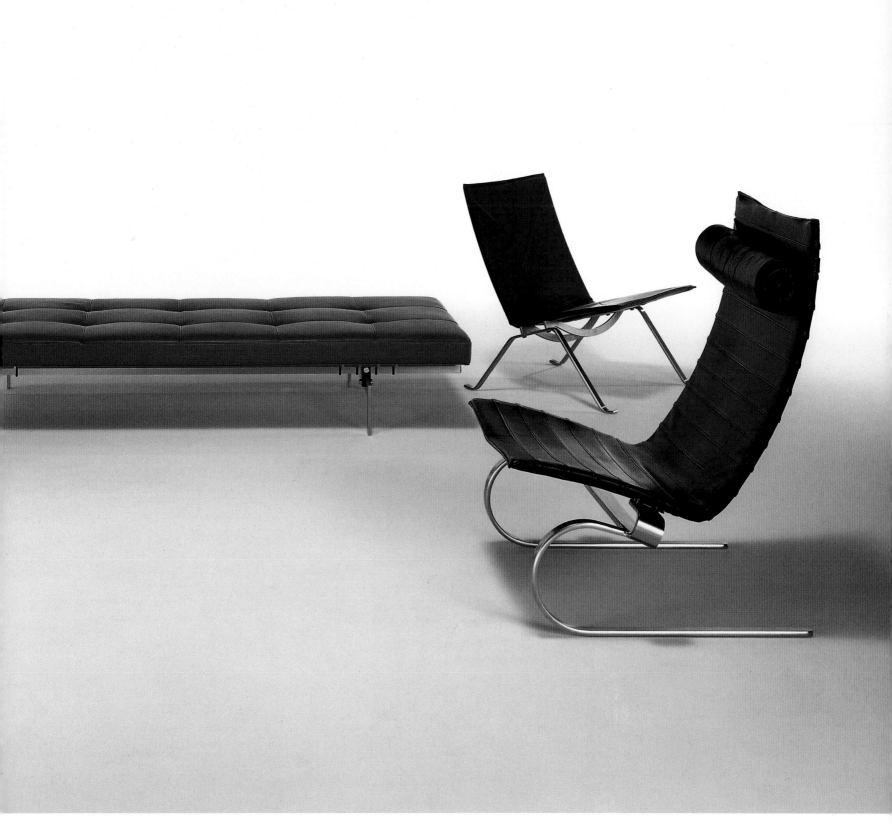

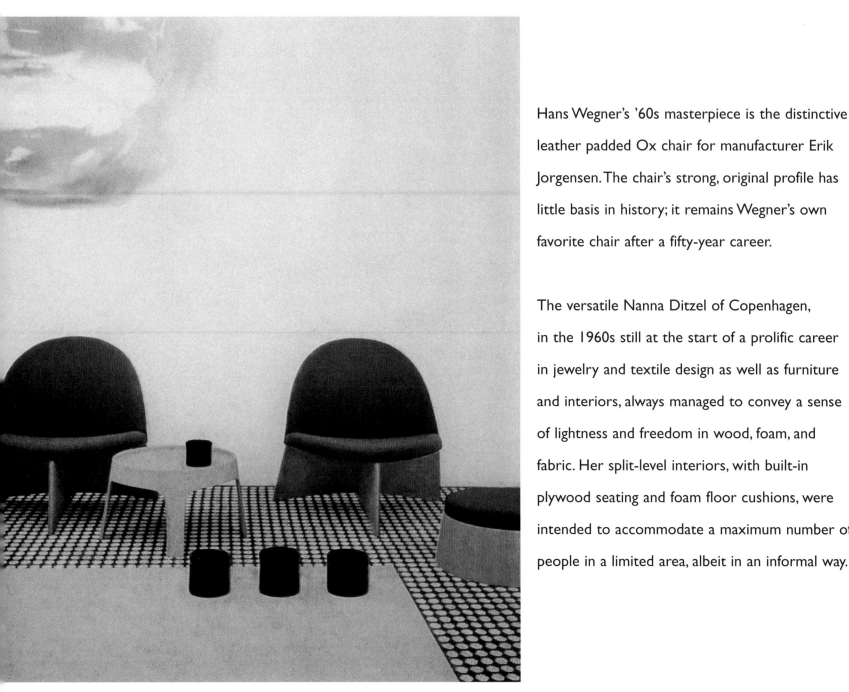

Hans Wegner's '60s masterpiece is the distinctive leather padded Ox chair for manufacturer Erik Jorgensen. The chair's strong, original profile has little basis in history; it remains Wegner's own favorite chair after a fifty-year career.

The versatile Nanna Ditzel of Copenhagen, in the 1960s still at the start of a prolific career in jewelry and textile design as well as furniture and interiors, always managed to convey a sense of lightness and freedom in wood, foam, and fabric. Her split-level interiors, with built-in plywood seating and foam floor cushions, were intended to accommodate a maximum number of people in a limited area, albeit in an informal way.

■ **Nanna Ditzel's split-level room, made by Poul Christiansen for an exhibition at Copenhagen's Museum of Applied Art,** **was playful Scandinavian Pop, with furnishings of laminated plywood and a polka-dot carpet.**

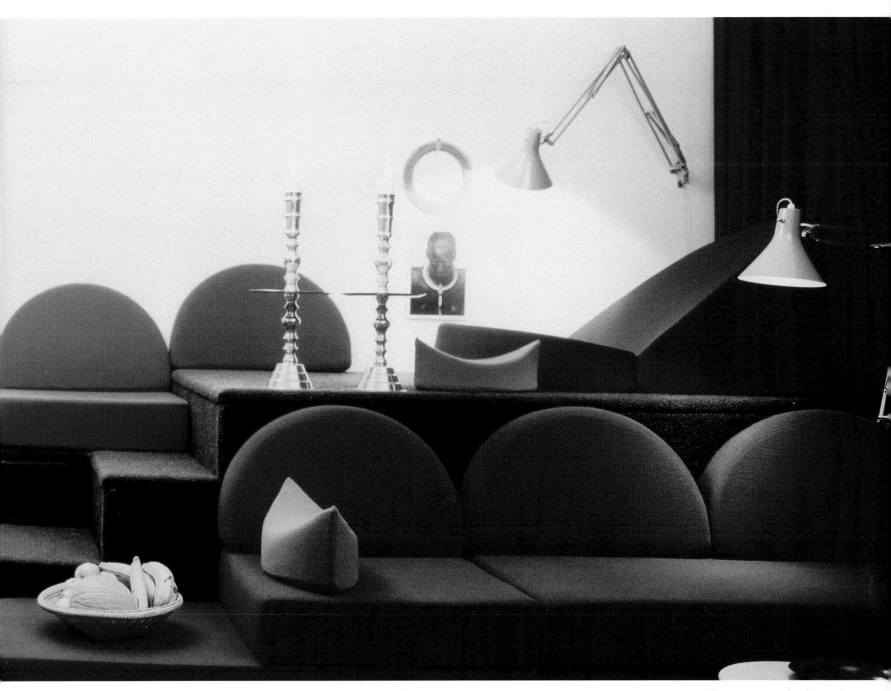

■ Fearless use of color and
floor-level foam seating at
Ditzel's own home in 1967
announced a charmingly
casual way of life.

■ "I received my education in a period when the only standard applied was function. To be sure, a chair is for sitting in, but it also expresses an age, eroticism, essence, human feelings, dreams." —Nanna Ditzel in *Nanna Ditzel Design*, Museum of Decorative Art (Kunstindustrimuseet), Copenhagen, 1994

Like many of Ditzel's furnishings, these wooden "toadstools" in a dreamscape environment were designed for children.

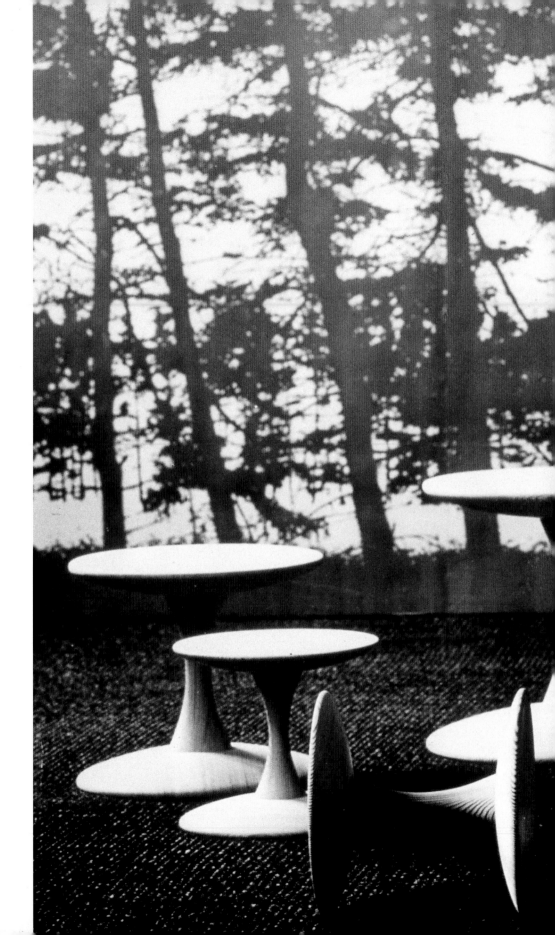

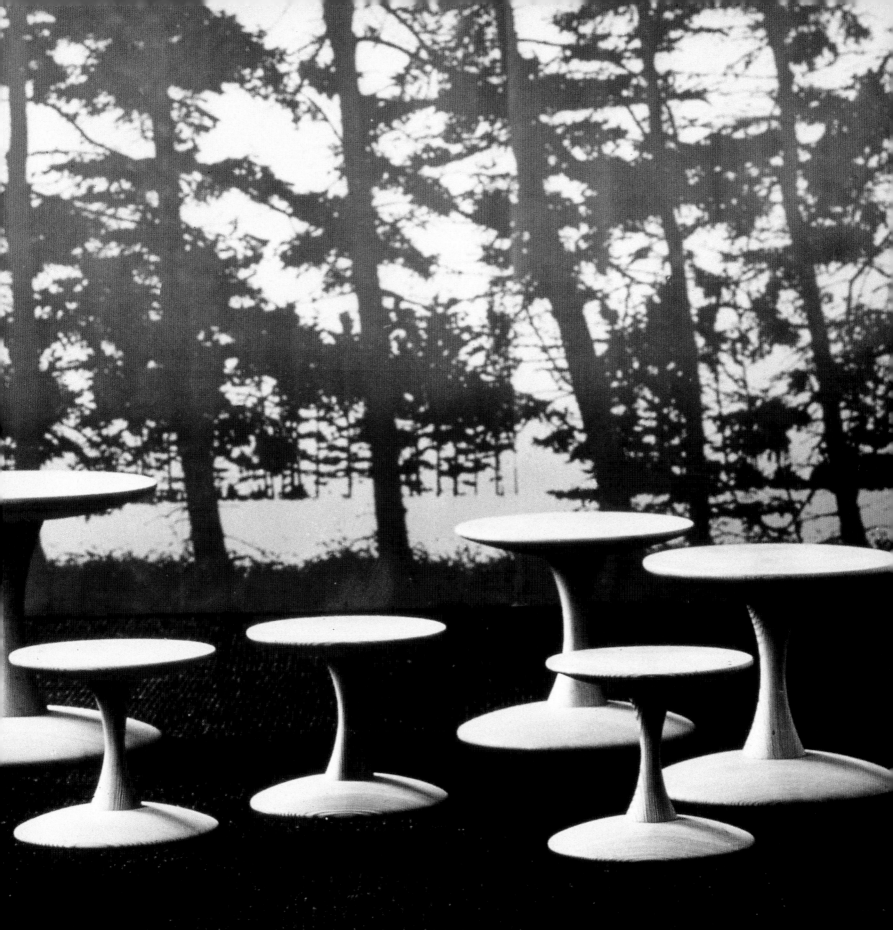

Scandinavian furniture by Wegner, Juhl, and others first came to this country through the efforts of a Polish-born American, George Tanier, who began importing it from Denmark in the late 1940s, later adding Finnish and other European designers to his roster. It was sold primarily through architects and designers from a showroom at Chicago's Merchandise Mart and agents in other cities; by the 1960s, retailers like Workbench in New York and Frank Brothers in California carried it as well. Tanier is generally credited with sparking the '50s and '60s Danish modern craze among American consumers (for which he was knighted by King Frederick IX of Denmark in 1967).

The Swedes excelled primarily in ceramics and glass-making in the 1960s, and the Finns in a range of decorative arts, from furniture to glass to textiles, leaving it to the Danes to be the foremost furniture makers and merchants. The clean, simple lines of the furniture produced in Danish factories, often of teak from the Philippines, were irresistible to imitators. Low-end spin-offs ate into the market as the decade progressed, somewhat sullying the style's reputation but never detracting from the brilliance of the real thing.

■ The crescent-shaped three-legged shell chair of 1963 is a rare instance of Hans Wegner choosing laminated plywood construction over solid wood.

■ Testing the Kevi chair (left) for strength. The widely copied Kevi (shown below in a Copenhagen square) by Jørgen Rasmussen was state-of-the-art in secretarial chairs when it was manufactured by Fritz Hansen and brought to the States by Knoll in 1970.

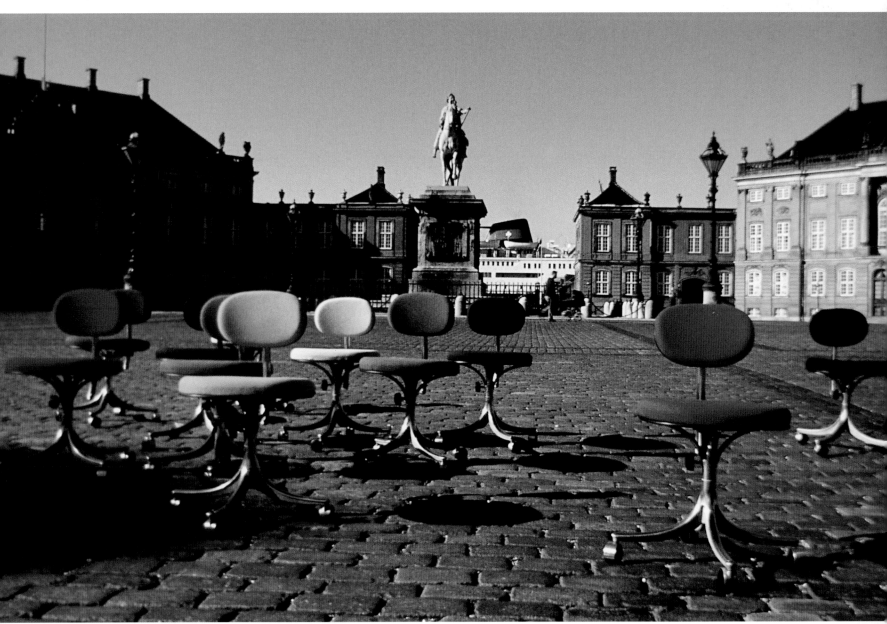

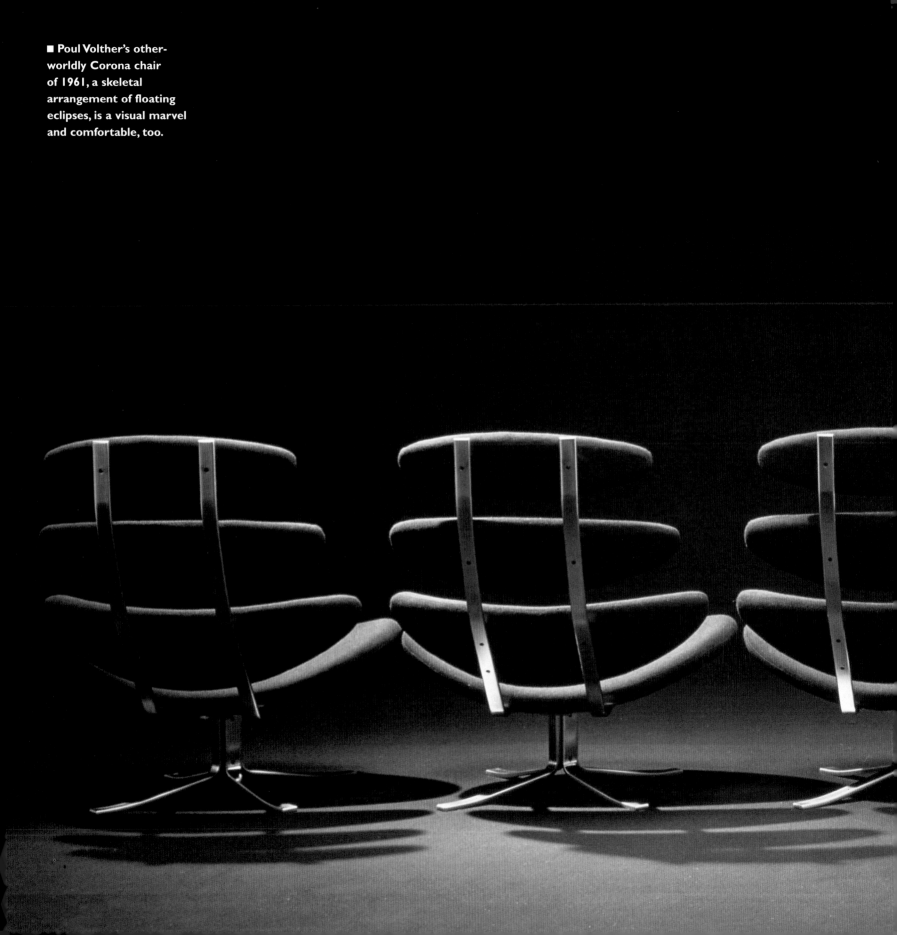

■ Poul Volther's other-worldly Corona chair of 1961, a skeletal arrangement of floating eclipses, is a visual marvel and comfortable, too.

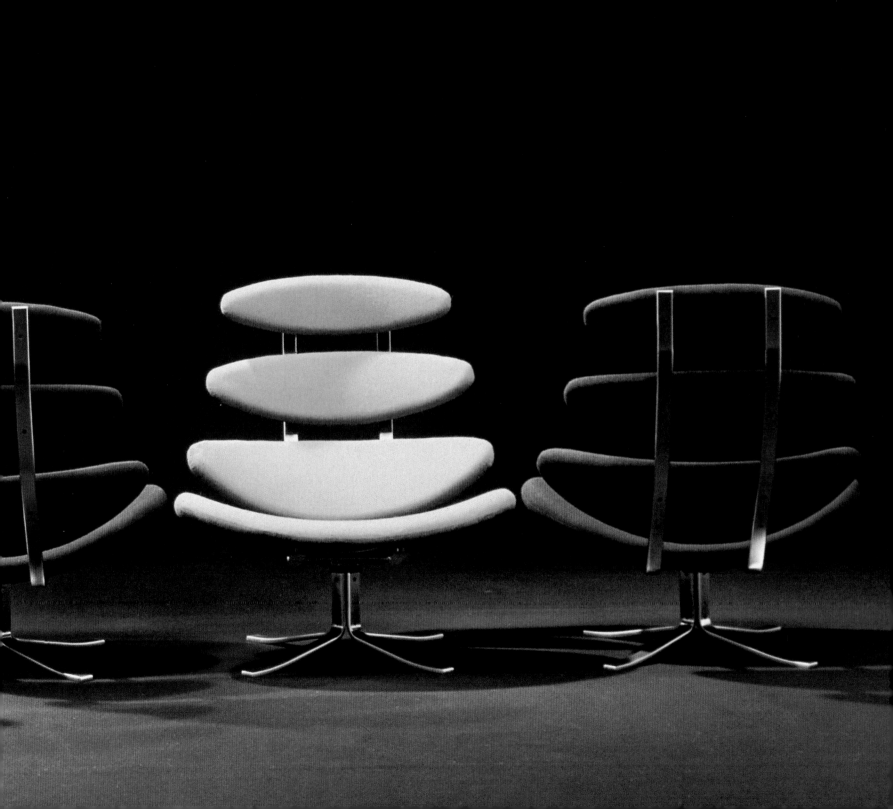

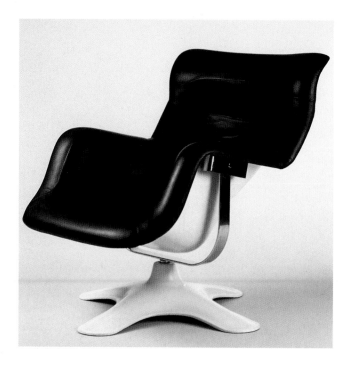

■ Yrjö Kukkapuro's 1965 Karuselli chair, with its singularly space-age aesthetic, was made by Finnish company Haimi-Oy in fiberglass with a gel coat.

■ Jørn Utzon's curvaceous 1969 lounge chair and footstool for Fritz Hansen was ambitiously large for a molded plywood–based design.

Tanier said his own list of top Scandinavian designs of the 1960s would include Poul Volther's otherworldly Corona chair for Erik Jorgensen; Jørgen Rasmussen's much-copied secretarial chair for Kevi; the Finn Yrjö Kukkapuro's unusually shaped Karuselli chair; Kjaerholm's wicker-and-steel chaise lounge, inspired, Tanier said, by Tito Agnoli's 1962 wicker chaise for Bonacina; and the dynamically modern work of Jørn Utzon, best known as architect of the seashell-like Sydney Opera House, for Fritz Hansen.

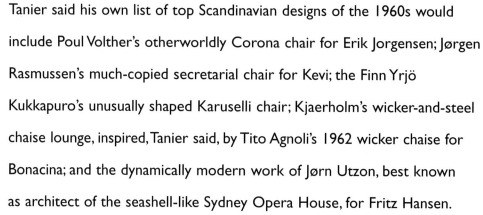

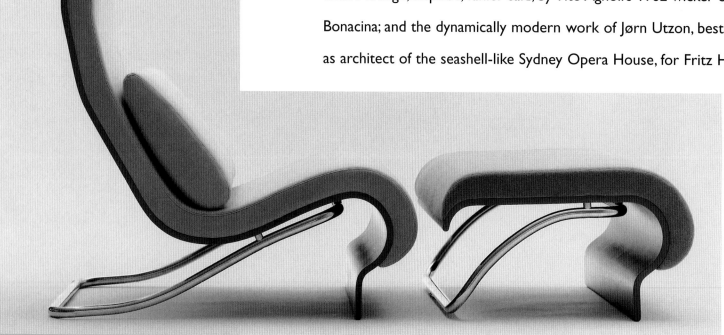

■ The 1968 Seagull
chair by Gosta Berg and
Stenerik Eriksson for
Fritz Hansen suggests
flight from the ordinary.

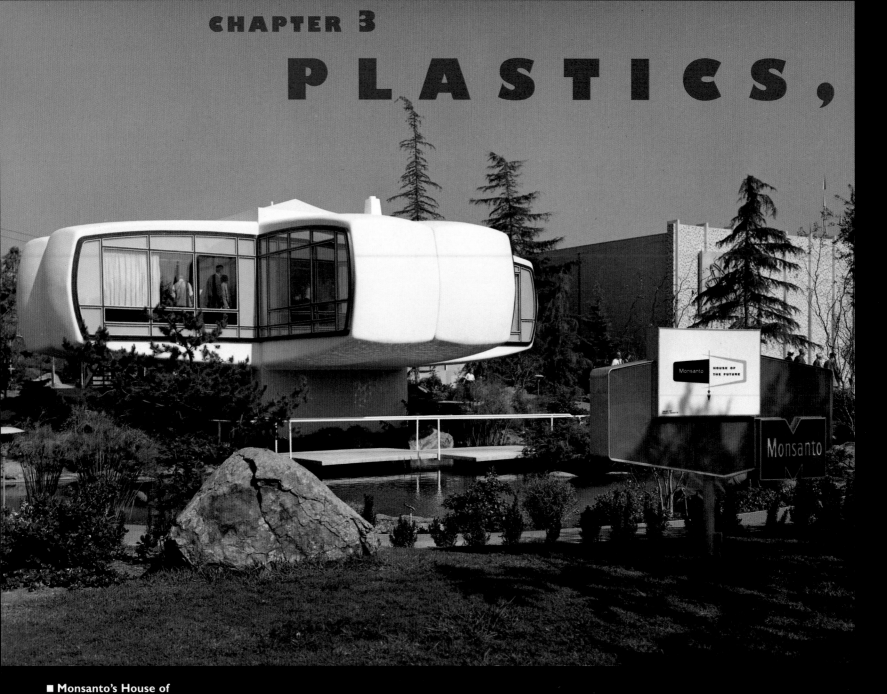

CHAPTER 3
PLASTICS,

■ Monsanto's House of
the Future at Disneyland
opened with the park in
the mid-1950s, a corporate
utopian vision of the world

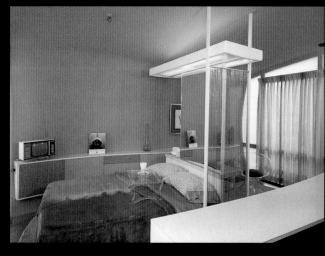

One of the biggest laugh lines in the 1969 film *The Graduate* had the young Dustin Hoffman taken aside by a friend of his father's, who advises, "I just want to say one word to you: plastics."

The chuckles came from general agreement. In the 1960s, plastics came into their own, and by the end of the decade, it seemed that the entire world would soon be made of them. Ever since the invention of the first plastics in the late nineteenth century, they had been regarded as a second-rate substitute for wood, but in the 1960s plastics finally got some respect—glorification, even. "Not a natural material anywhere!" crowed the literature for Monsanto's House of the Future at Disneyland when its interiors were redone, in 100 percent plastic, by Vladimir Kagan in 1962.

All through the 1960s, multisyllabic megamolecules from a booming

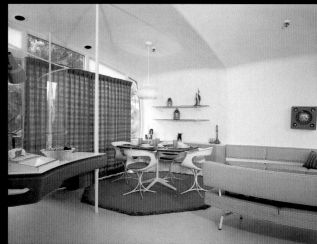

■ Vladimir Kagan reflected the glories of plastic when he redecorated Monsanto's House of the Future in 1962 with deep blue vinyl floors and man-made materials throughout.

(or lack thereof) were set aside. It was a very exciting time: furniture could now look like *anything*.

The properties of the new materials guaranteed innovation. A four-legged wooden chair looks the way it does largely because of the long tradition of building in wood. A plastic chair, however, could be a ball, a cube, a cone, an abstract shape. It could be hard or soft. It could have any number of legs, or none at all.

The '60s menu of synthetics went well beyond DuPont's Lucite of Art Deco days and the fiberglass-reinforced plastic shell chairs of the 1950s, in which you could see and feel the threads. Plastics in the 1960s were smooth, glossy, and light-reflecting, with many fine practical and aesthetic qualities: plastics perfected.

The big four

Four types of plastics, new or improved in the 1960s, were instrumental to the look of the decade:

Dense polyurethane foam rises like baking bread when two composite chemicals are mixed. It can be cut or molded, used over a frame or without supporting structure. One type of polyurethane foam forms its own smooth "skin." Foam took every guise, from monolithic slab to eccentric swirls like Nani Prina's foam lounges. Lightweight foam made possible the spate of sectional furniture that could glide effortlessly around a room.

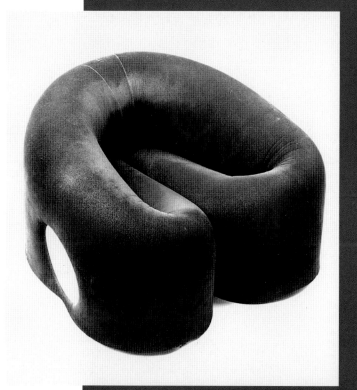

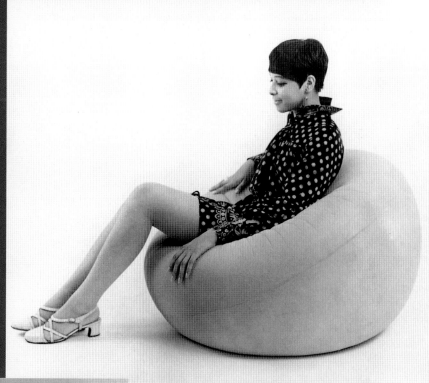

■ Polyurethane foam made possible shapes like the Volva 2 armchair (above), resembling a glazed donut, by Tinsley Galyean and Marc Hermelin for Design Media St. Louis.

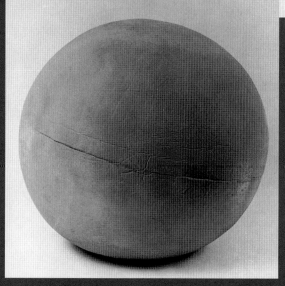

■ One size fits all: this utterly simple foam ball, called Orb, by Terrence Cashen for Design Media St. Louis, molded itself to the sitter.

■ Synthetics were clearly at home in this European interior, with its plastic-framed sofa and transparent acrylic coffee table (right).

■ Gianfranco Frattini's 1966 nesting tables for Cassina (below) were made of beechwood with plastic laminate tops. Kartell produced a nearly identical design entirely of injection molded plastic.

ABS (an "alloy" of acrylonitrile, butadiene, and styrene) is a rigid plastic that can be injection molded, the industrial process by which one-piece chairs and tables are stamped out in a single operation. ABS and injection molding are almost synonymous with Italy. No other country handled the material as well. Strong, light, glossy on both surfaces, and easily colored, ABS led to great fun in chairs, rolling carts, stacking units, small tables, lamps, and accessories, all of which were widely imported into the United States.

Acrylics had new strength and clarity; they could be as transparent as glass. In sheets that could be bent, cut, and folded, clear acrylics were a favorite plaything of '60 designers for their space-age look. They did tend to scratch, however.

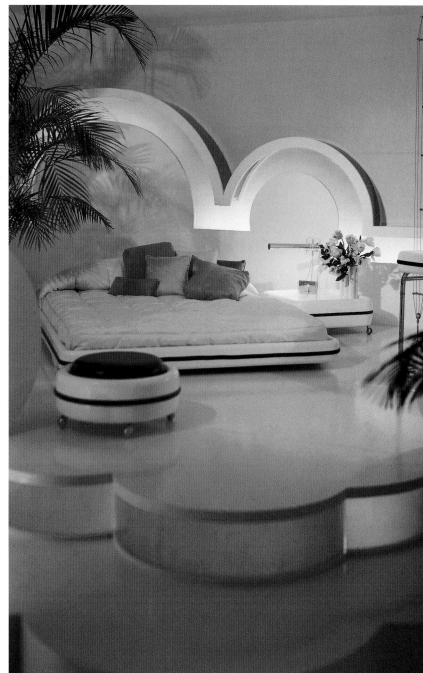

■ **Marc Held's lightweight desk (left) captured the ease and mobility prized in the '60s. A late-'60s model room at Bloomingdale's (above) featured Held's low-to-the-ground bed, night table, and ottoman. Transparent acrylic risers and soffits were used to produce dramatic lighting effects.**

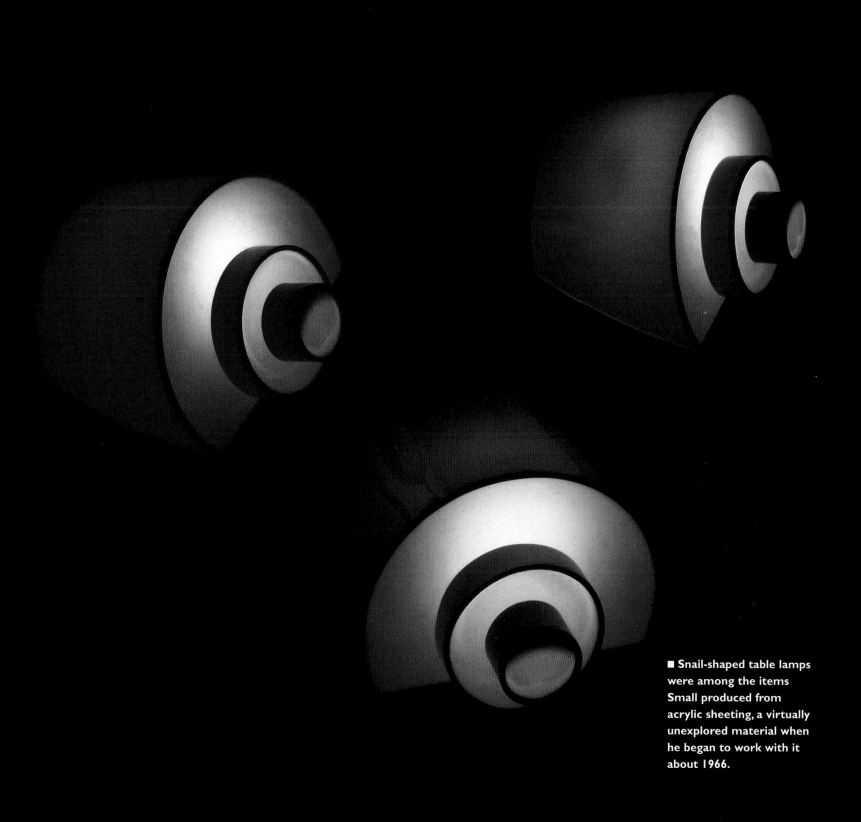

■ Snail-shaped table lamps
were among the items
Small produced from
acrylic sheeting, a virtually
unexplored material when
he began to work with it
about 1966.

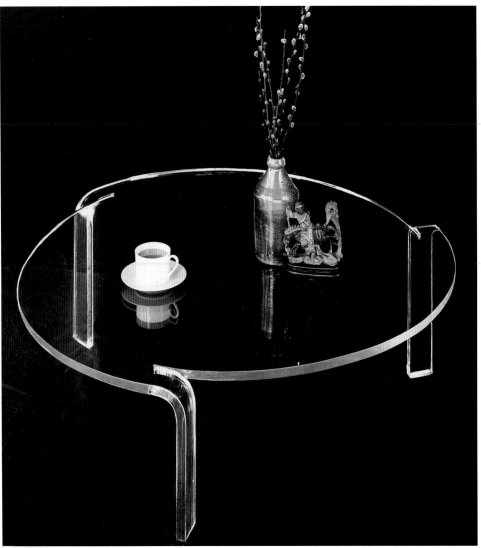

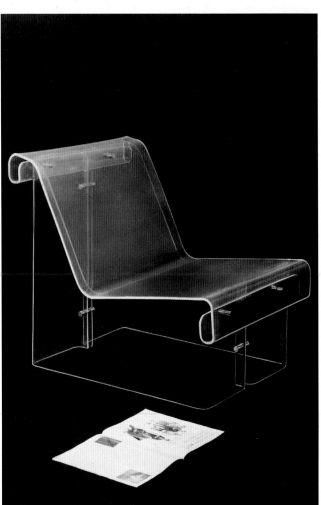

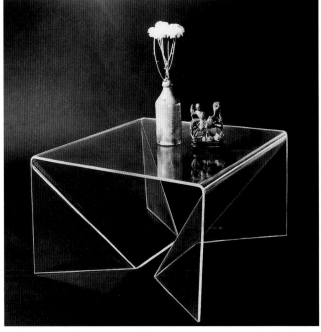

■ Neal Small's round table began with a tremendous, inch-thick piece of acrylic and retailed for about $600, a lot in its day.

■ This chair's seat is hot pink, bolted an inch above the clear acrylic base to provide some spring (above, right).

■ A more substantial version of Small's folded table (right) was a full 36" square.

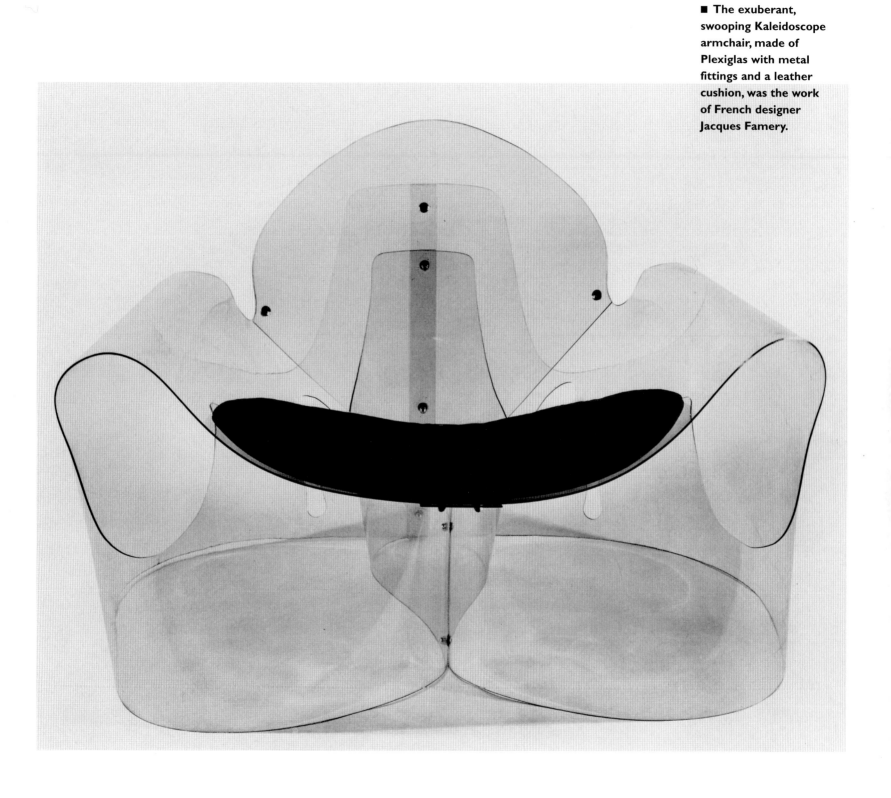

■ The exuberant, swooping Kaleidoscope armchair, made of Plexiglas with metal fittings and a leather cushion, was the work of French designer Jacques Famery.

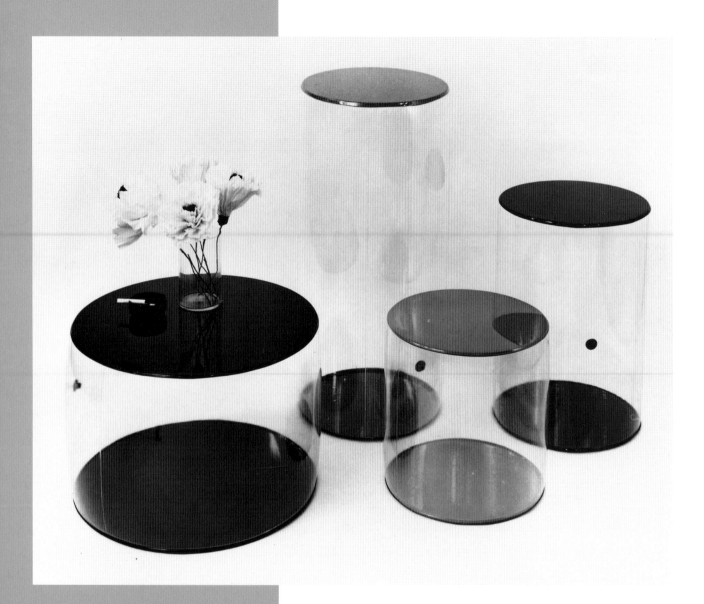

Polyvinyl chloride (PVC) is a flexible film, available opaque or transparent.

It can be cut, glued, heat formed, used to cover a surface, or, as was

famously discovered in the 1960s, filled with air.

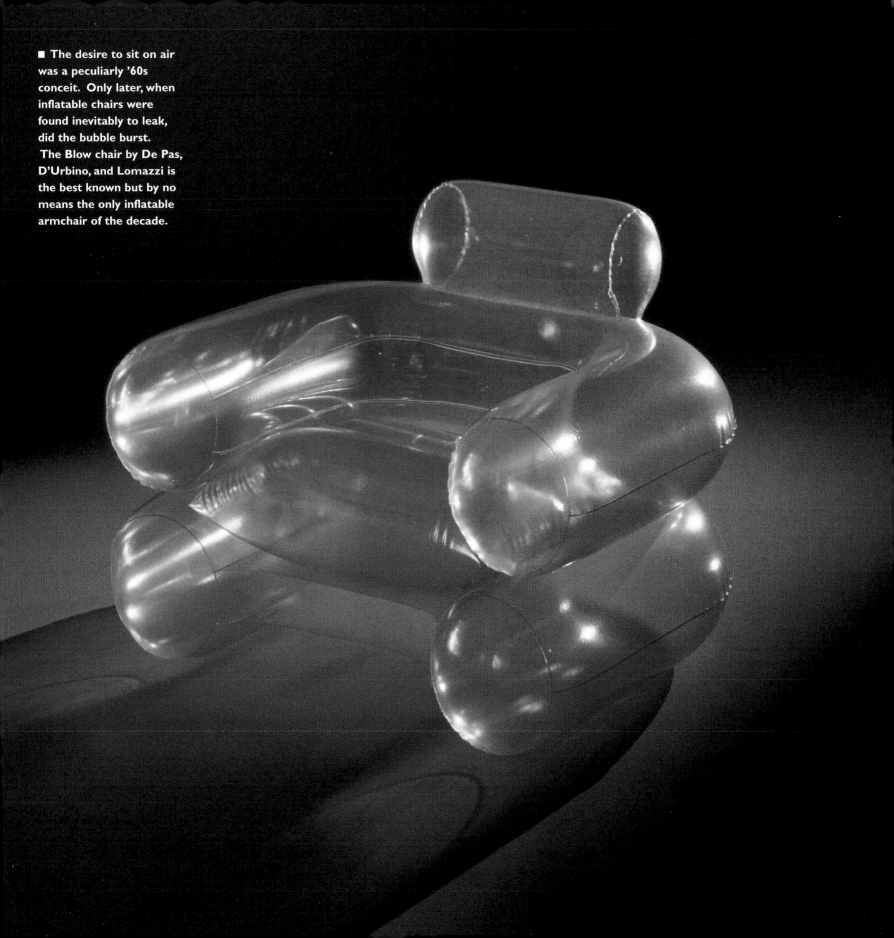

■ The desire to sit on air was a peculiarly '60s conceit. Only later, when inflatable chairs were found inevitably to leak, did the bubble burst. The Blow chair by De Pas, D'Urbino, and Lomazzi is the best known but by no means the only inflatable armchair of the decade.

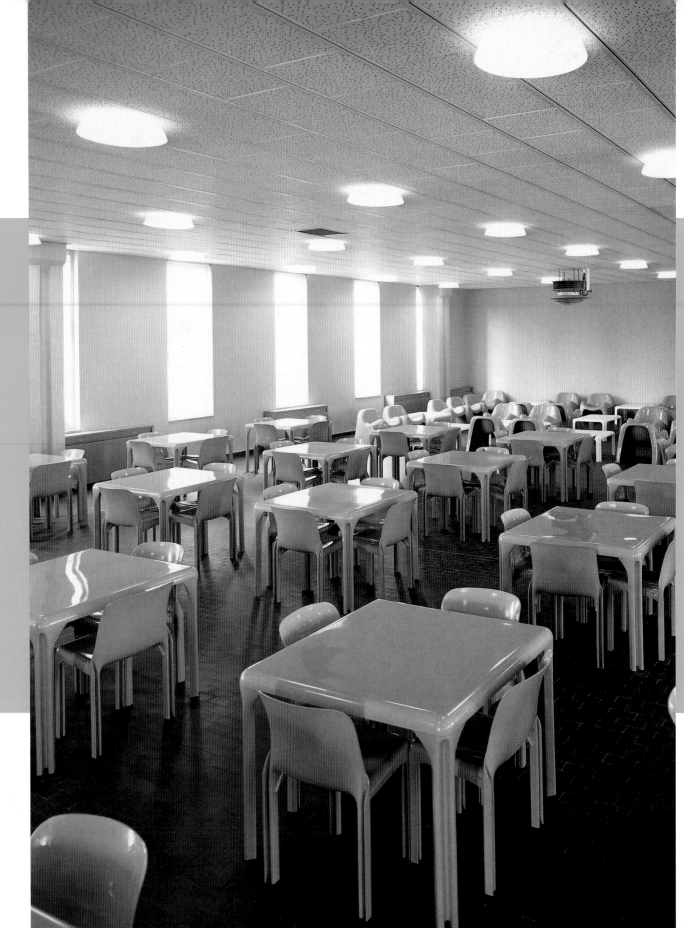

■Vico Magistretti's injection-molded plastic chairs and tables for Artemide were an unqualified success as industrial design. Their functional elegance won design recognition worldwide.

VICO
MAGISTRETTI

■ Magistretti's many
designs for Artemide—
including the 1969 Selene
chair and 1970 Stadio
table (above), and 1971
Vicario chair and low
Mezza tessera table
(left)—had a silky,
luxurious quality despite
their industrial origins.

Pricey plastics

The original idea in the '60s was that volume production of plastic furniture would bring the unit price down so that great numbers of people could afford to buy it. This rarely proved to be the case.

In more recent times, of course, plastics have been extraordinary successful. The inexpensive garden chairs you can get almost anywhere are the offspring of '60s experiments in plastic injection-molding.

But in their own day, the expenses of tooling up and shipping, and a conservative buying public, kept many '60s plastic designs in limited distribution and high price range. Exceptions included Robin Day's polypropylene shell chair of 1962 for the British Hille & Co., which found a high-volume contract market and reached the consumer at an affordable price (about $17), as well as the general category of smaller, easy-to-ship, injection-molded furnishings and housewares, mostly made in Italy of ABS, for which there was a healthy demand in the United States.

Fifties tastes had ensured a ready audience for the wood craft of Scandinavian modern furniture. The '60s consumer, with ever shrinking living space and an eye attuned to Pop Art, responded even more enthusiastically to the colorful chairs and stacking storage units produced by Italian companies like Kartell, Artemide, and Bellato/Elco that gave the buyer a flexible system at relatively low cost.

■ Glossy plastic seats in a variety of colors jazzed up this 1969 tubular-steel stacking chair by Rodney Kinsman, a British designer.

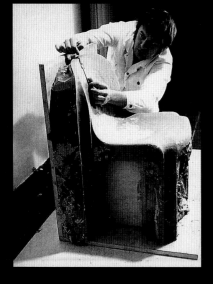

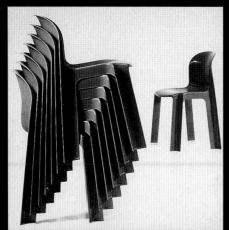

■ Eero Aarnio (above)
molding a chair form
in clay. When stacked,
the finished chairs (right)
create their own rhythms.

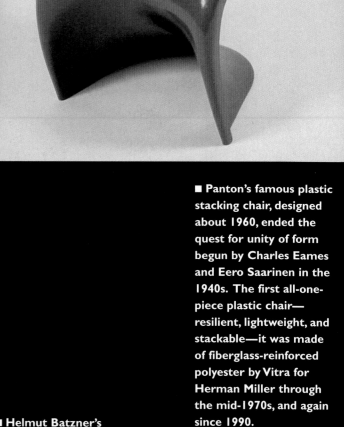

■ Panton's famous plastic
stacking chair, designed
about 1960, ended the
quest for unity of form
begun by Charles Eames
and Eero Saarinen in the
1940s. The first all-one-
piece plastic chair—
resilient, lightweight, and
stackable—it was made
of fiberglass-reinforced
polyester by Vitra for
Herman Miller through
the mid-1970s, and again
since 1990.

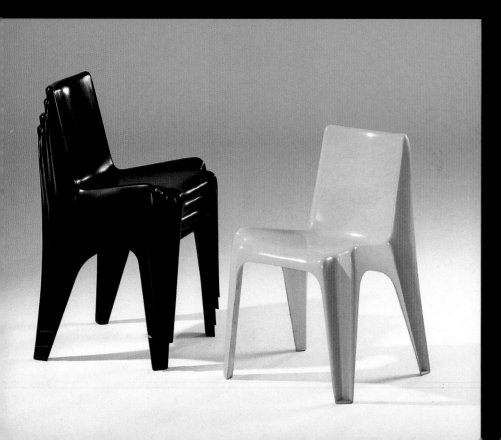

■ Helmut Batzner's
Bofinger chair, introduced
in 1966, is the first
one-piece plastic chair
brilliantly suited to mass
production. Compression
molding of the fiberglass-
reinforced polyester resin
chair took all of five minutes

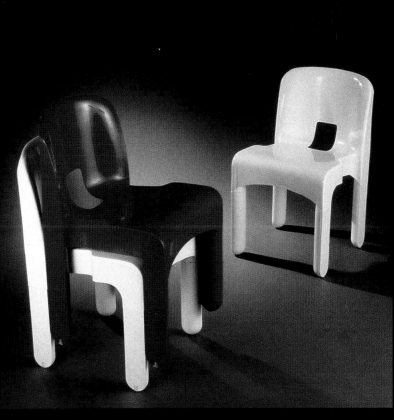

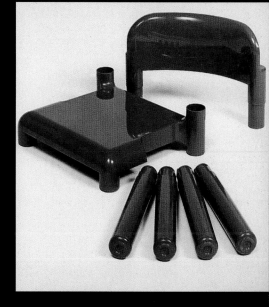

■ Joe Colombo's Universale stacking chair for Kartell (left), common since its debut in 1967, is still one of the sturdiest, most comfortable plastic chairs ever. An Aarnio design for a knock-down plastic chair (right).

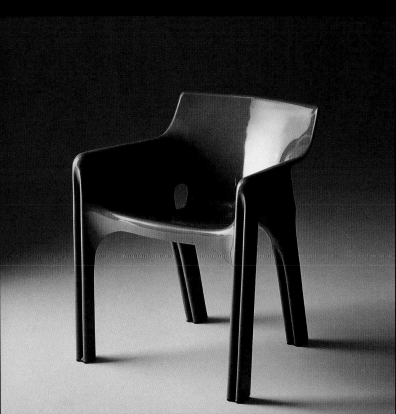

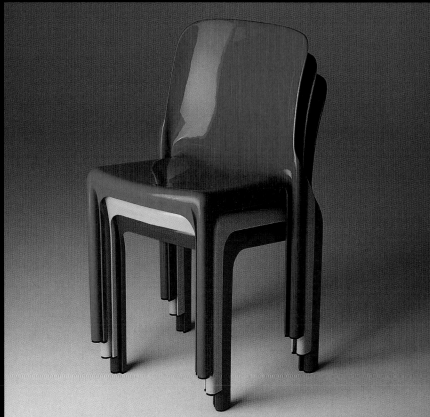

■ Vico Magistretti's Gaudi (left) and Selene chairs (above) came in a vivid array of colors.

George Beylerian, an importer and manufacturer of Italian plastics in the 1960s, is the main reason such pieces were as ubiquitous as they were in the United States. In 1966, he began importing the output of the Milanese company Kartell, including Joe Colombo's Universale stacking chair with detachable legs, Anna Castelli Ferrieri's round sliding-door units, and Englishman Simon Fussell's stacking drawers.

Beylerian set up boutiques within Macy's and Bloomingdale's, the first time the store-within-a-store concept had been tried. From 1964 to 1973, he also purveyed sculptured mirrors by Verner Panton; Pop graphics by Milton Glaser, Seymour Chwast, and others; and home furnishings by Italian greats, including Gae Aulenti and Marco Zanuso, from a retail store called Scarabaeus a stone's throw from Bloomingdale's.

■ In 1968, the New York showroom of Beylerian, Ltd. demonstrated a variety of configurations for Simon Fussell's plastic stacking drawers.

Still, Beylerian had the field of Italian plastics nearly to himself each year at the High Point Furniture Market in North Carolina. When the petrochemical crisis of 1973 caused raw material prices to skyrocket, rising costs prevented furniture designers from exploring still-latent possibilities in plastic. Beylerian and others shifted gears, and a glorious era in plastics was over.

■ Beylerian's showroom was the New York outpost
for a wide range of Italian plastics, some imported,
some manufactured in South Carolina under
licensing agreements with Kartell and others.

CHAPTER 4
WELCOME TO
THE FUN HOUSE

Optimistic, celebratory, free from the constraints of the past, Pop Art exploded on the American landscape (*POW! BANG!* in the words of a Roy Lichtenstein painting) with a 1962 exhibition, *New Realists,* at Sidney Janis's New York gallery. The new movement aroused tremendous indignation among defenders of mainstream culture for the way its practitioners—led by Lichtenstein, Andy Warhol, James Rosenquist, Tom Wesselmann, and others of the New York school—appropriated advertising, media, and comic-book imagery into the language of fine art.

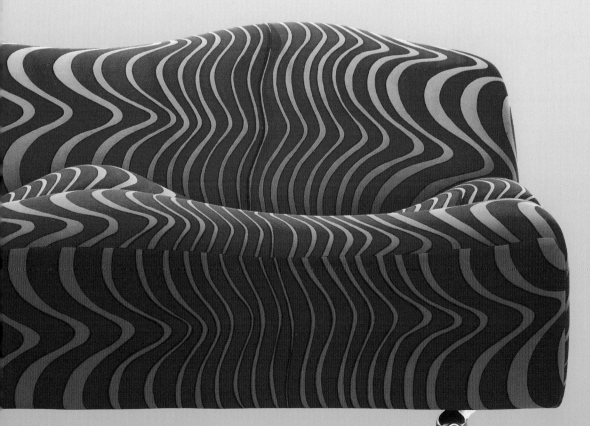

■ Individual fiberglass seating shells, upholstered with polyurethane foam, formed the basis of Pierre Paulin's 1968 ABCD system for the Dutch company Artifort. Here, three units are linked to form a wavy sofa.

Pop Art's intention, and its effect, was to transform the crass realities of consumer culture. "What pop art has done for me is to make the world a pleasanter place to live," architect Philip Johnson told William Zinsser for a mid-1960s magazine essay. "I look at things with an entirely different eye—at Coney Island, at billboards, at Coca-Cola bottles . . . it's fun to go into a supermarket now."

Pop Art provided a longed-for antidote to the tyranny of good taste. Its audacity was contagious, and furniture designers caught the bug. The emphatic color, exaggerated scale, and tongue-in-cheek attitude of much '60s furniture owe a huge debt to Pop Art painters and to the soft sculptures of Claes Oldenburg, which made mundane industrial objects adorable.

■ **"It used to scare me when I came home at night,"** designer Olivier Mourgue has said of his anthropomorphic 1968 chaise, called Bouloum, after a childhood friend. Still in production by Arconas Corporation of Canada.

But what is Pop furniture?

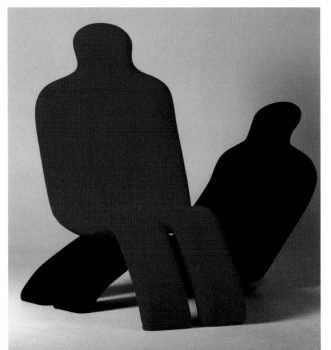

There is no official definition of Pop furniture; it's largely a subjective matter. "Fun" may be about as close as one can get. A perfect Pop piece is Olivier Mourgue's anthropomorphic "man" chaise, light enough to sling under one arm. It's got personality; it's good-humored, jolly, and bold.

In Pop furniture, some of the most cherished ideas of the chair are gone, such as that it must have identifiable parts called *seat, back, arms, legs*. In 1956, Eero Saarinen had attempted to "clean up the slum of legs" with his pedestal group for Knoll. In the 1960s, the absolute requirements for *chair*

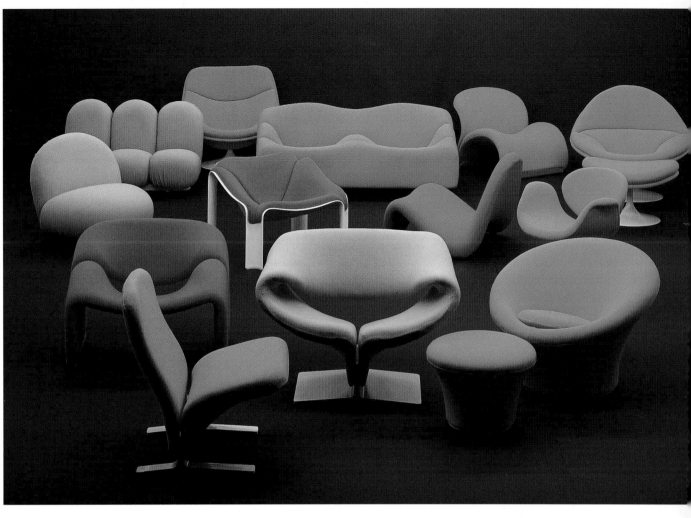

■ Paulin's late-'60s
production for Artifort—
the Mushroom, the Ribbon,
et al.—are sculptural to
look upon and soundly
ergonomic. Constructed
of polyfoam over a tubular
metal frame, they were
upholstered in period
colors like magenta, kelly
green, pumpkin, and ocher.

were further reduced. A chair could be Verner Panton's wire cone

balancing on a pinpoint or Pierre Paulin's sideways S.

A recurring motif in Pop furniture has been the human anatomy.

A graceful mahogany chair carved in the shape of a human hand by

Mexican artist Pedro Friedeberg is an early icon of Pop, an idea soon

knocked off in many plastic variations. Wendell Castle, an American

conceptual artist and worker in wood, playing around in the late 1960s with

colorful plastics, used a human molar as inspiration for a series of chairs.

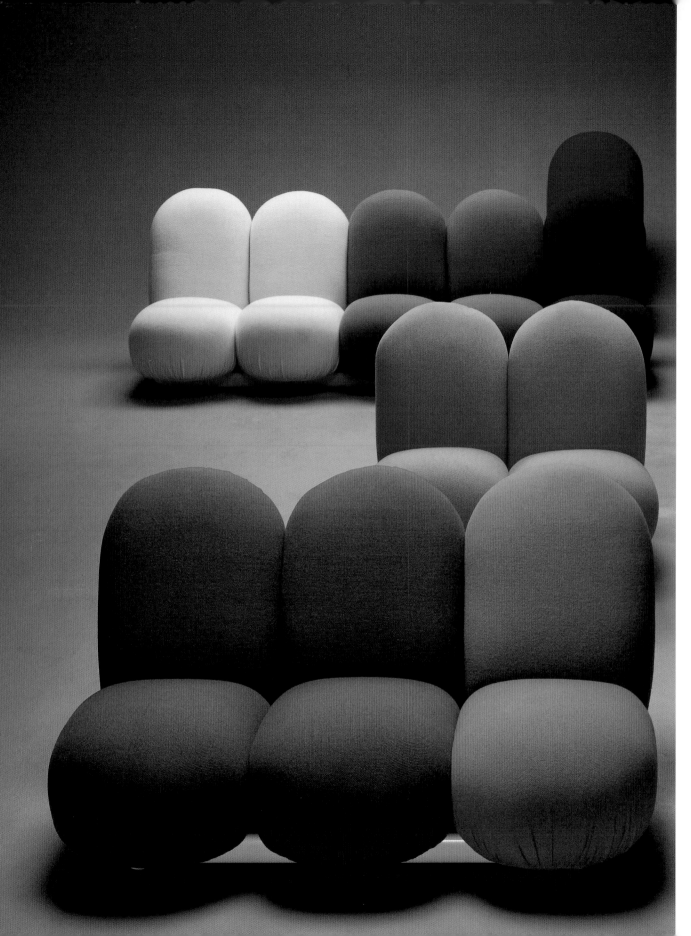

■ Paulin's multicolored seating units for Artifort have a cartoon-like simplicity characteristic of Pop furniture.

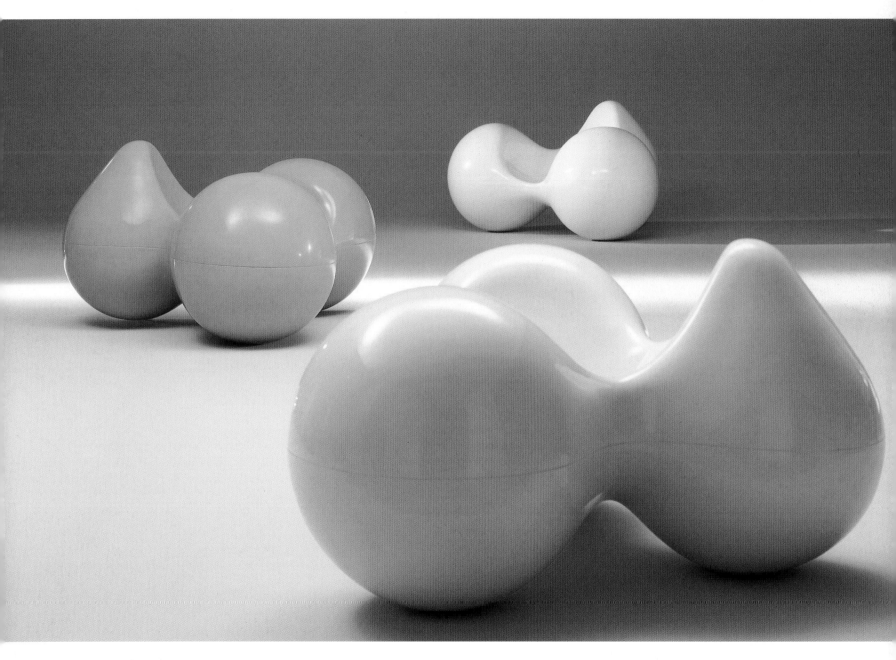

■ The indestructible fiber-
glass Tomato chair of 1971
was Eero Aarnio's most
dramatic silhouette yet.

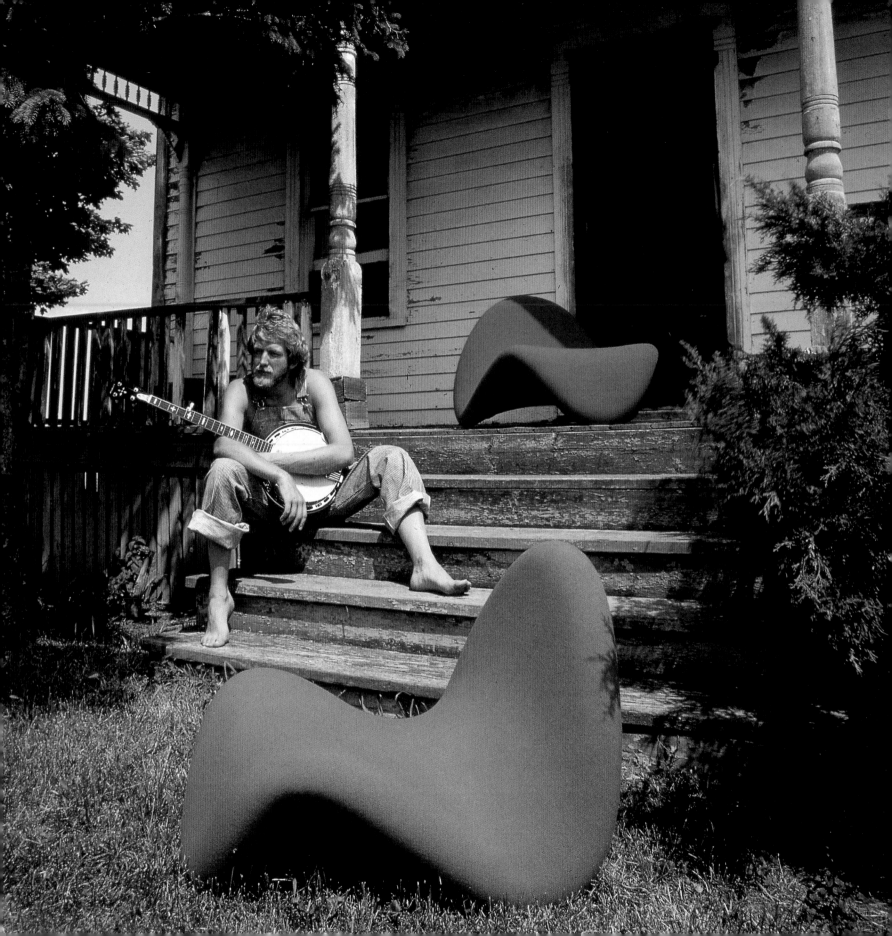

■ Artifort appealed to Woodstock Nation in this advertisement for Pierre Paulin tongue chairs.

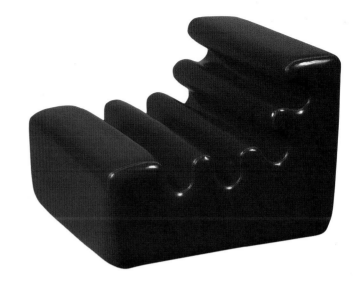

■ Squiggles lent strength to Lijsi Beckmann's 1966 sag-proof Karelia chair (top) for Zanotta, made of dense polyurethane foam. Bernard Rancillac's 1966 fiberglass Elephant from France (above) and Jan Ekselius's 1970 Jan chair and footstool (right), foam-upholstered steel from Sweden, show that sinuous shapes made possible by new materials were an international idea whose time had come.

■ Fundamental shapes brought to the States by Stendig: the all-foam 1969 Mozza, or Drum, lounge chair (left) by Giuseppe Raimondi for Gufram, and the molded-foam Digit system by Virgil Forchiassin (below), which could be extended to any length.

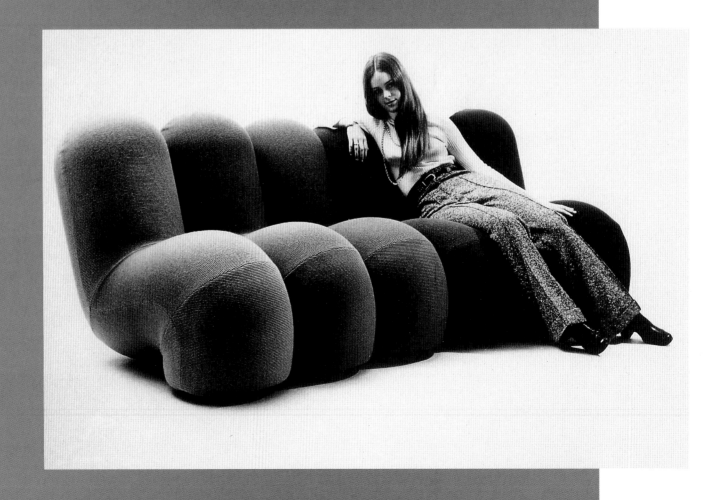

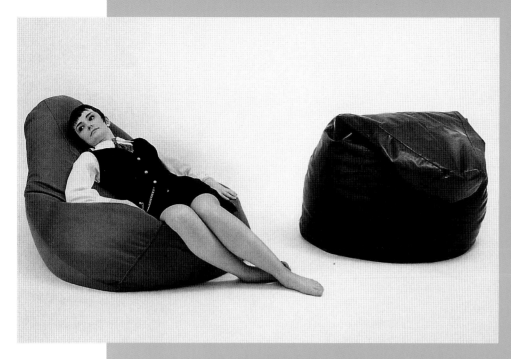

■ Stendig was the first to import the 1969 bean bag by Piero Gatti, Cesare Paolini, and Franco Teodoro, but he lost exclusivity and never actually sold the piece.

■ The Wedge by Piero de Rossi for Gufram, a 1969 lounge chair with an arched front, conformed to the shape of the sitter.

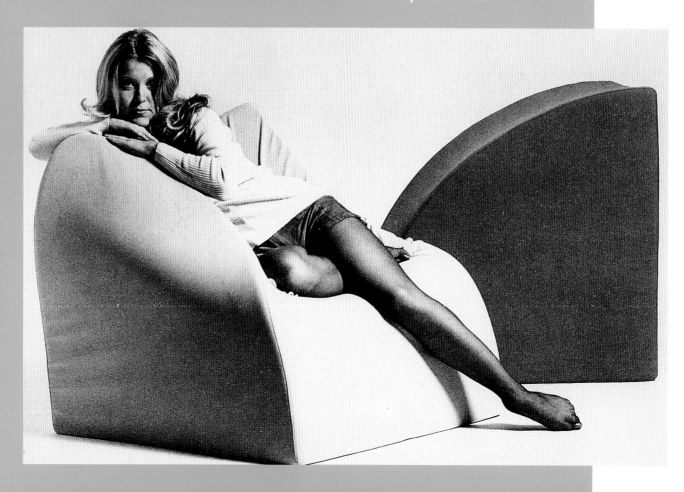

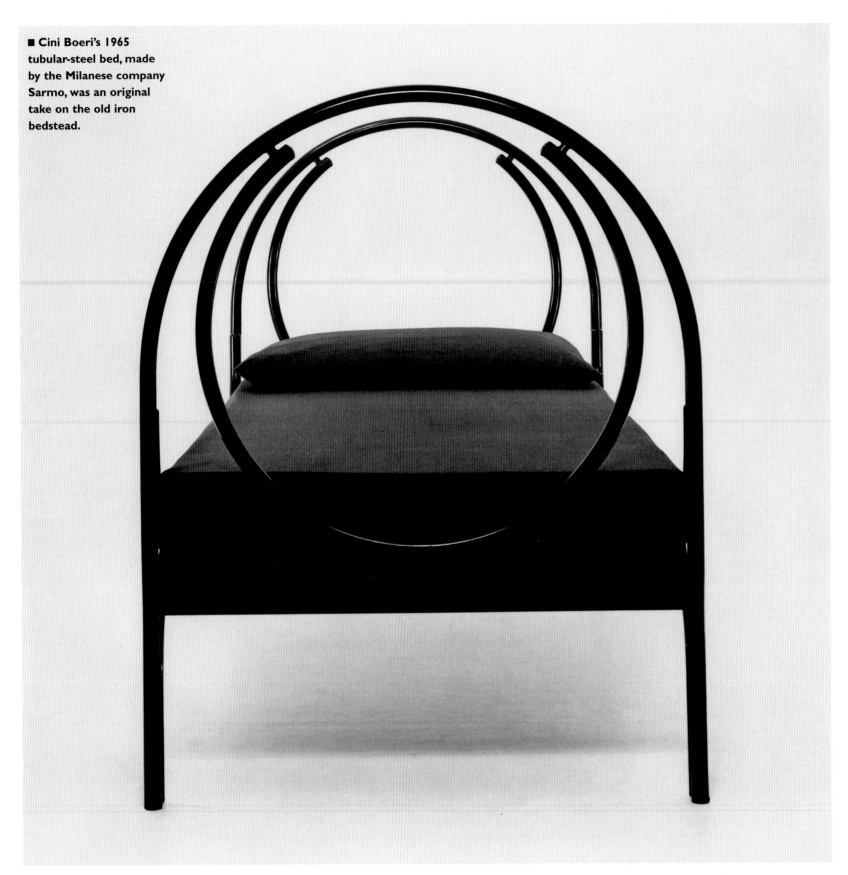

■ Cini Boeri's 1965 tubular-steel bed, made by the Milanese company Sarmo, was an original take on the old iron bedstead.

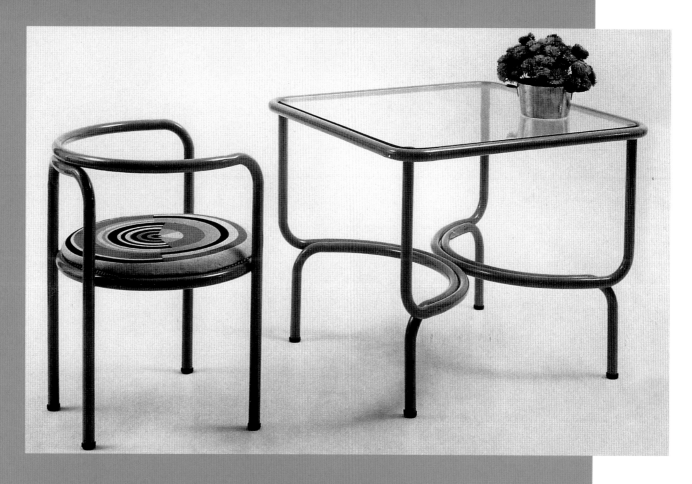

■ Locus Solus, Milanese
architect Gae Aulenti's
1964 line of indoor/
outdoor tubular-steel
furniture for Poltronova,
came enameled in jolly
colors like yellow, orange,
and apple green.

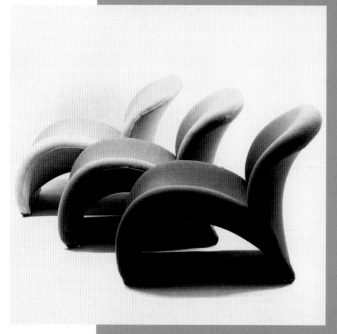

■ This jaunty low chair for
Artifort was designed by
Pierre Paulin, who was
instrumental in devising
the foam-upholstered
tubular-steel frame,
covered with tight-fitting
stretch fabric, that allowed
infinite sculptural varia-
tions on a theme.

Gaetano Pesce's oversize foot, an allusion to the bygone glories of ancient Rome, made up the odd seventh member of his 1969 UP series.

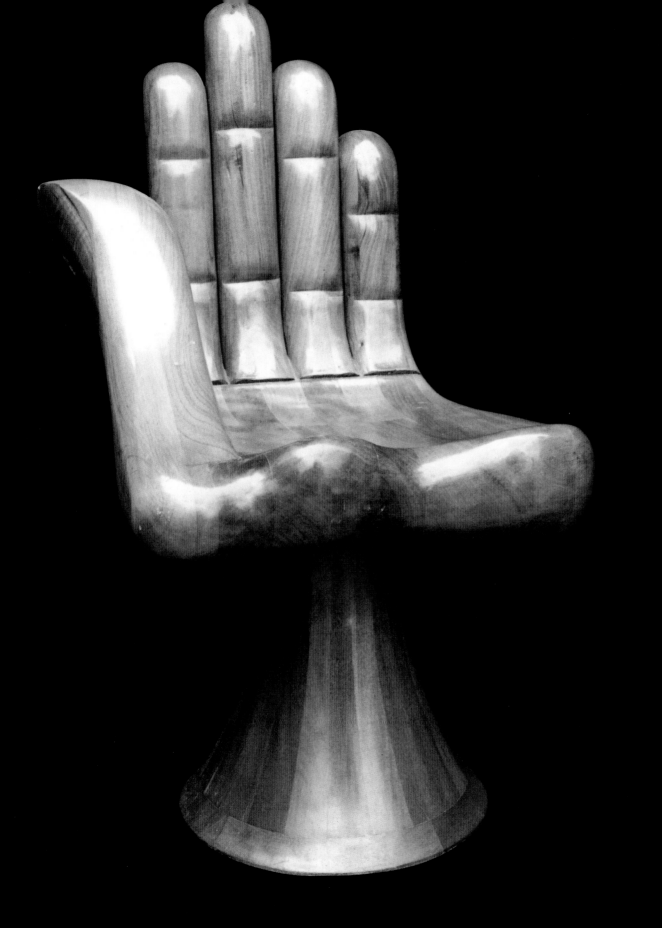

■ When Pedro Friedeberg of Mexico City, an artist and creator of satirical fantasy furniture, lit upon the human hand as a suitable chair form in 1962, he created a Pop icon in mahogany.

Bauhaus turnabout

Though Pop Art was primarily an American phenomenon, it found its fullest furniture expression in Italy, where an informal new style of life was replacing age-old tradition and there was some semblance of prosperity after decades of privation. The new Italians were described by Ettore Sottsass at a 1987 conference at New York's Metropolitan Museum of Art as "the young, modern, optimistic, aggressive, excited, spreading middle class, ready to take possession of everything that could be offered by a modern industrial culture"—in other words, ready for whatever designers could dish out.

One offering that became a virtual symbol of the decade was the 1968 Sacco (bean bag) chair by Piero Gatti, Cesare Paolini, and Franco Teodoro, a vinyl pouch filled with polystyrene pellets. This most amorphous seating piece brilliantly mocked the basic tenet of modernism. Form still followed function, but not in the way the Bauhaus founders had intended. The original notion was that the proper form for something would emerge in the design process. Yet here is a chair whose form changes with each shift of the occupant's position—a design process that never ends.

Pop furniture often required the participation of the user. Inflatable chairs cannot exist without it. Gaetano Pesce's UP series of foam seating pieces, vacuum-packed for shipping, literally sprang to life upon opening, making the consumer part of an at-home art "happening."

Flexible function was another Pop hallmark, exemplified by such pieces as Alessandro Becchi's three-position Anfibio sofa-bed, and the outpouring of upholstered foam sectionals that could be rearranged at whim, like Roberto Sebastian Matta's puzzlelike seating for Knoll.

Saner than it looks

For all its flash and whimsy, most Pop furniture was rational, functional, and ergonomic, carefully considering the human form. Pierre Paulin's inviting mushrooms for Artifort are still in production after all these years because they *work*. Richard Sapper and Marco Zanuso's plastic injection-molded child's stacking chair of 1964 can be seen as Pop because of its amusing shape and lipstick red color, yet it was the result of three years of experiment and refinement.

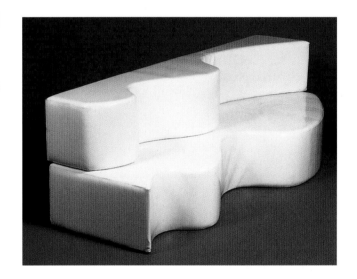

Foam, often upholstered with newly available stretchy fabrics like Helenca, developed for skiwear, was a defining material of Pop furniture. It made possible the sensuous shapes of Paulin and Mourgue, though Pop sensibilities could be captured in all kinds of materials, including shiny vinyl. Willy Landels's inexpensive Throwaway sofa and Archizoom's Superonda were meant to be somehow disposable—a brash '60s concept that alone qualifies them as Pop.

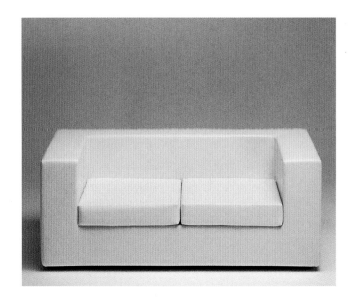

Color breakout

■ Verner Panton's
phantasmagoric foam
environment for Visiona II,
the Bayer company's
exhibition at the Cologne
Furniture Fair in 1970,
was like a psychedelic
light show in three
dimensions. Visitors said
they felt like Jonah in the
belly of the whale.

Thanks, too, to Pop Art for opening up the way color was used in the 1960s. A decade earlier, Herman Miller's Alexander Girard had been forced to seek furnishings fabrics in Macy's basement, the only place he could find bright colors instead of the conservative neutrals that then prevailed in the contract industry. "In those days," Girard recalled in *The Design of Herman Miller,* by Ralph Caplan, "a brilliant pink or magenta carried a connotation of double-barreled horror."

Not so in the 1960s. First to appear were the kindergarten primaries of a Lichtenstein comic strip. Italian manufacturers such as Kartell and Artemide used Pop painting's clear colors: red, yellow, green, orange, and white (the black of the 1960s). Later in the decade, more sophisticated combinations came into play—like navy, brilliant green, and pumpkin for Knoll's 1968 edition of the Matta Malitte.

Things only got wilder from there. Verner Panton's cut-foam environment for *Visiona II,* an exhibit for Bayer AG, the German chemical company, at the 1970 Cologne Furniture Fair, was a riot of turquoise, magenta, indigo, red, and orange. In George Tanier's opinion, *Visiona II* "established the way color was used for the next two decades."

Good vibrations

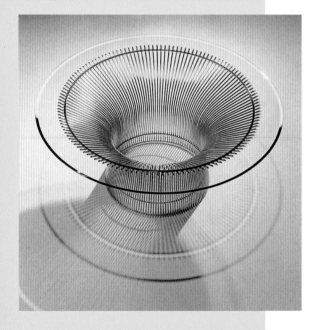

■ The steel rods of
Warren Platner's 1966
wire group tables and
chairs for Knoll create
intriguing moire-like
patterns of light and
shadow.

Op Art, a jazzy offshoot art movement that had its day in the mid- to late 1960s, appeared on everything from building facades to shopping bags. Op (for "optical") Art explored the visual phenomena that occur when patterns of shapes and color result in sensations of movement and vibration. Many of Op Art's kinetic tricks were conceived by Victor Vasarely, a Hungarian-born painter and art dealer who, for a few years in the 1960s and 1970s, had a small empire that included a gallery on New York's Madison Avenue and a museum in Gordes, France.

Op Art was primarily two-dimensional, affecting graphics and textiles more than furniture, but Op Art fabrics, usually black-and-white, perked up many an upholstered piece. It was a strong influence on the interior design schemes of Verner Panton, some of which positively vibrated from floor to ceiling.

Op fascinated everyone, for a time. But if there's a single foundation of '60s design, it's Pop. Other design developments of the decade all borrowed liberally from Pop's provocative essence and brazen challenge to convention.

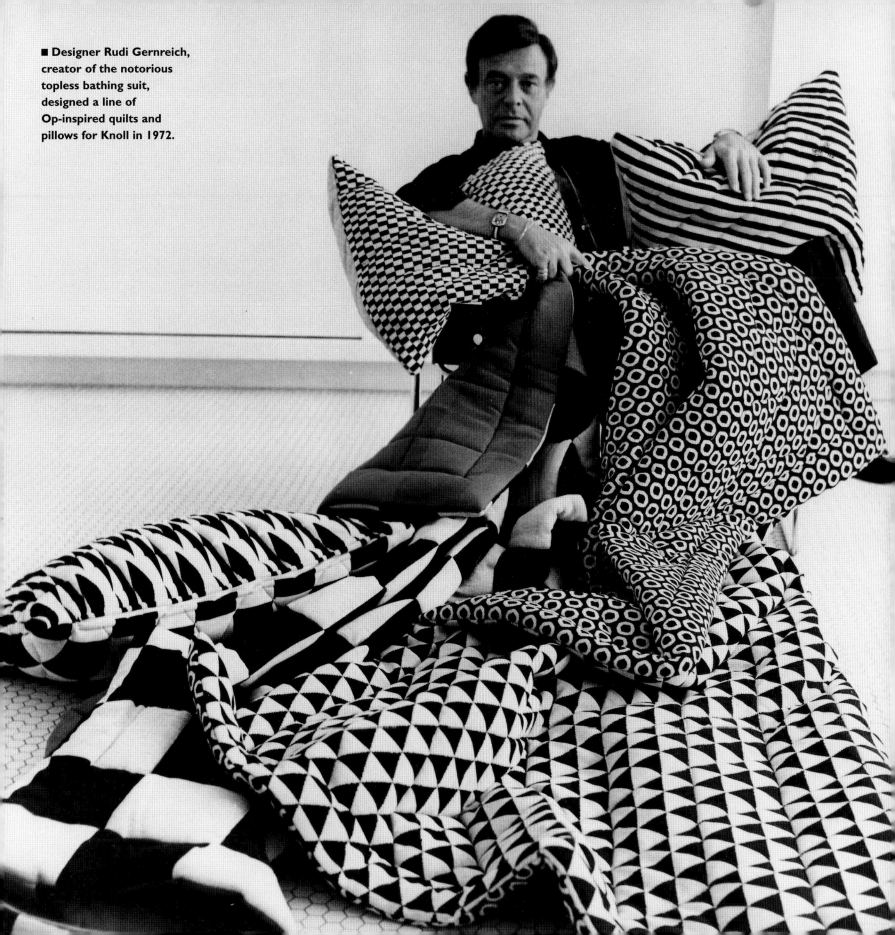

■ Designer Rudi Gernreich, creator of the notorious topless bathing suit, designed a line of Op-inspired quilts and pillows for Knoll in 1972.

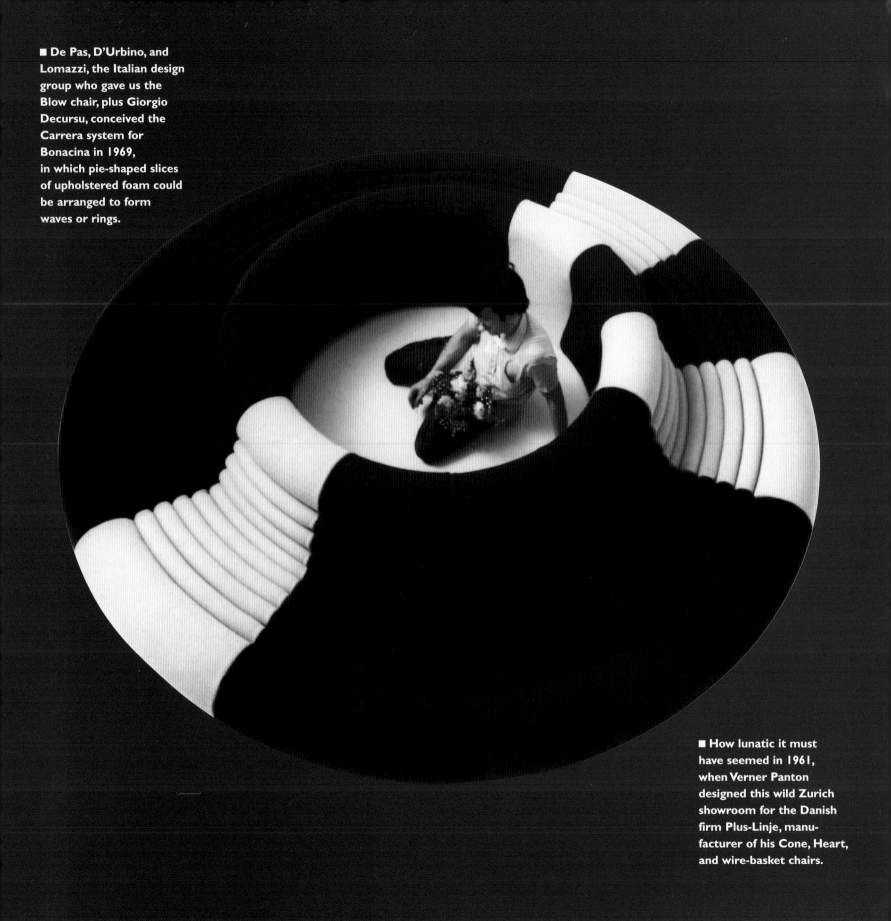

■ De Pas, D'Urbino, and Lomazzi, the Italian design group who gave us the Blow chair, plus Giorgio Decursu, conceived the Carrera system for Bonacina in 1969, in which pie-shaped slices of upholstered foam could be arranged to form waves or rings.

■ How lunatic it must have seemed in 1961, when Verner Panton designed this wild Zurich showroom for the Danish firm Plus-Linje, manufacturer of his Cone, Heart, and wire-basket chairs.

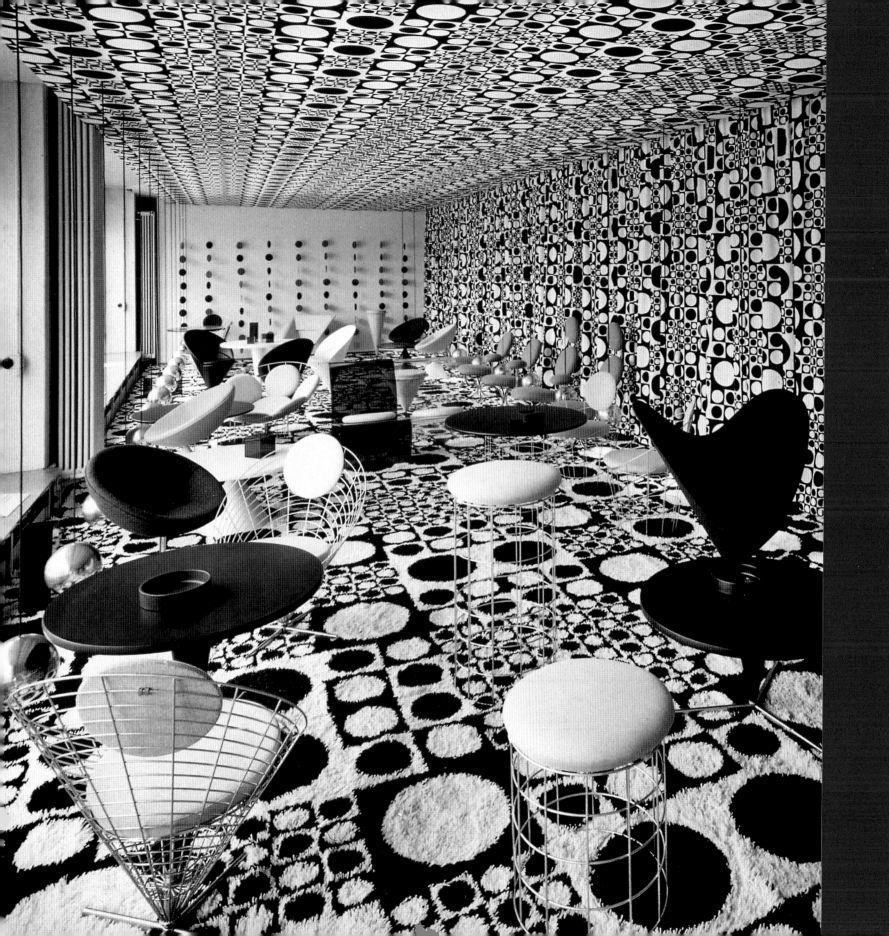

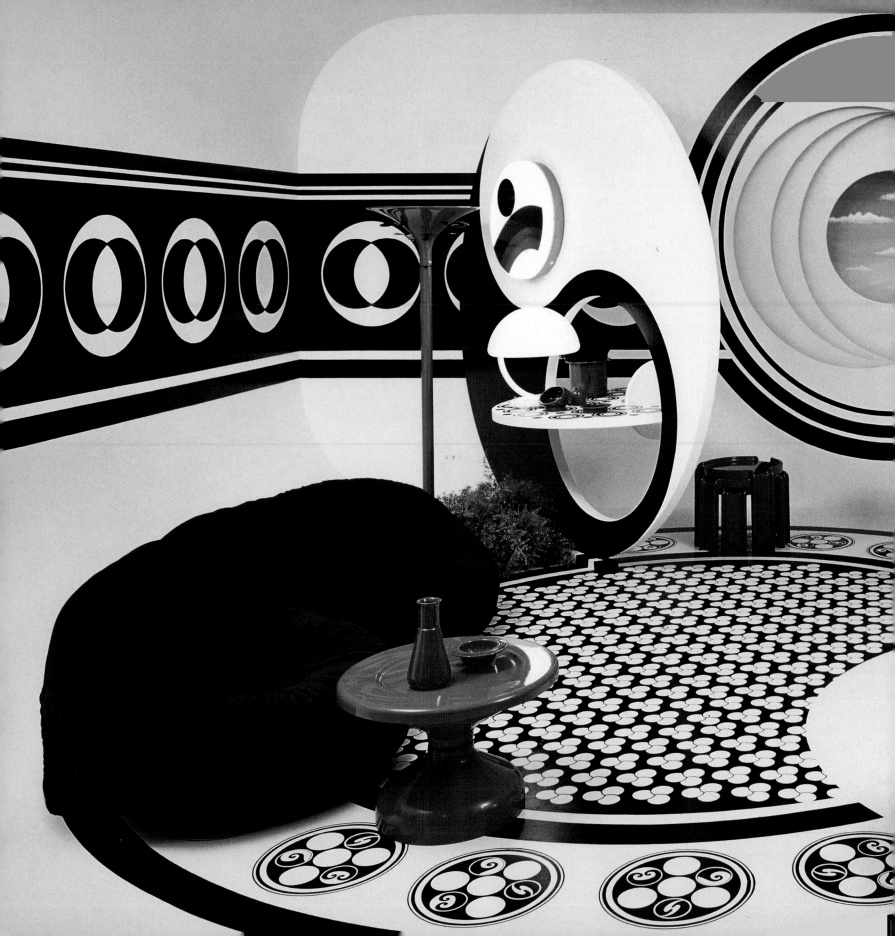

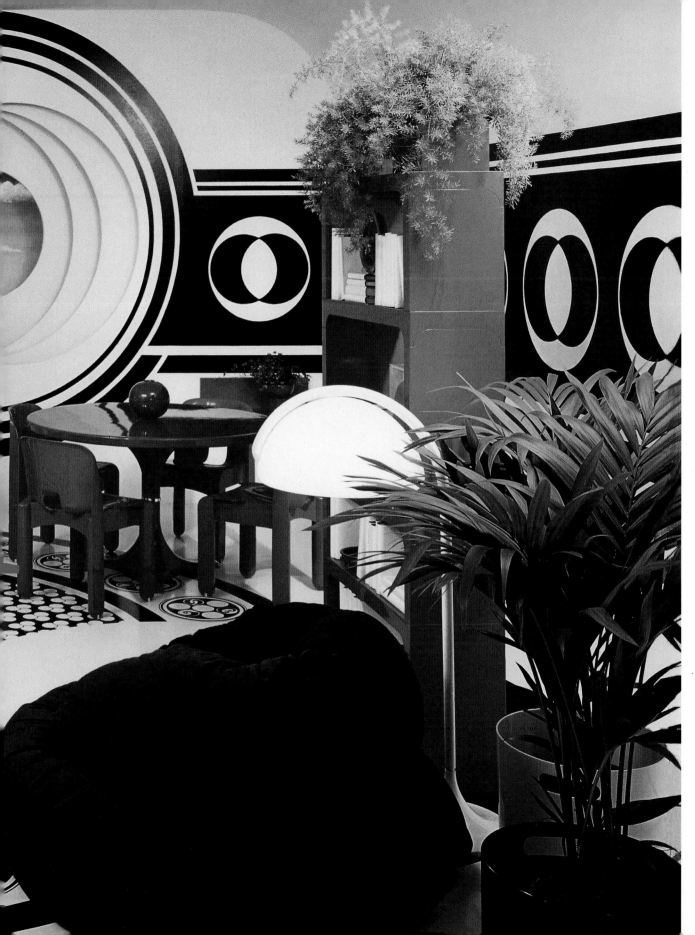

■ This Bloomingdale's
model room was named
"Saturday's Generation"
after the throngs of young
people who gathered
in the store's furniture
department on Saturday
afternoons. George
Beylerian supplied
plastics from Kartell;
designer Barbara D'Arcy
orchestrated the
supergraphics.

JOE COLOMBO

Milanese designer Joe Colombo (1931–71) was heir to Le Corbusier in his view of home as a machine for living. Colombo's work ranged from sober-looking industrial design to the furthest reaches of the avant-garde, all in a breathtaking ten-year span from 1962 to 1971.

Colombo's prime concerns were functionality and ease of manufacture, with the result that his pieces were frequently more interesting than attractive.

■ Square plastic carts like these for Elco encompassed storage, work, and serving functions in a very small space.

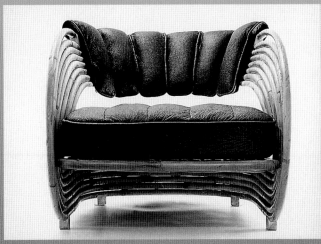

■ Commodious Colombo armchairs (left, top to bottom): 1965's Continua, a rattan chair with leather upholstery for Pierantonio Bonacina; the ingenious and important curved armchair of 1964 for Kartell, whose three plywood pieces slot together without connectors; the 1963 Astrea armchair for Comfort, which also came as a two-seater.

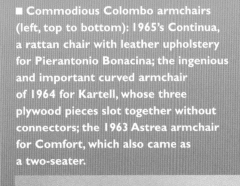

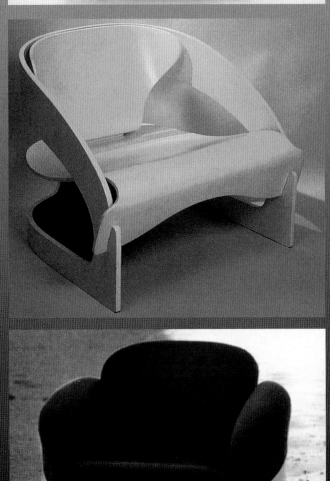

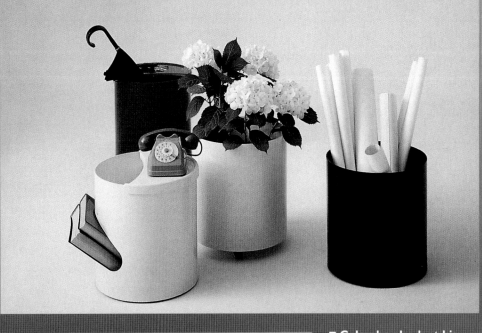

■ Colombo also lent his genius to modest items like cylindrical umbrella and plant stands (above). Always mindful of the details, he put rotating ashtrays in the corners of his 1968 glass-topped poker table for Zanotta (left).

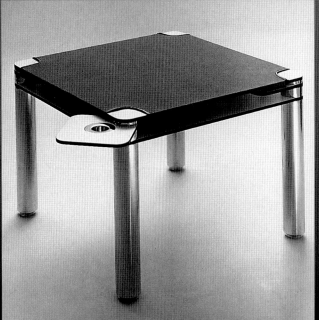

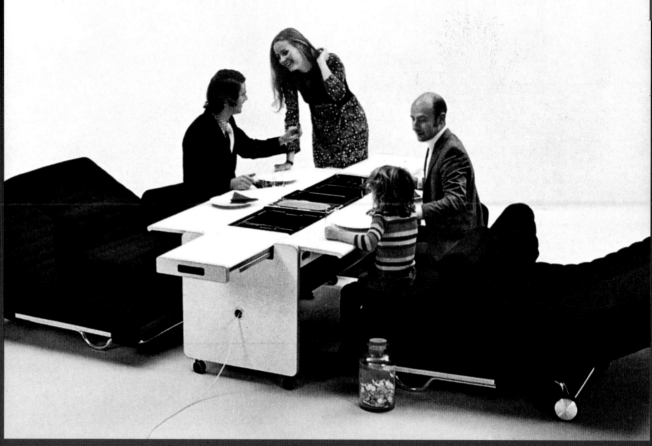

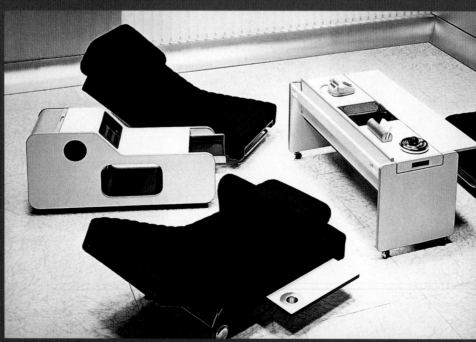

terraces, beside swimming pools, or in guest rooms. The wheeled dining units featured storage for china, glasses, and cutlery, as well as ice buckets and plate warmers. The smaller service unit held cards, games, reading material, and so on.

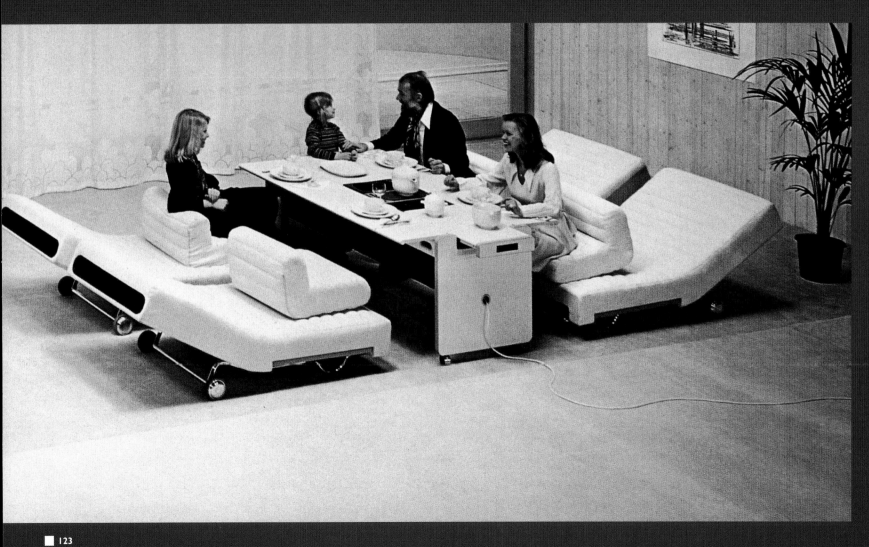

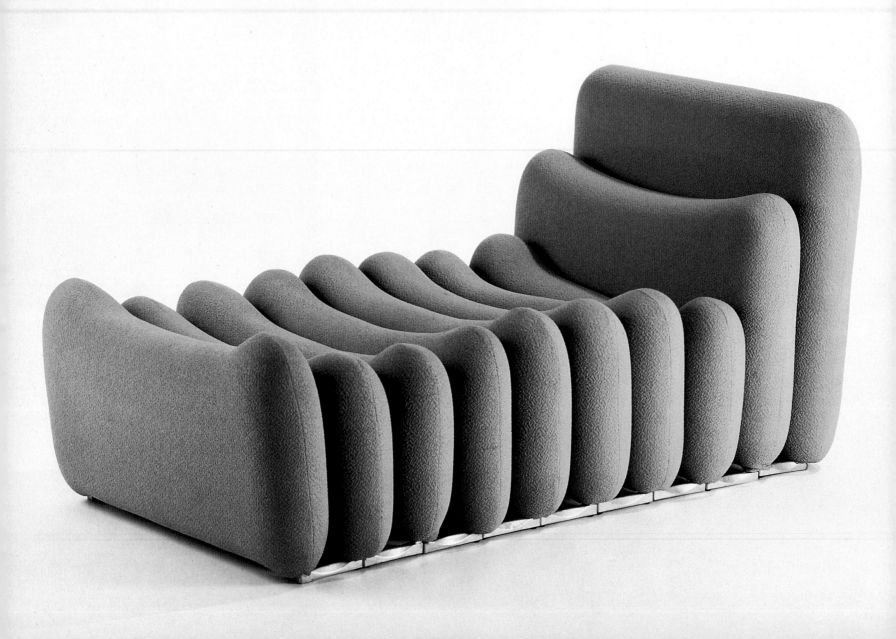

■ Colombo's 1967
Additional System for
Sormani offered foam
cushions in six different
sizes, with aluminum
linking pins that could
be used to create
armchairs, chaises,
sofas, and ottomans.

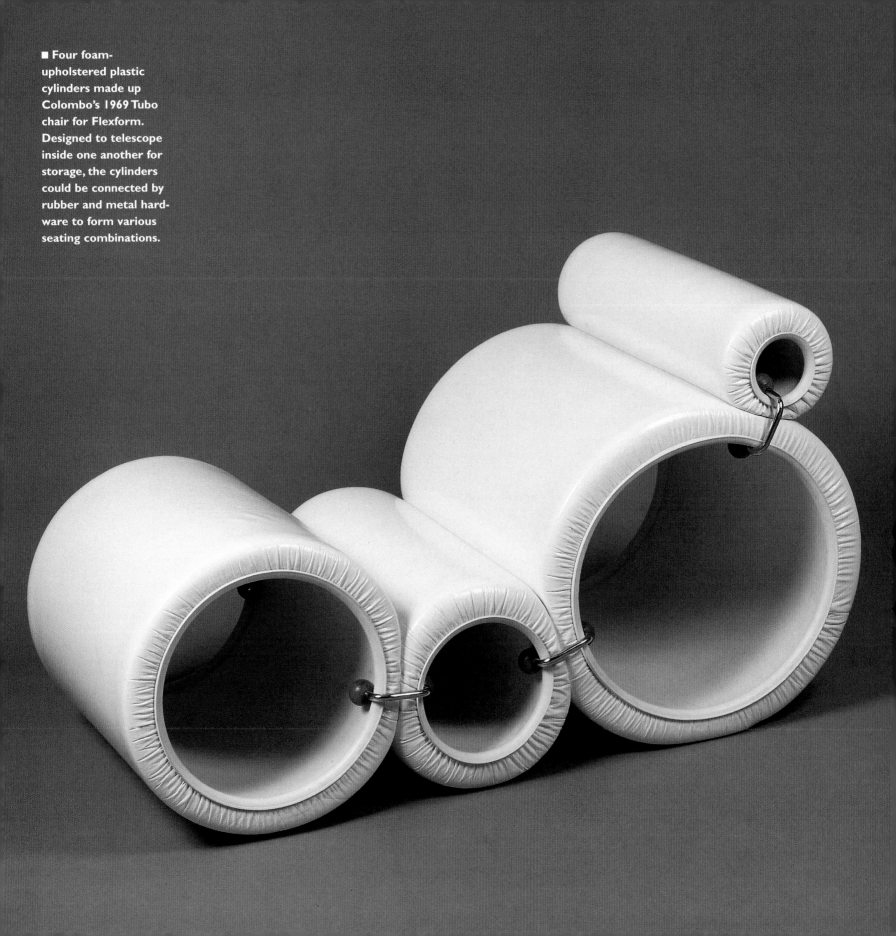

■ Four foam-upholstered plastic cylinders made up Colombo's 1969 Tubo chair for Flexform. Designed to telescope inside one another for storage, the cylinders could be connected by rubber and metal hardware to form various seating combinations.

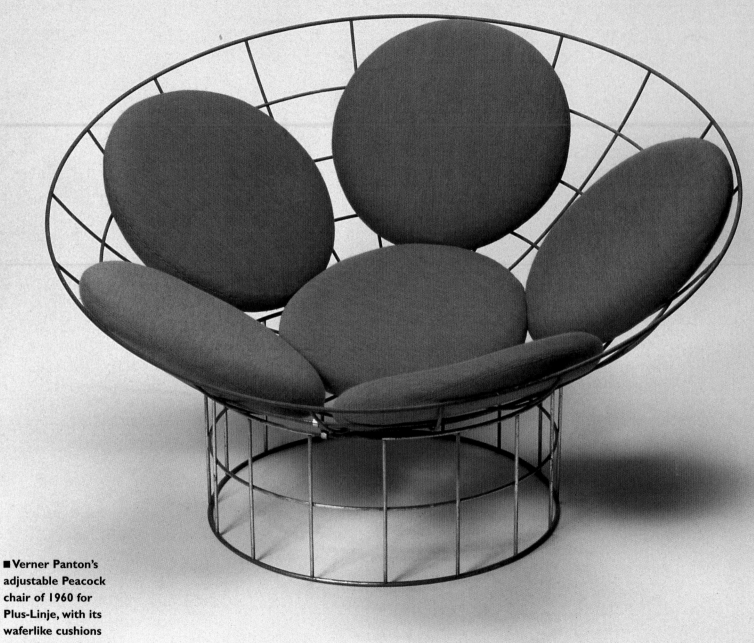

■ Verner Panton's
adjustable Peacock
chair of 1960 for
Plus-Linje, with its
waferlike cushions
on a platter of steel
wire, is testimony to
the startling originality
of his designs.

VERNER PANTON

Danish-born Verner Panton (shown at right about 1970) was a multidisciplinary artist and rogue genius whose advanced visions were grounded in basic geometries. Known primarily as a furniture designer, but also a printmaker, textile designer, and something of a mad colorist and interior designer, Panton's color palette knew no taboos. His schemes often involved pyramidal or hemispherical ceiling and wall projections intended to improve acoustics as well as visually enliven a room. Panton operated out of a design office in Basel, Switzerland, until his death in 1998.

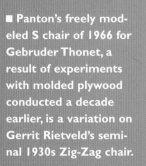

■ Panton's freely modeled S chair of 1966 for Gebruder Thonet, a result of experiments with molded plywood conducted a decade earlier, is a variation on Gerrit Rietveld's seminal 1930s Zig-Zag chair.

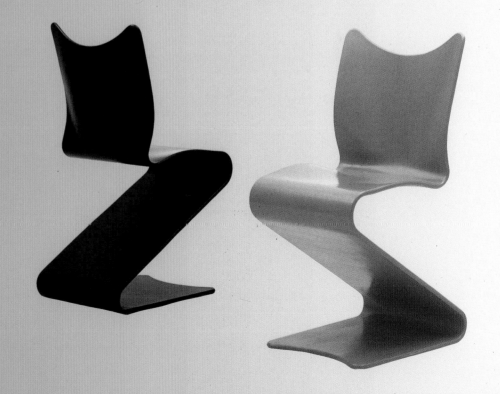

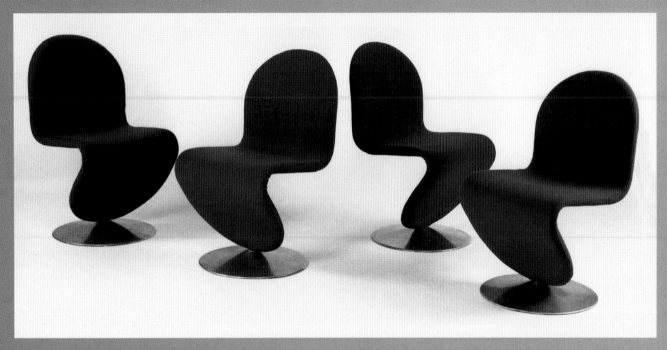

■ Panton's 1-2-3 chairs for
Fritz Hansen in 1973 give
the cantilevered Z a perky
anthropomorphic look.
The chair came on a disc
pedestal or five-prong
steel base with casters.

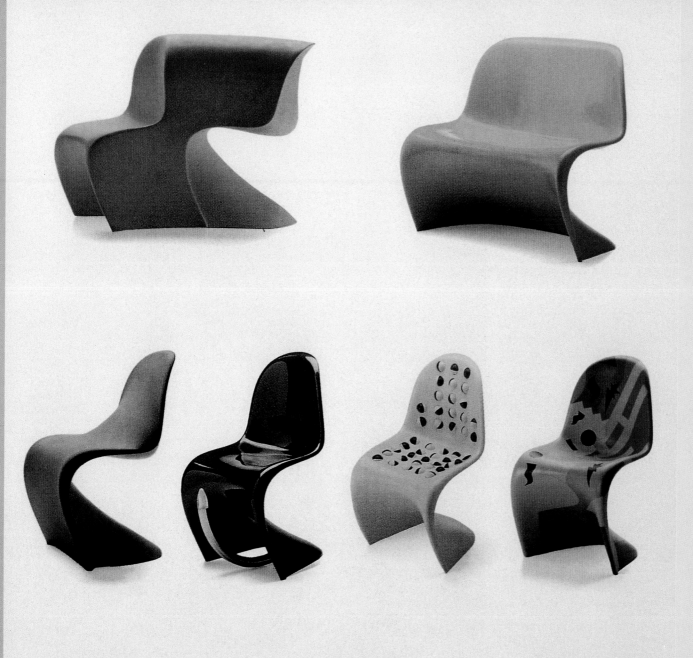

■ Avant-garde
imaginings used
the classic Panton
plastic chair as
a taking-off point.

■ Variations on Panton's
1-2-3 chairs, some with
high backs and arms,
in a sleek (not to say
slick) corporate setting.

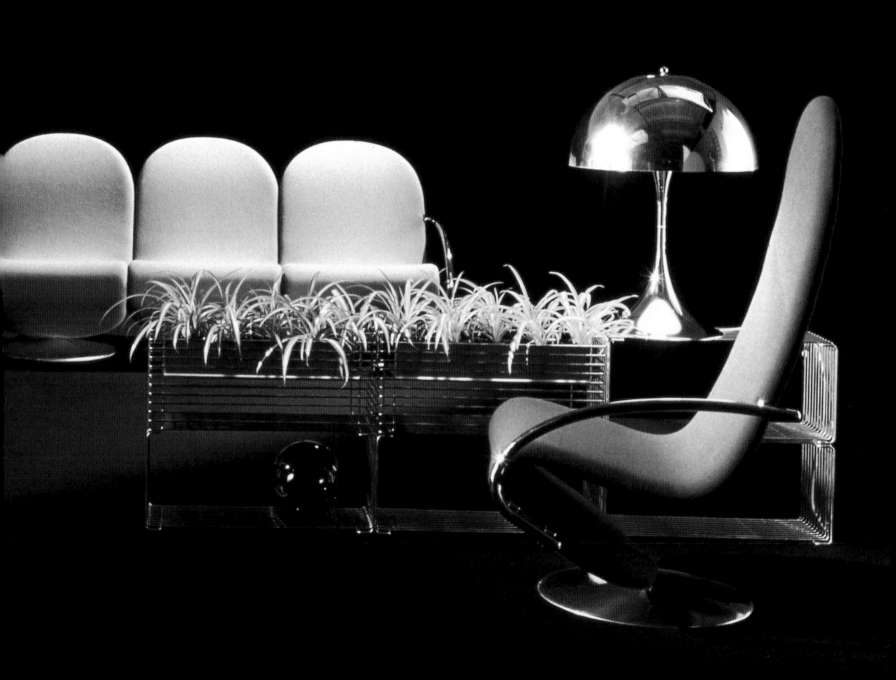

■ Thayer Coggin's High Point showroom at one point sported an Op-effect mirrored wall by Verner Panton (below).

■ In 1969, Panton chose Warren Platner's wire chairs for his rhapsodic green Hamburg lobby for Spiegel, the German publisher (right).

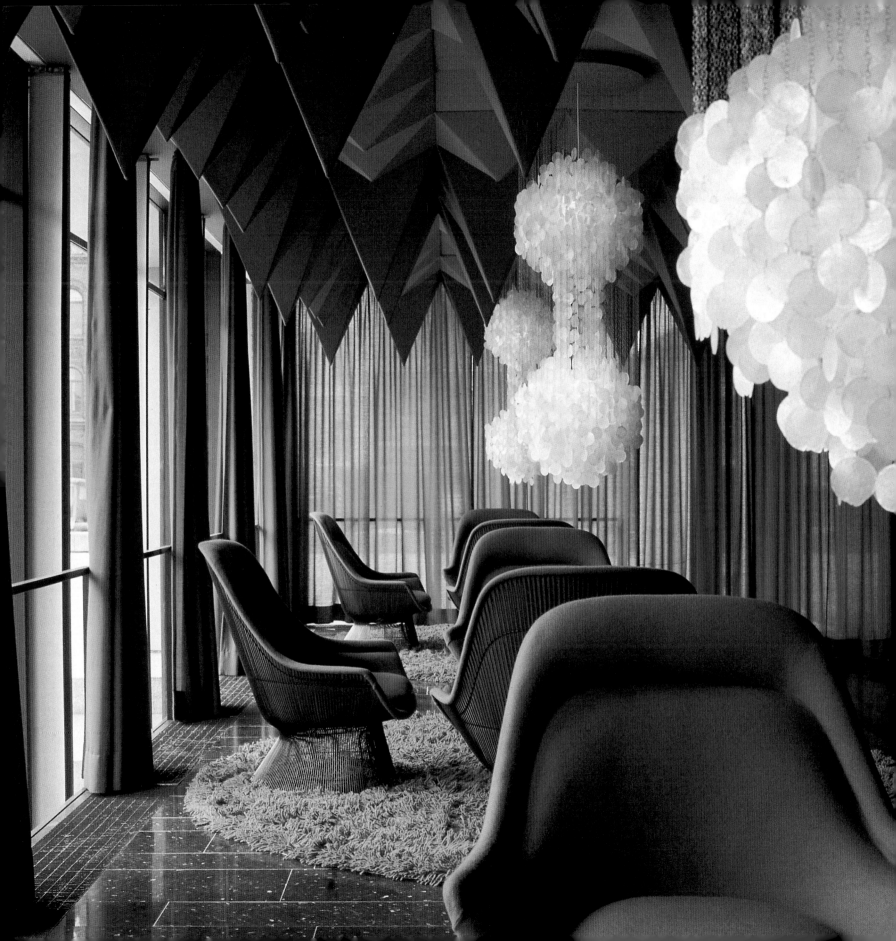

■ Fabrics for Mira-X,
a Swiss textile
company, reveal
Panton's inexhaustible
interest in pattern
and geometry.

■ Panton's Moon lamp
for Louis Poulsen (left),
with aluminum hoops
of diminishing size
spreading to form
a cocoon, dates
from 1960.

■ With its Tinkertoy
frame of tubes and
spheres, plus bolsters
and loose seat pads
on a stretched frame,
Panton's distinctive
1967 contract seating
for Gebruder Thonet
had infinite potential
for rearrangement
(right).

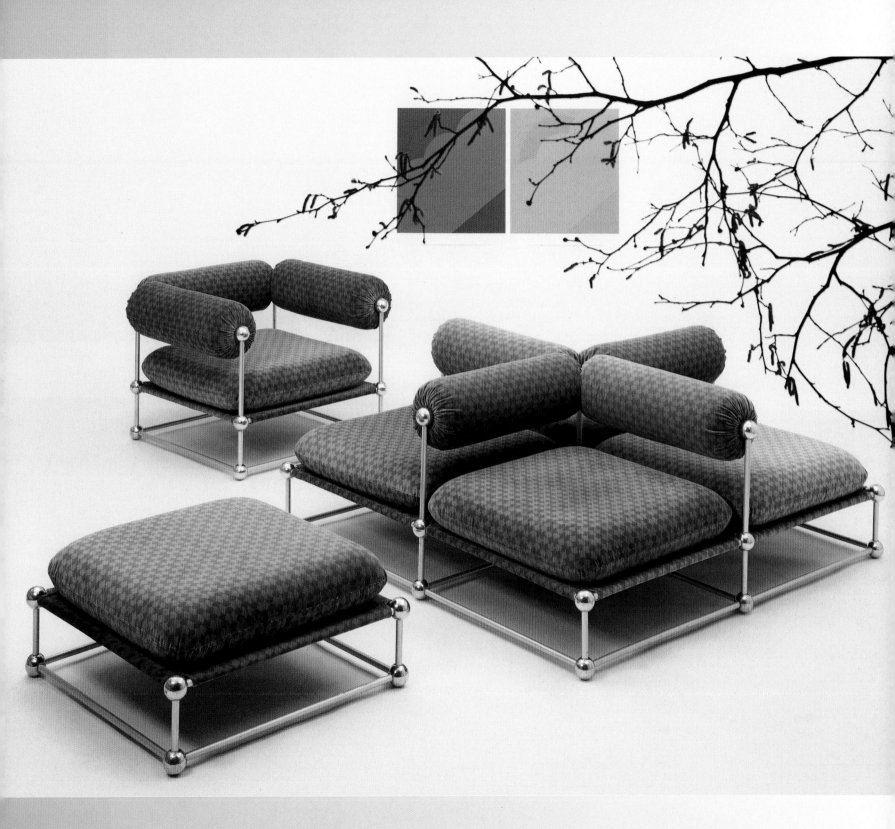

EERO AARNIO

Extraordinary Aarnio (left, inside his Ball chair at
the Cologne Furniture Fair, January 1966), known
for his magical ways with plastic, set up shop in
Helsinki in 1962 and quickly gained
global acclaim with the Ball, Pastille, and Tomato
chairs, each the work of a sculptor whose medium
happens to be plastic.

Aarnio has designed a great deal beyond
the few pieces that are well known. Though
plastics is his main métier, Aarnio has also
worked in metals and other materials, designed
numerous interiors in his native Finland, and
is active today creating new designs for the
German furniture manufacturer Adelta.

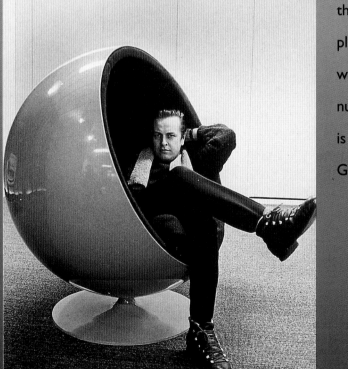

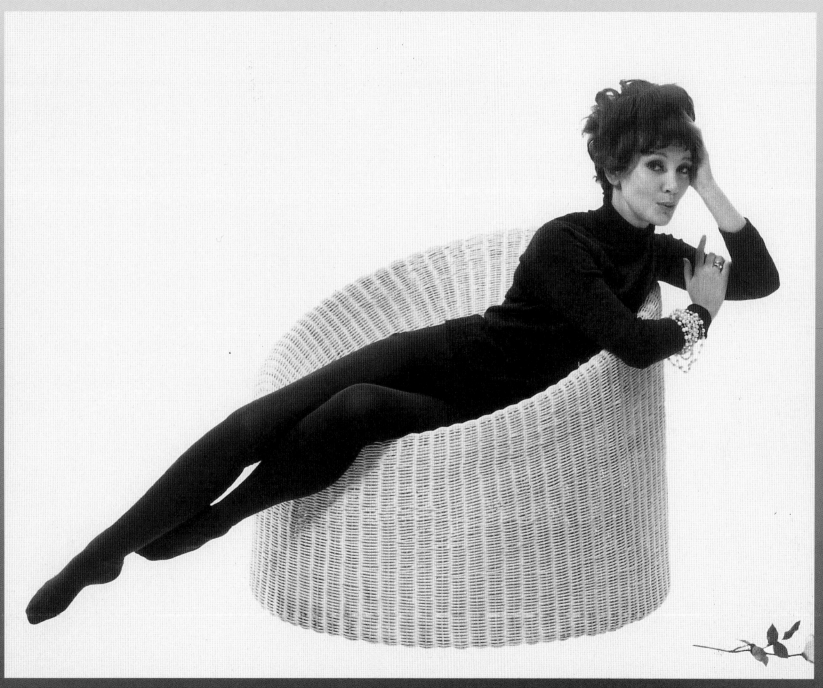

■ Some of Aarnio's
earliest designs were
in woven fiber, such as
the rattan mushroom
of 1961.

■ An Aarnio sampler (clockwise from top left): the prototype of this rectilinear steel-plate chair of 1970 was lost in shipping and never found; undulating built-in seating for a mid-'70s apartment in Lahti, Finland; cozy cubic seating for a Finnish doctor's home; a mid-'60s Aarnio interior for a magazine shoot, with light fixtures by Yki Nummi.

■ (opposite page) Aarnio's set for a Finnish shelter magazine featured Eero Saarinen's 1956 pedestal table and chairs for Knoll.

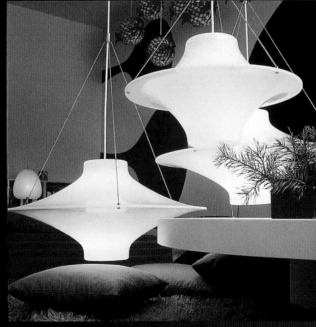

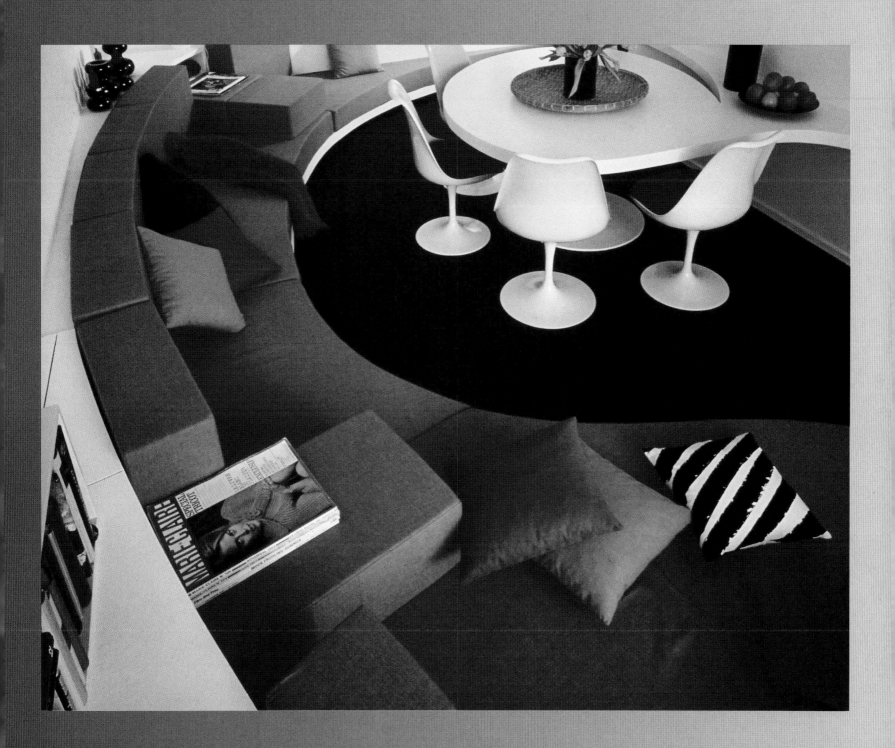

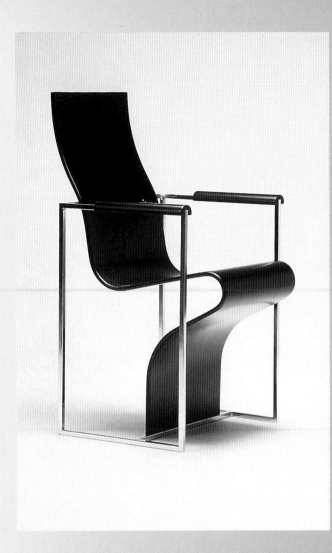

■ Aarnio's square-armed 1972 chair (left) has an eccentric ribbon seat that subverts International Modernism with a loopy gesture.

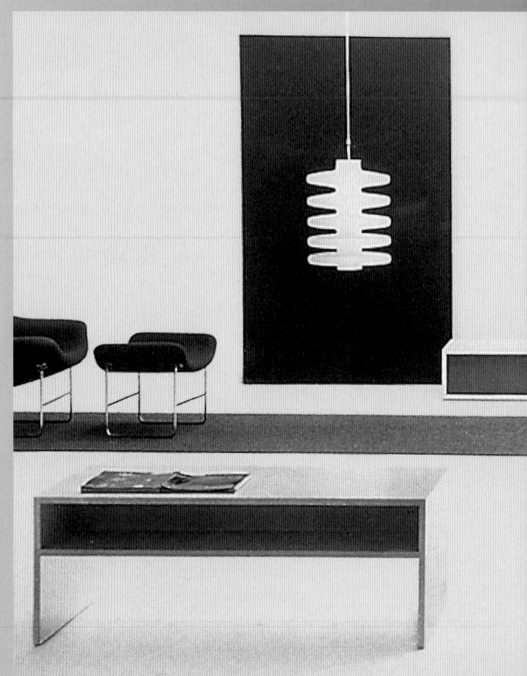

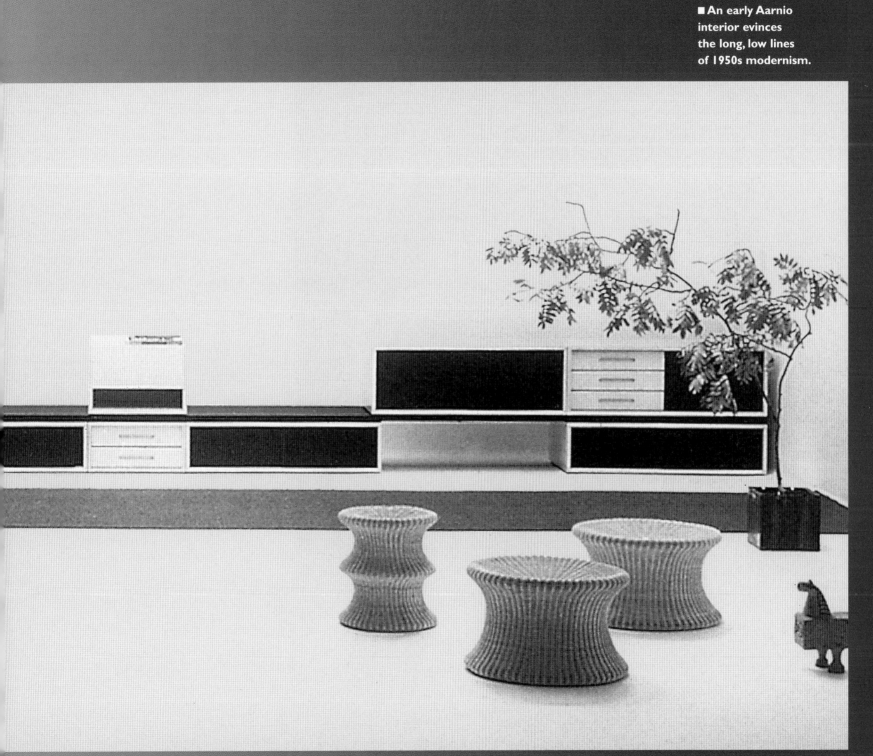

■ An early Aarnio
interior evinces
the long, low lines
of 1950s modernism.

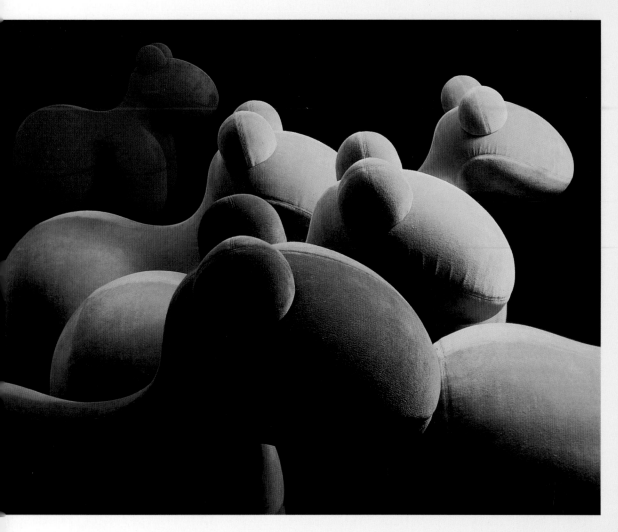

■ Aarnio's delightful velvet-covered Ponies of 1973 (left) were not intended only for children.

■ The monolithic, indestructible Pastille chair of 1968 (so named because it looks like a sucking candy) can overwinter outdoors, even in Scandinavia. It is made today by Adelta.

■ Among the Pastille's
properties, it floats.

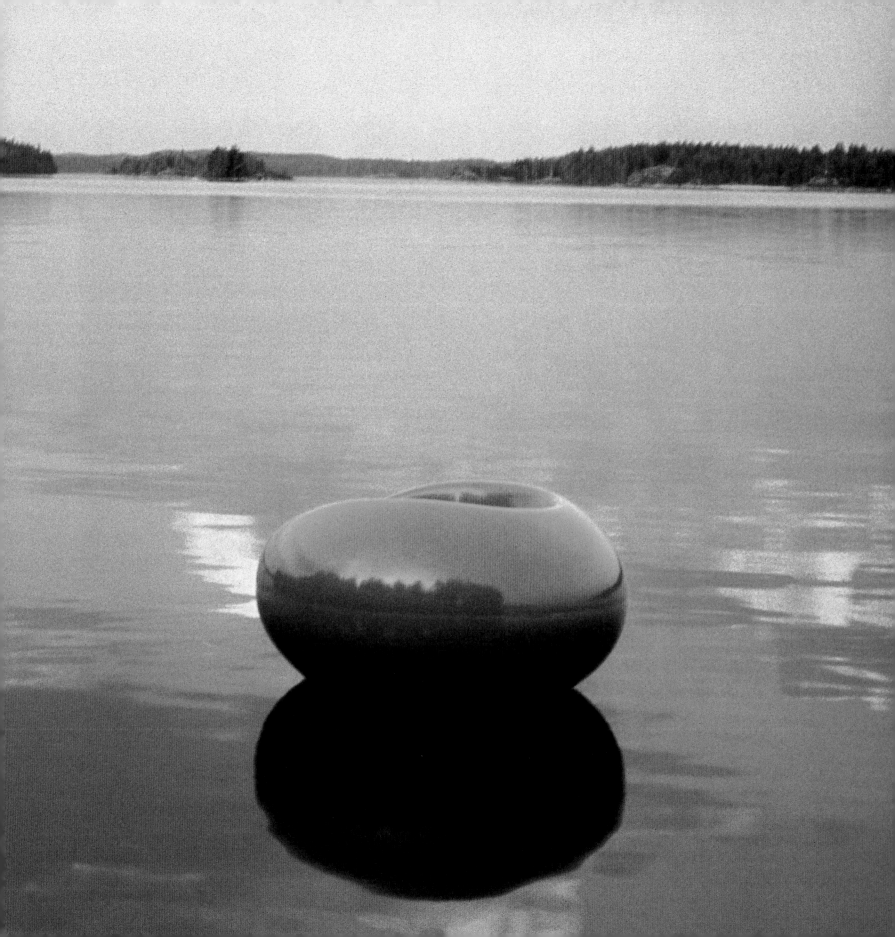

TOMORROW IS

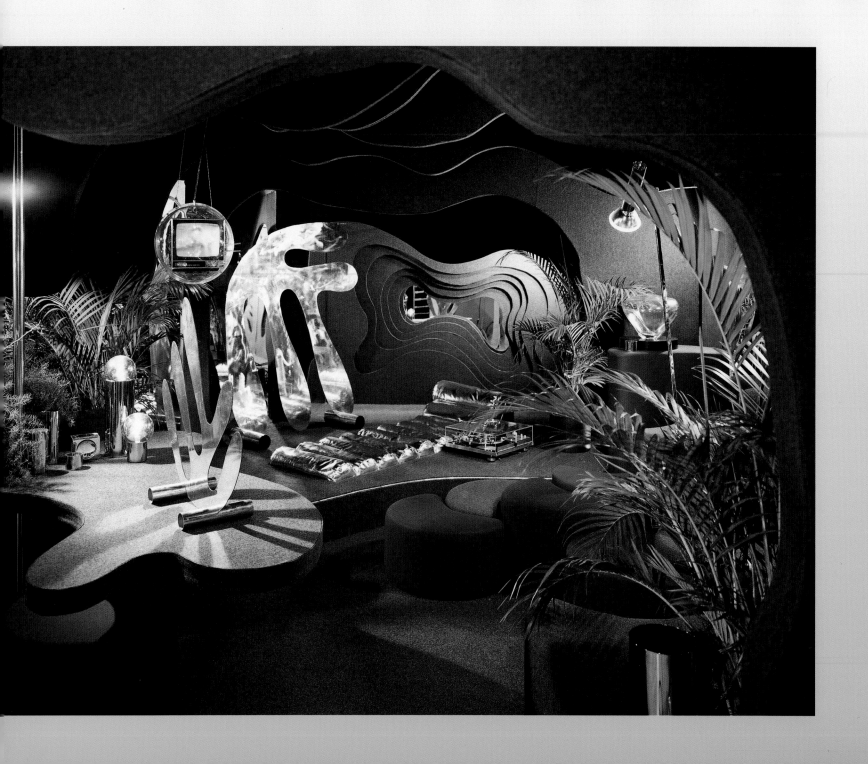

HERE

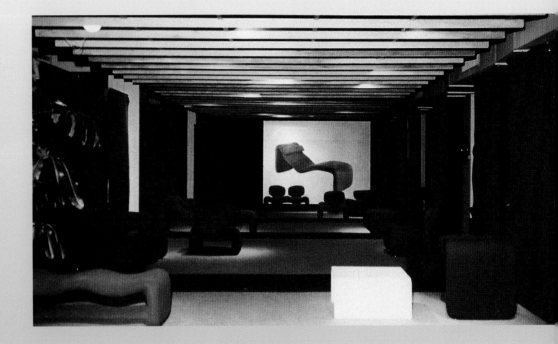

■ Amoeba-shaped risers and baffles upholstered in gray felt defined fashion designer Pierre Cardin's early-'70s model room at Bloomingdale's, which included crescent-shaped seating of dense foam, a desk cantilevered from a floor-to-ceiling stainless-steel pole, and a round Plexiglas globe holding a TV set with all the works visible.

The 1960s were years of futurist fantasy. Instead of looking to tradition, movie, fashion, and furniture designers bravely pursued visions of the world to come. White, silver, and transparent plastic sashayed down the runways at Paco Rabanne and André Courrèges. Set designers for the film *2001: A Space Odyssey* chose Olivier Mourgue's low-slung Djinn seating in bright red to add zip to the sterile look of a space station lounge.

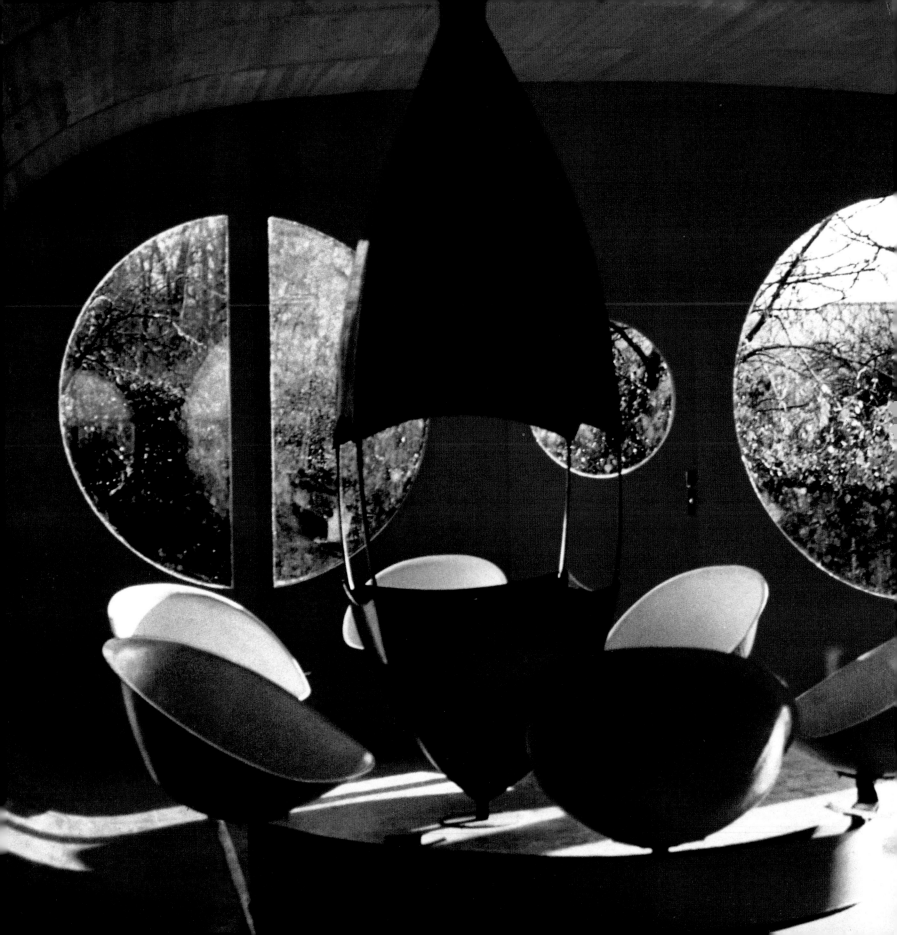

In the hands of '60s designers, the future did not look cozy. Barbarella's fur-lined spaceship aside, the projected world was a cold hall of mirrors. Interior designers couldn't get enough silver in search of a new aesthetic. And who really wants to be served dinner by a robot? But space-inspired design was fun to play with for a few years.

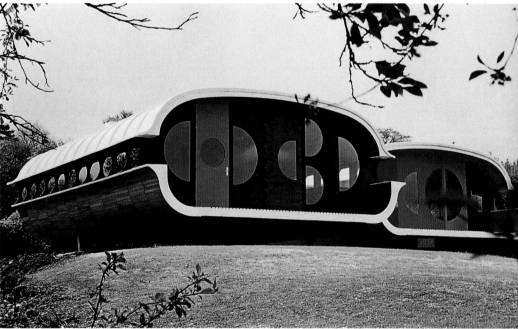

■ **Architect Gerard Grandval of Paris devised this futuristic ski lodge in La Plagne, France, with furnishings of plywood and prefabricated marine polyester, in 1966.**

The space race began in earnest in 1962, when JFK announced America's intention to put a man on the moon by the end of the decade. From that point on, imagery associated with space travel appeared on a daily basis. Geodesic domes and circular dwellings on pedestals with a 360-degree view of the landscape were the dream houses of the day.

Space-age symbol

Early satellites, including Russia's Sputnik and Echo, the round U.S. satellite of 1960, launched the sphere as a perfect symbol for the decade, especially in high-tech products that appeared about ten years later, like televisions and stereo speakers.

However, Eero Aarnio claims he was thinking of nothing less esoteric than an egg when he conceived his masterpiece, the Ball chair, in 1963. Looking for a structural form that would work well with the newly available plastics technology that interested him, the designer realized that the egg is one of nature's strongest, most perfect designs. Along the way to its final form, the ovoid became spheroid. The photogenic Ball chair captured the world's attention when it was introduced in 1966 at the Cologne Furniture Fair, selling immediately into twenty-seven countries and becoming an evocative symbol of the space age—the embodiment of the moon itself.

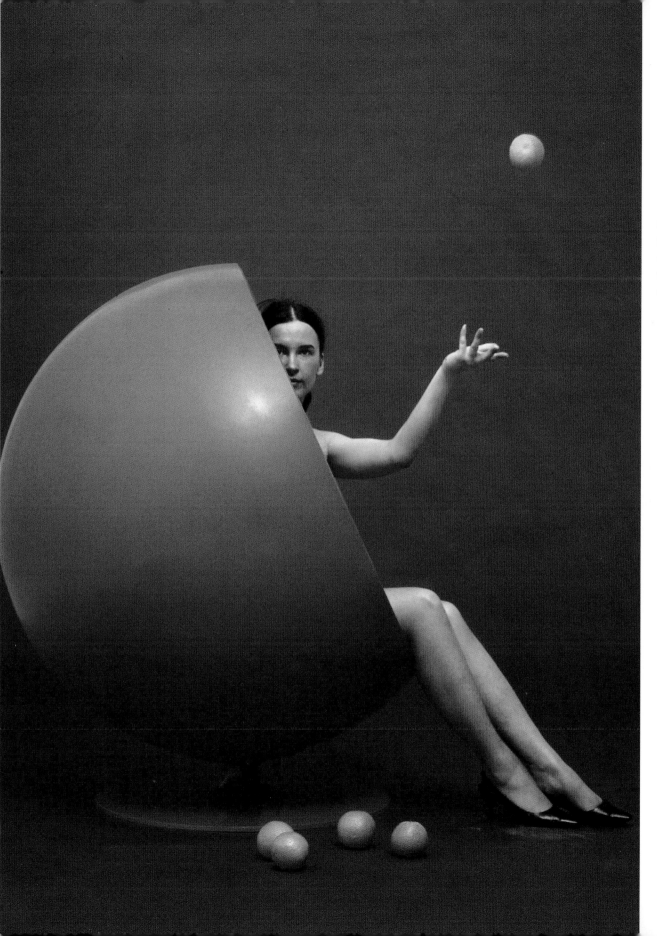

■ An advertising shot
for Eero Aarnio's Ball
chair played upon
the color orange,
a screaming '60s hue.

Future habitat

Future

America may have made the first moon landing, but Europe had *Visiona 69*, the name given by Bayer AG to its exhibition at the Cologne fair. Bayer invited maverick Italian designer Joe Colombo to envision an interior of the future. This turned out to be a swanky space-age bachelor pad, with a round bed, round TV, and pink and purple decor veering dangerously close to kitsch.

Though Colombo designed many beautiful lamps and chairs in his brief career, which ended with his death in 1971 at age forty-one, his forays into futurism were more attractive conceptually than visually. Colombo was fascinated with "living cells" and "total furnishings units," which would maximize efficiency by having everything a family needed from dawn to dusk in a compact area. It was a typically '60s concept, based on the idea that square footage would soon be at a premium as we colonized space.

■ A fish-eye view of the future: Joe Colombo's kitchen for *Visiona 69*.

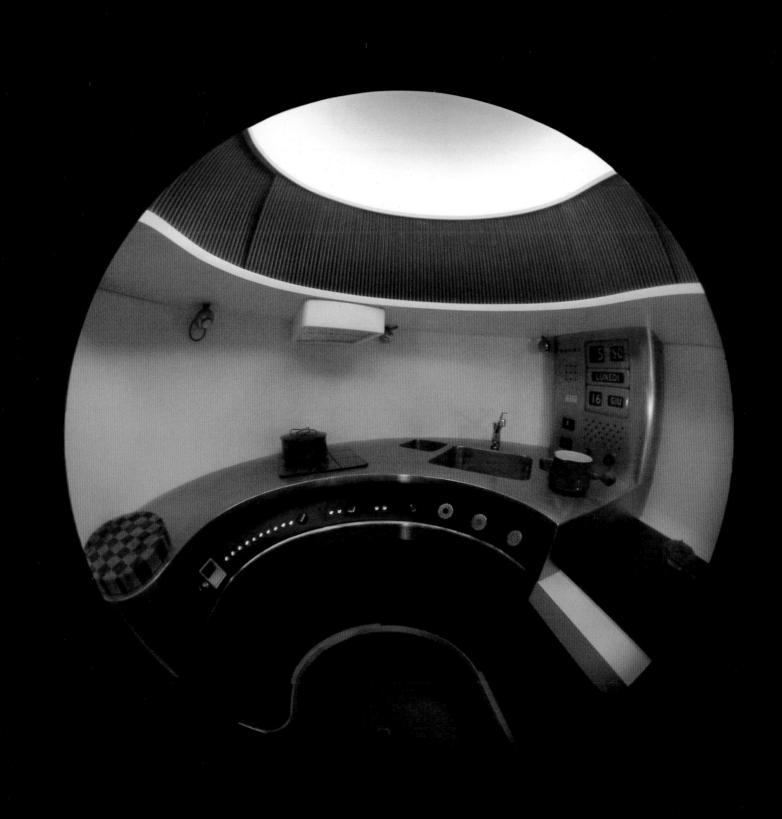

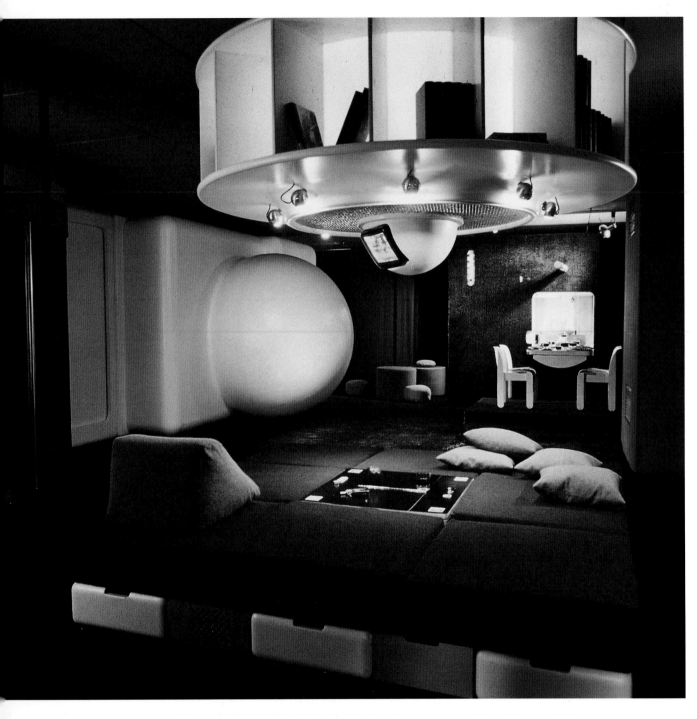

■ Spherical elements dominated Colombo's *Visiona 69* apartment, from the protruding wall to the rotating TV/ bookcase unit overhead to the bed itself.

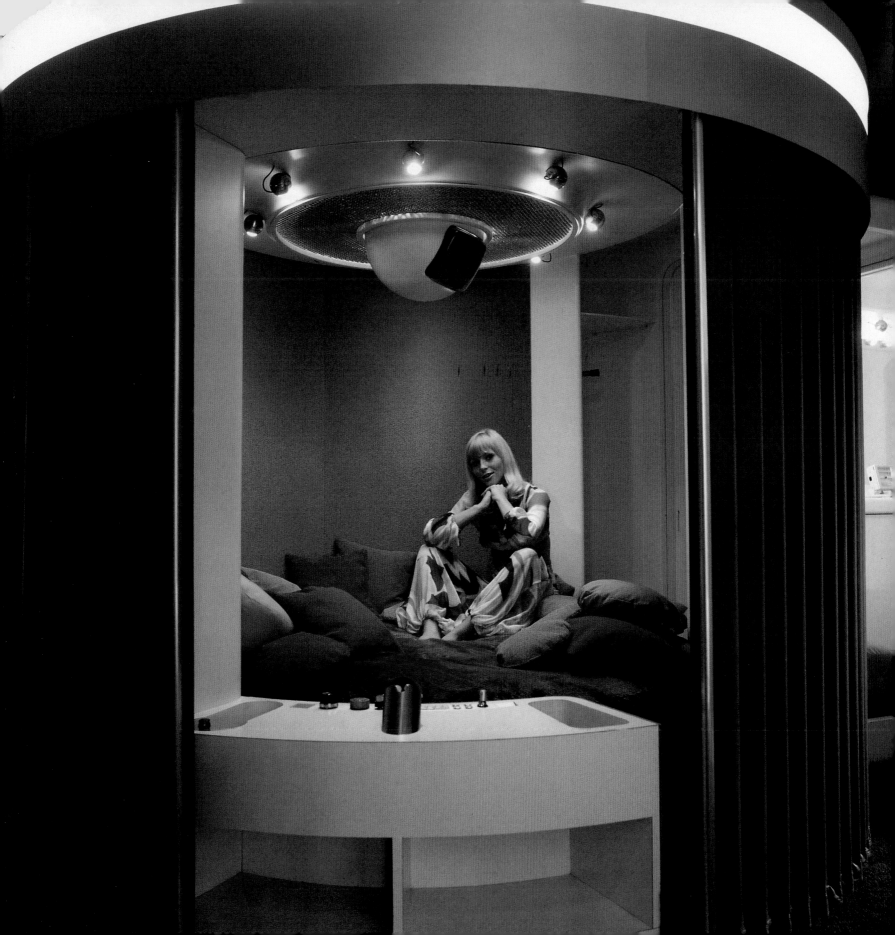

Far out

■ Pierre Paulin's daring experimental designs at a 1967 Paris exhibition included a table system with a central foot and adjustable tops, and seating composed of foam-covered wooden "slices" linked to allow a variety of shapes and angles.

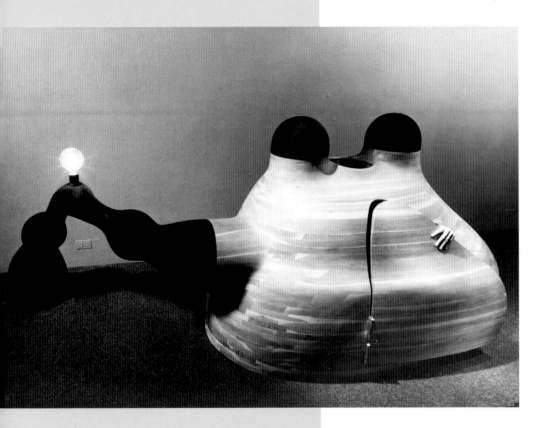

■ Wendell Castle's twelve-foot-long laminated oak "reclining environment," with upholstered interior, skylight, and reading light, was a cozy human burrow—warm, well lit, and private without being claustrophobic.

New York's American Craft Museum, formerly the Museum of Contemporary Crafts, encouraged futuristic thinking in shows like 1970's *Contemplation Environments*. In addition to the expected Zen monastery, the exhibition contained Wendell Castle's snug, lighted crawl space and the Moon-Man Fountain, a domed, transparent-plastic environment for two.

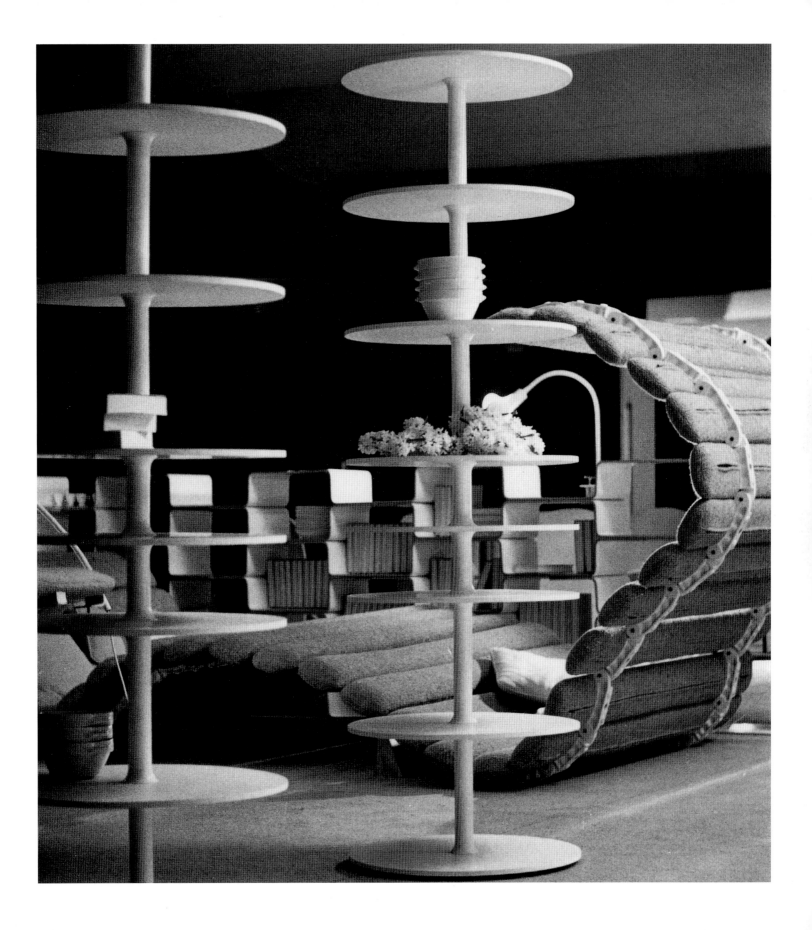

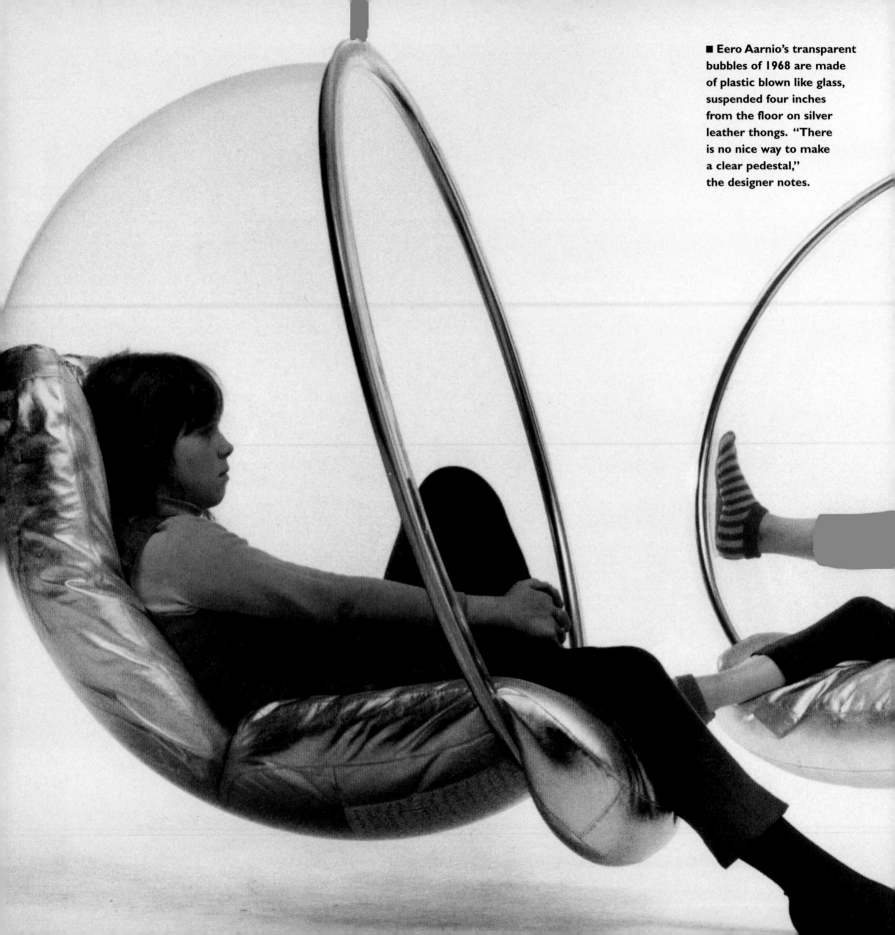

■ Eero Aarnio's transparent bubbles of 1968 are made of plastic blown like glass, suspended four inches from the floor on silver leather thongs. "There is no nice way to make a clear pedestal," the designer notes.

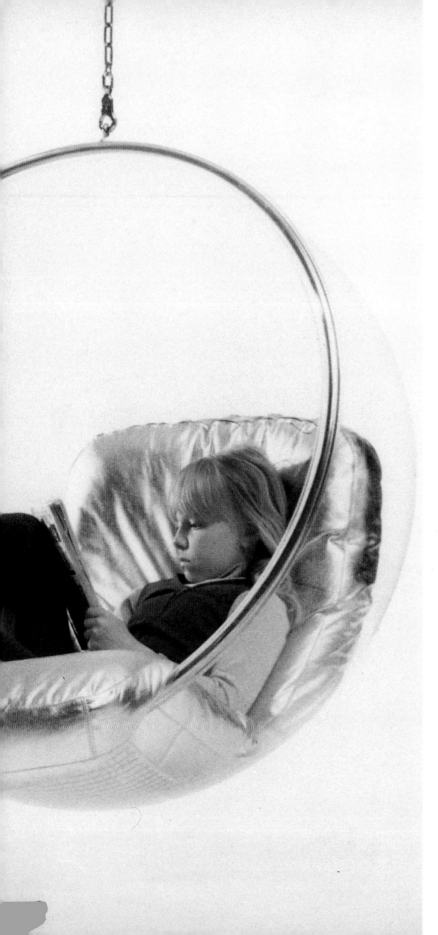

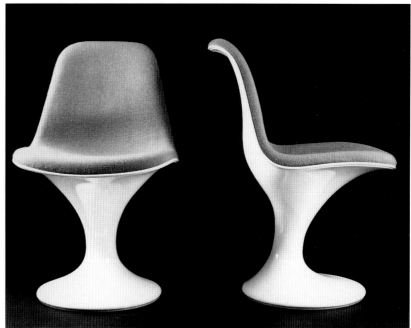

■ The German design team of Farner & Grunder created amorphous Orbit chairs for Herman Miller in the 1960s—white plastic shells with concealed swivel mechanisms that would look fitting on the starship *Enterprise*.

The space fixation seemed to fade once the moon landing was accomplished. Over the ensuing decade, the problems of this planet began to seem more pressing than those of outer space. For all its farsighted visions, space as a design directive petered out, and most space-inspired furnishings remain a campy reminder of their era.

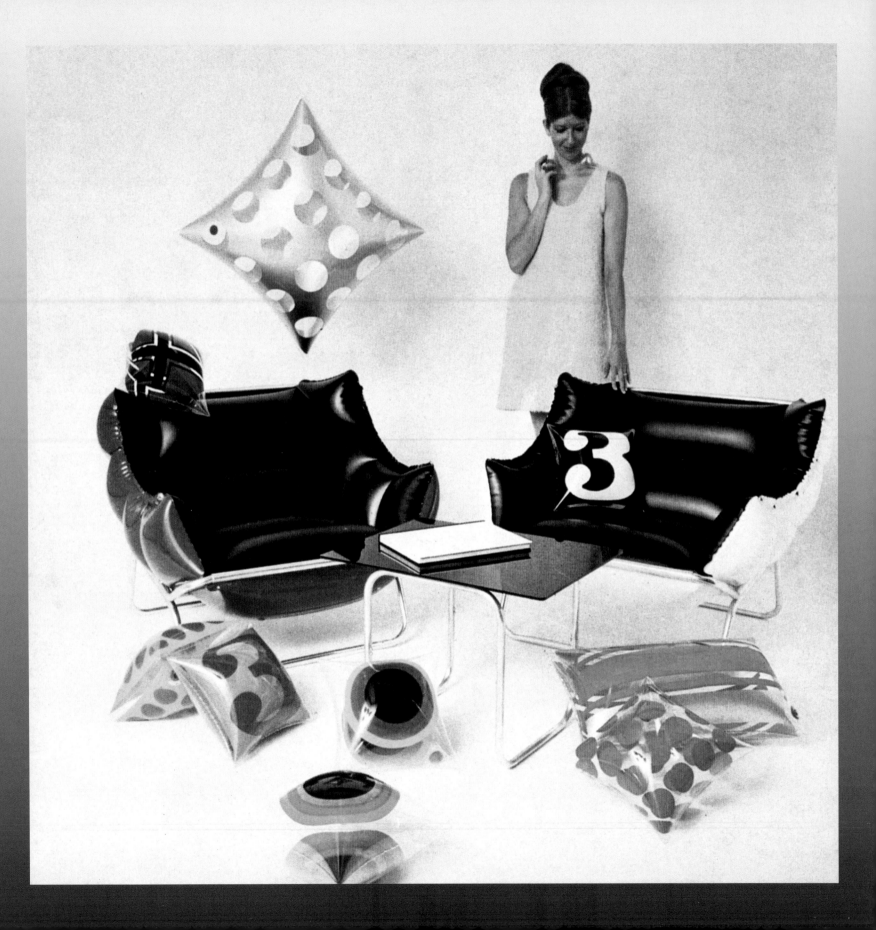

CHAPTER 6

BLOW-UP

As long ago as the 1920s, Marcel Breuer is said to have dreamed of sitting on a column of air. What could be more comfortable? Breuer came as close as he could to reducing furniture to thin air with his lean, taut tubular-steel chairs, but air-supported furniture did not become a reality until the mid-1960s.

Blow-up furniture was a direct outgrowth of the utopian "pneumatic" architecture movement. In 1965, Reyner Banham, the British architecture critic, conceived the Un-House, an inflated plastic shell, though he himself asked, Can you really bring up a family in a plastic bag?

The iconoclastic British design group Archigram devised something called the Cushicle, a cross between a suit of clothes and a chaise longue. The Cushicle expanded in phases and in its final, wheeled phase could serve as a vehicle and means of communication as well.

The goal of utopian designers was maximum flexibility, adaptability, and mobility. This sat very well with the emerging youth culture, which found the idea of a chair you could pack in a suitcase quite irresistible.

■ American artist and businessman Philip Orenstein's thickly channeled inflatable chair of 1966 predated better-known European efforts by at least a year. The pillows were commonplace gift items.

Pneumatic developments

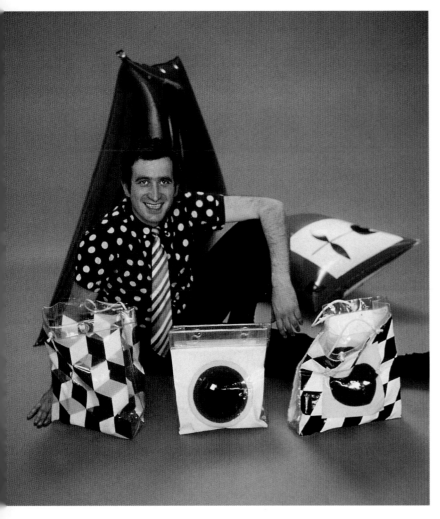

■ Orenstein posed for
a publicity shot with an
array of Mass Art products.

In 1965, New York sculptor Philip Orenstein, wanting to do something light and airy, displayed a vinyl inflatable sculpture in a downtown gallery show. The next year, he began work on an enveloping inflatable chair, thick channels of heavy-gauge vinyl on a tubular-aluminum frame. His Mass Art company, set up to produce it, received a sensational amount of press in national magazines like *Life* and *Time,* sold $1.5 million worth of chairs at $45 apiece, and then collapsed. "The chair was supposed to be art for the masses," Orenstein said. "It became a novelty item."

The pneumatic architecture movement was loudest in France. The design group Utopie saw evil materialism in the weight and permanence of monumental architecture, upholding inflatable structures as an enlightened solution to social problems. Its high point was a Paris exhibition, *Structures Gonflables,* in March 1968, which featured the latest in pneumatic architecture and design. But the movement, never commercially viable, proved almost entirely academic (politics and inflatables having no real connection), and some of its members scurried back to their Beaux Arts backgrounds.

In Italy, the young architects Gionatan De Pas, Donato D'Urbino, and Paolo Lomazzi, after issuing a "manifesto" in 1967 on the need for new furniture

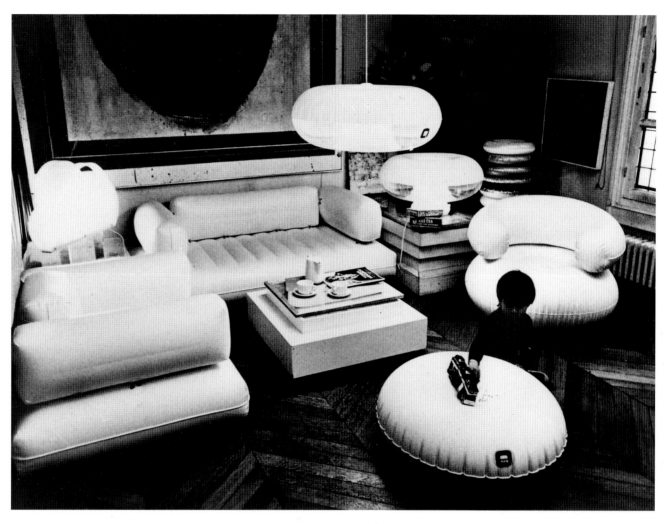

■ **This Milan apartment (above) was furnished entirely with air-supported furniture. Inflatable panels of vinyl and Lucite (left) snapped together to form a sleeping surface of any size in this 1966 Orenstein design.**

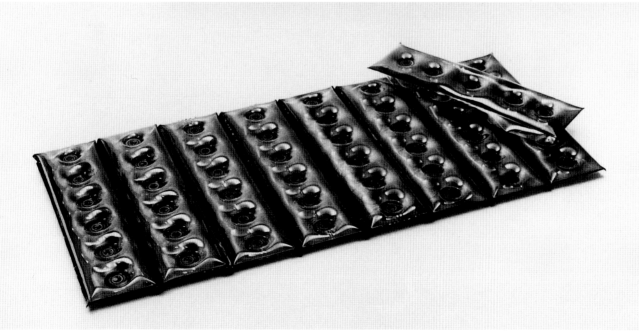

for a new world, sold manufacturer Zanotta on the idea of an air-supported chair. Their design was nothing more exotic than an inflatable dinghy cut in half, one U-shaped section stacked upon the other. Zanotta embarked on several months of experiments to perfect a welding technique, and the Blow chair, sold with an air pump and patch kit for about $20, became the first Italian design object to reach beyond an elite clientele. Introduced in Milan in 1968, it drew international press attention, became a symbol of the glorified youth culture, sold many tens of thousands, and was copied in numerous variations. It was somewhat fragile, though, and—as was all inflatable furniture—subject to leakage.

Air-headed

Making fun of inflatables, the design critic Victor Papanek wrote in his 1971 book *Design for the Real World,* "The attempt to translate fashionable daubs into three-dimensional objects for daily use still continues. While it is not a bad idea to have a pillow that sells for $1.50, that can be folded and stored in one's pocket, these small plastic horrors . . . yield but slightly and don't 'breathe,' hence the user sweats profusely. . . . They squeak against each other like suckling pigs put to the knife. . . . And imagine the dismay of having some romantic interlude punctured by a sudden blow-out. . . . Their use indicates that, as in so many areas, we have sacrificed all our other needs for a purely visual statement."

Inflatable furniture might have become just another finished fad, except that the Blow chair, like the bean bag, has become an icon of '60s popular culture, and knock-offs abound once more.

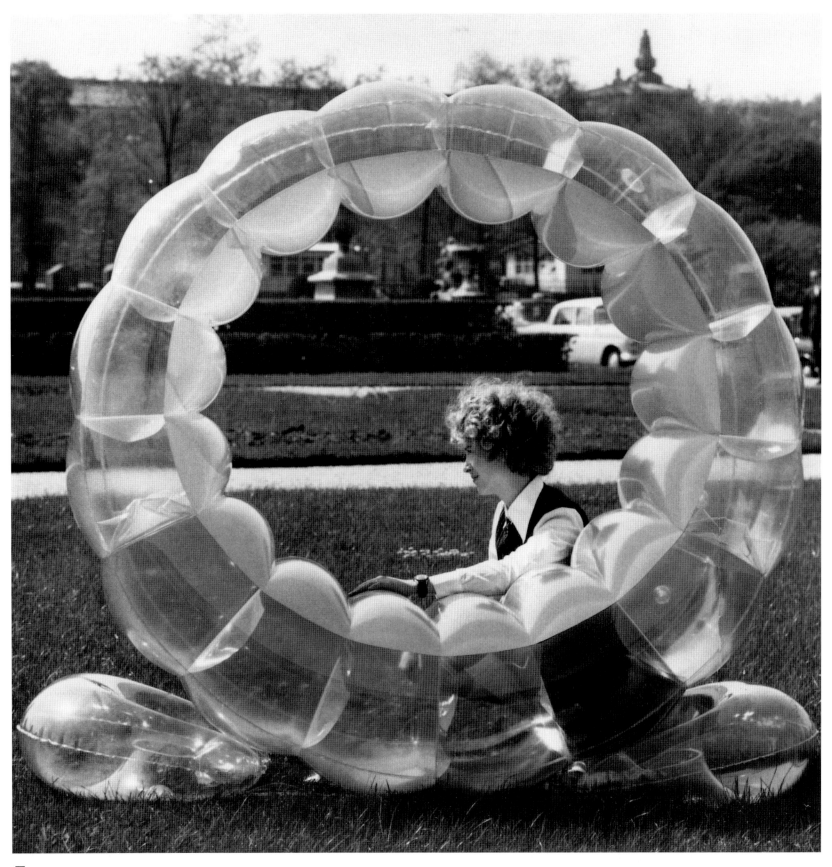

BEYOND

■ Central to the
concept of Gaetano
Pesce's 1969 UP series
was its packaging:
compressed in flat
cartons, the foam
pieces expanded
upon opening, forcing
consumers into active
confrontation with
their furniture.

P O P

Through the 1960s and beyond, Italian design was a ball of fire. Just as heated was the level of debate among intellectuals, the rigorous discourse over what direction design (and society) should take. As Ettore Sottsass recalled in a 1987 speech at a conference on twentieth-century design at New York's Metropolitan Museum of Art: "All that fussing . . . all that turbulence . . . all those prototypes published in magazines, all those drawings, those nonsense exhibitions, all those incomprehensible lectures . . ."

In Italy, years of Fascist strictures on what could be built or manufactured at all had turned design itself into a political event. On May 30, 1968, 250 protesters, well-known architects and designers among them, managed to shut down the venerable Milan Triennale, an international exhibition of product design and applied arts, for three whole weeks.

They did a great deal of damage, even splashing red Maoist slogans on white display walls. Their complaint, that the Triennale's administration and selection process were not democratic enough, echoed what young Americans were protesting at universities and government offices—but that much passion about a design fair? Only in Italia.

■ Experiment with materials or rude comment on society? Danish painter Gunnar Aagaard Andersen's 1964 chair *Portrait of My Mother's Chesterfield* was literally poured onto a metal frame, using buckets full of molten urethane foam.

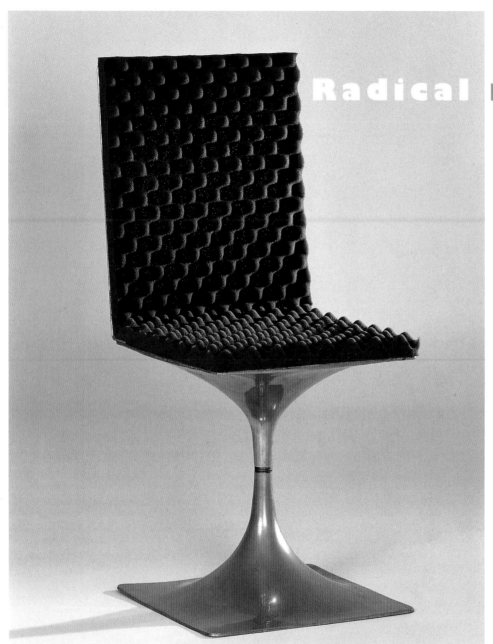

Radical ideas

Provocative work was being done all over Italy in the late 1960s and early 1970s. Designers and groups like Superstudio and Archizoom in Florence; Sottsass, Alessandro Mendini, Gaetano Pesce, and others in Milan; and the Strum group in Turin formed a radical avant-garde that blasted away at those quaint old notions: functionalism and Good Design.

■ In 1965, French designer Roger Tallon devised this inhumane but cool-looking chromed-aluminum pedestal chair, using inexpensive latex foam packing material as upholstery.

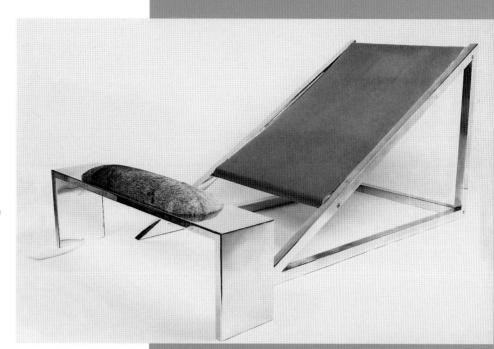

■ Either an homage to the Bauhaus master or a subtle put-down, Archizoom's Mies chair of 1969 (right) used steel and leather in a way that looks uninviting, until one settles into its elastic seat.

■ Gruppo 14's 1970 Fiocco lounge chair for Busnelli (below) is a sinuous sweep of stretch jersey on a tubular steel frame.

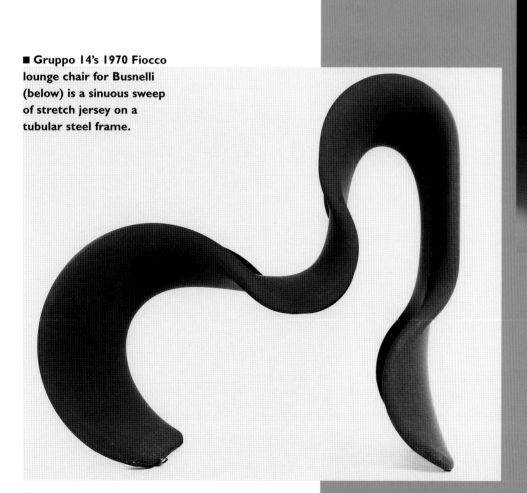

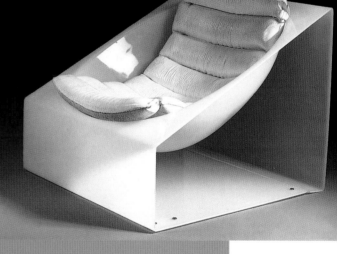

■ In Rossi Molinari's clever 1968 Toy chair for Totem (above), an uninterrupted strip of Plexiglas forms a parallelogram with a hemispherical recess for a seat.

■ Ionic, ironic, and iconic, the 1971 Capitello chair (above), a foam rubber capital created by Piero Gilardi of the Italian design group Studio 65, made a joke out of classicism.

■ Another postmodern prank, Piero Gilardi's Porfido cocktail table (right) looks like a slab of rough granite but is actually made of solid molded foam.

Freewheeling creativity came from the manufacturer Gufram, which turned out ironically shaped foam objects halfway between art and furniture. Gufram's designers went for shock value, all the way to the surreal. Il Pratone (The Meadow) was wildly unfunctional, a patch of stiffly varnished polyurethane "grass" on which you could sprawl, perhaps, but hardly sit. I Sassi (Stones), foam rocks to be casually strewn about the home or garden, had little evident utility.

At this juncture in Italian design, the concept *furniture* seemed to have lost its meaning. Certainly the word *modern* had lost all meaning—or rather, reverted to its original one, "of the moment," and beholden to no moment but the ephemeral present.

■ The first pet rocks, the provocative 1967 I Sassi (Stones) by Piero Gilardi for Gufram, were boulders of varnished polyurethane on which to sit. Strewn about for effect, they blurred the line between art and furniture.

Poetry in design

■ An overscale show of the latest in foam technology, Nani Prina's 1968 lounge for Somani also harked back to the crafts age, sporting a panel of hand-finished ebonized wood on its arm.

But even the most impractical pieces of the so-called Anti-Design movement had a poetic function. Curiously, the joyful-looking, flamboyant furniture produced by design groups such as Archizoom and Superstudio for Poltronova presupposed a dark view of everyday life. In the June 1969 issue of the Italian design magazine *Domus,* a manifesto issued in the name of Superstudio described life as nothing less than a "horror thrust upon us by the ambiguities of rationalism and functionality"—a horror we needed to escape, apparently, through objects that put the poetry, the symbolism, the ambiguity, the irrationality back into an increasingly mechanized existence.

Archizoom, led by Andrea Branzi, used materials like leopard skin and fake marble purposely to thumb its nose at good taste. Its flowerlike 1968 Safari sofa, ideal for a rich hippie's den, was sold by insulting the customers. "An imperial piece within the sordidness of your own home. . . . A beautiful piece that you simply don't deserve! Clear out your lounges! Clear out your own lives as well!" There, in a nutshell, is the insolence—sometimes good-natured, sometimes not—that characterized the Anti-Design milieu.

GAETANO PESCE

Gaetano Pesce, visionary architect-designer-sculptor-glassmaker-performance-artist, is usually considered part of the Anti-Design crowd. How else to categorize a man whose contribution to the 1972 *New Domestic Landscape* show at New York's Museum of Modern Art was an archaeological guided tour, set in the distant future, of the subterranean dungeons in which late-twentieth-century citizens had been forced to seek refuge after the apocalypse?

Quite by contrast is the cheery Pop look of Pesce's famous 1969 UP series, his most successful foray into the world of commercial production. The erotically shaped pieces suggest a plump woman in chains, a beckoning mother's lap.

Since spongelike polyurethane foam is 90 percent air, Pesce reasoned it would be possible to compress and vacuum-seal formed foam furniture, which upon opening would retake its shape before your eyes. C&B Italia took on production, the experiment worked, and a solution to an age-old shipping problem was born from an attempt to "nourish the spirit" of industrial production.

■ **Gaetano Pesce's II Pugno (Fist) of the early '70s went hand in hand with number 7 of 1969's UP series, a gigantic foam foot.**

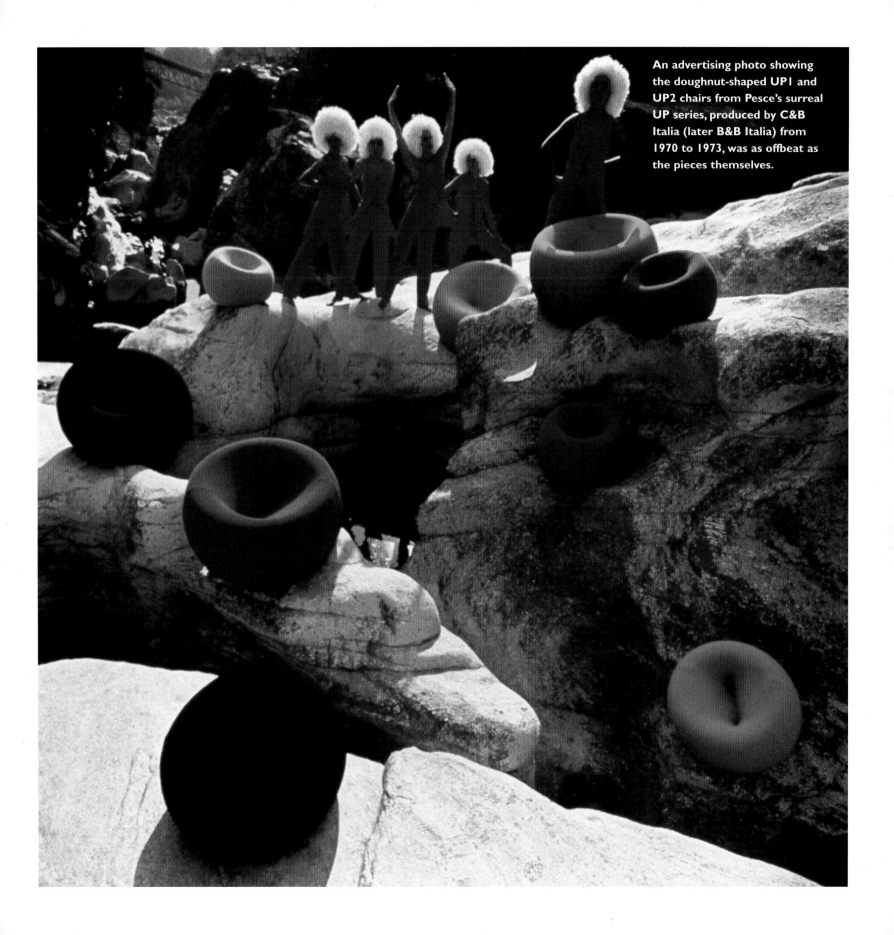

An advertising photo showing the doughnut-shaped UP1 and UP2 chairs from Pesce's surreal UP series, produced by C&B Italia (later B&B Italia) from 1970 to 1973, was as offbeat as the pieces themselves.

■ UP5, or Donna, is a
womanly Venus of
Willendorf, attached to
a ball and chain. "Women
are their own prisoners,"
the designer has said.
Along with the bean bag
of Gatti, Paolini, and
Teodoro (right), it is
among the most emblem-
atic shapes of the '60s.

■ Once unwrapped, it took about an hour for Gaetano Pesce's UP5 chair to swell "up" to its final form.

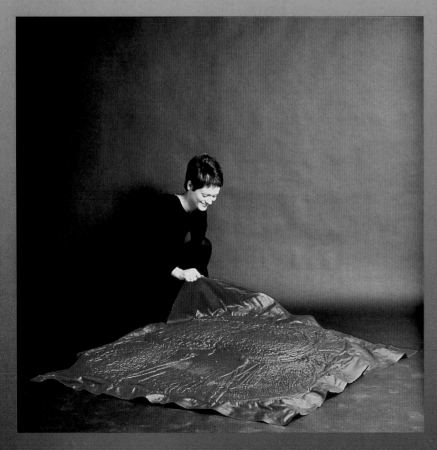

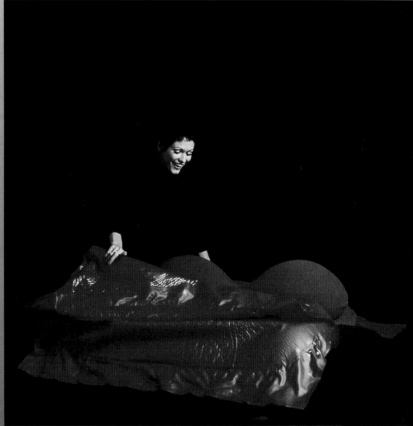

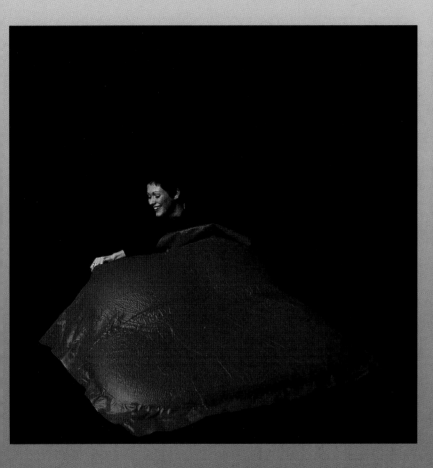
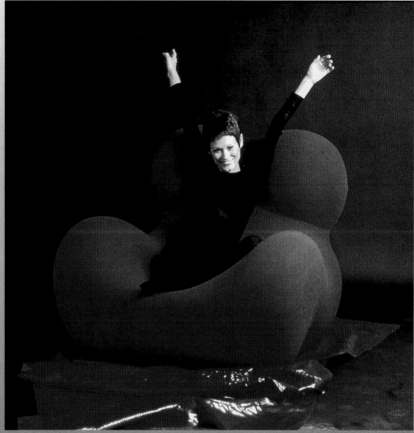

Design lives

Key figures of '60s Anti-Design—Sottsass, Mendini, Branzi—evolved later into the influential Milanese design groups of the 1970s and 1980s, Memphis and Studio Alchimia. While answering questions put to him by the Philadelphia Museum of Art in connection with the 1984 retrospective *Design Since 1945*, Sottsass took exception to the term *Anti-Design*. "Design does not end with the product put into production by industry, but starts from that moment," he said. "It starts when it enters our homes, enters our streets, towns, skies, bodies, and souls . . . when it becomes the visual, physical, sensorial representation of the existential metaphor on which we are laying down our lives."

■ The schematic line and ribbed construction of Cesare Leonardi and Franca Stagi's 1967 molded-fiberglass Dondolo rocker were answers to questions of functionality.

Design lives and breathes, Sottsass was saying. It is shaped by we who use it—never more so than in the 1960s. He might have been speaking for the output of the whole extraordinary decade when he continued, "Which also means that so-called Anti-Design in fact was 'anti' nothing at all, it was just all for enlarging and deepening the design event."

■ Things to come: Ettore Sottsass's rectilinear, robotlike 1964 cabinet for Poltronova is a conservative progenitor of the wild shapes of plastic laminate cabinetry that would make Sottsass the leading figure of 1980s postmodernism.

SOURCE GUIDE
STORES SELLING VINTAGE 1960s FURNITURE

ARIZONA

Vintage Modern Gallery
1515 North Central
Phoenix, Arizona 85004
602/462-5790

CALIFORNIA

Boomerang for Modern
2040 India Street
San Diego, California 92101
619/239-2040

Fat Chance
162 North LaBrea Avenue
Los Angeles, California 90036
213/930-1960

Futurama
446 North LaBrea Avenue
Los Angeles, California 90036
213/937-4522

Jet Age
250 Oak Street
San Francisco, California 94102
415/864-1950

Johnny B. Wood
1409 Abbot Kinney Boulevard
Venice, California 90201
310/314-1945

Modern One
7956 Beverly Boulevard
Los Angeles, California 90048
213/651-5082

Skank World
7205 Beverly Boulevard
Los Angeles, California 90036
213/939-7858

X-21
1639 Market Street
San Francisco, California 94102
415/252-1112

FLORIDA

Urbana
665 Central Avenue
St. Petersburg, Florida 33701
813/824-5669

ILLINOIS

Modern Times
1508 North Milwaukee
Chicago, Illinois 60622
312/772-8871

Urban Artifacts
2928 North Lincoln
Chicago, Illinois 60657
312/404-1008

Studio M
1901 W. Belmont Avenue
Chicago, Illinois 60657
773/388-0883

MASSACHUSETTS

Machine Age 20th Century Design
354 Congress Street
Boston, Massachusetts 02210
617/482-0048

MICHIGAN

First 1/2
43 North Saginaw
Pontiac, Michigan 48342
248/334-9660

NEW JERSEY

House of Modern Living
701 Cookman Avenue
Asbury Park, New Jersey 07712
732/988-2350

O'Vale
2 Broad Street
Red Bank, New Jersey 07701
732/933-0437

NEW YORK

Ace
269 Elizabeth Street
New York, New York 10012
212/226-5123

A&J 20th Century Designs
255 Lafayette Street
New York, New York 10012
212/226-6290

Art and Industrial Design Shop
399 Lafayette Street
New York, New York 10012
212/477-0116

C.I.T.E.
100 Wooster Street
New York, New York 10012
212/431-7272

Elan
345 Lafayette Street
New York, New York 10012
212/529-2724

Form & Function
95 Vandam Street
New York, New York 10013
212/414-1800

Frank Rogin, Inc.
21 Mercer Street
New York, New York 10013
212/431-6545

Full House
133 Wooster Street
New York, New York 10012
212/529-2298

Gueridon
357 Lafayette Street
New York, New York 10012
212/677-7740

Lin & Weinberg
84 Wooster Street
New York, New York 10012
212/219-3022

Lost City Arts
275 Lafayette Street
New York, New York 10012
212/941-8025

Modern Age
102 Wooster Street
New York, New York 10012
212/966-0669

1950
440 Lafayette Street
New York, New York 10012
212/995-1950

R
326 Wythe Avenue
Brooklyn, New York 11211
718/599-4385

Regeneration
38 Renwick Street
New York, New York 10013
212/614-9577

30 Bond
30 Bond Street
New York, New York 10012
212/995-8037

280 Modern
280 Lafayette Street
New York, New York 10012
212/941-5825

OHIO

Go Modern
2360 West 11th Street
Cleveland, Ohio 44113
216/241-5485

PENNSYLVANIA

Mode Moderne
159 North 3rd Street
Philadelphia, Pennsylvania 19106
215/627-0299

TENNESSEE

Fever
113 Gay Street
Knoxville, Tennessee 37902
615/525-4771

TEXAS

Aqua
1415 South Congress
Austin, Texas 78704
512/916-8800

Collage
307 Routh Street
Dallas, Texas 75201
214/880-0220

Citi Modern
2928 Main Street
Dallas, Texas 75226
214/651-9200

VIRGINIA

Daniel Donnelly Decorative Arts
107 North Fayette
Alexandria, Virginia 222314
703/549-4672

WASHINGTON, D.C.

Millennium
1528 U Street N.W.
Washington, D.C. 20009
202/438-1218

Mobili
2201 Wisconsin Avenue N.W.
Washington, D.C. 20007
202/337-2100

WISCONSIN

Atomic Interiors
961 South Park Street
Madison, Wisconsin 53715
888/254-1950

MANUFACTURERS/DISTRIBUTORS OF 1960s FURNITURE DESIGNS IN CURRENT PRODUCTION

Adelta International
Friedrich-Ebert-Str. 96
D-46535 Dinslaken
Germany
Tel 011 49 20 64 40 797
Fax 011 49 20 64 40 798
Adelta@t-online.de
Eero Aarnio

Airborne
B.P. 7
33702 Merignac Cedex
France
Olivier Mourgue

Arconas Corporation
580 Orwell Street
Mississauga, Ontario L5A 3V7
Canada
Tel 905/272-0727
Fax 905/ 897-7470
Olivier Mourgue

Artifort
St. Annalaan 23
PO Box 1179
6201 BD Maastricht
The Netherlands
Tel 011 31 43 325 00 08
Fax 011 31 43 321 14 09
postbus@artifort.com
www.artifort.com
Pierre Paulin

Dennis Miller Associates
306 East 61st Street
New York, New York 10021
Tel 212/355-4550
Wendell Castle

Design Selections International
PO Box 809
Croton-on-Hudson, New York 10520
Tel 914/271-3736
Fax 914/271-3793
Hans Wegner
Poul Kjaerholm

Fritz Hansen
Allerødvej 8
DK-3450
Allerød
Denmark
Tel 011 45 48 17 23 00
Fax 011 45 48 17 19 48
www.fritzhansen.com
Poul Kjaerholm
Arne Jacobsen
Henning Larsen

Herman Miller
PO Box 302
855 East Main Avenue
Zeeland, Michigan 49464
Tel 800/646-4400 or 616/646-4400
www.hermanmiller.com
Charles Eames

ICF Group
704 Executive Boulevard
Valley Cottage, New York 10989
Tel 914/268-0700
Fax 914/268-7114
Poul Kjaerholm

Erik Jorgensen Mobelfabrik A/S
Industrivaenget 1
DK-5700
Svendborg
Denmark
Tel 011 45 62 21 53 00
Fax 011 45 62 22 90 24
Poul Volther
Hans Wegner

Vladimir Kagan Design Group
1185 Park Avenue
New York, New York 10028
Tel 212/289-0031
Fax 212/360-7307
Vladimir Kagan

Knoll
105 Wooster Street
New York, New York 10012
Tel 212/343-4000
Fax 212/343-4170
www.knoll.com
Warren Platner

Richard Schultz
806 Gravel Pike
PO Box 96
Palm, Pennsylvania 18070
Tel 215/679-2222
Fax 215/679-7702
Richard Schultz

AUCTION GALLERIES FEATURING VINTAGE 1960s FURNITURE

John Toomey Galleries
818 North Boulevard
Oak Park, Illinois 60301
Tel 708/383-5234
Fax 708/383-4828

Treadway Galleries
2029 Madison Road
Cincinnati, Ohio 45208
Tel 513/321-6742
www.treadwaygallery.com

Bonhams Knightsbridge
Montpelier Street
London SW7 1HH
England
Tel 011 44 171 393 3900
Fax 011 44 171 393 3905

Bukowskis
Box 1754
111 87 Stockholm
Sweden
Tel 011 46 8 614 08 00
Fax 011 46 8 611 46 74
www.bukowskis.se

Christie's South Kensington
85 Old Brompton Road
London SW7 3LD
England
Tel 011 44 171 581 7611
Fax 011 44 171 321 3321
www.christies.com

David Rago Auctions, Inc.
Lambertville Antique and Auction Center
333 North Main Street
Lambertville, New Jersey 08530
Tel 609/397-9374
Fax 609/397-9377
www.ragoarts.com

Los Angeles Modern Auction
PO Box 462006
Los Angeles, California 90046
Tel 213/845-9456
Fax 213/845-9601
www.lamodern.com

William Doyle Galleries
175 East 87th Street
New York, New York 10128
Tel 212/427-2730
Fax 212/369-0892

Phillips Fine Art Auctioneers
406 East 76th Street
New York, New York 10021
Tel 212/570-4830
Fax 212/570-2207

Sotheby's Chicago
215 West Ohio Street
Chicago, Illinois 60610
Tel 312/670-0010
Fax 312/670-4248

Sotheby's London
34–35 New Bond Street
London W1A 2AA
England
Tel 0171 293 5000
Fax 0171 293 5989

Southland Auctions, Inc.
3350 Riverwood Parkway
Atlanta, Georgia 30339
770/818-2418

WEB SITES OFFERING VINTAGE 1960s FURNITURE FOR SALE

http://www.centurymodern.com (US)

http://www.deco-echoes.com (US)

http://www.gomod.com (US)

http://www.haus.co.uk (England)

http://www.inforamp.net/~qmodo (Canada)

http://www.mancha.demon.co.uk (England)

http://members.aol.com/dalchicago (US)
(Joe's Cool Website of '50s–'70s Design)

http://www.m-pm.com (Australia)

http://www.retromodern.com (US)

http://users.skynet.be/fiftie-fiftie (Belgium)

http://www.xxo.com (France)

INDEX

PHOTO CREDITS